Norman Rockwell

and

THE SATURDAY EVENING POST

THE MIDDLE YEARS

by DR. DONALD R. STOLTZ
and
MARSHALL L. STOLTZ

 MJF BOOKS
NEW YORK

We are grateful to a number of persons and organizations whose assistance and cooperation were indispensible to the production of this book. Our thanks go to:

Arthur Abelman, Esq.
James E. Barrett—Production Manager, *Saturday Evening Post*
Frederic A. Birmingham—Managing Editor and Associate Publisher, *Saturday Evening Post*
Starkey Flythe, Jr.—Executive Editor, *Saturday Evening Post*
William S. Gardiner—Director of Licensing and Royalties, *Saturday Evening Post*
Beurt SerVaas—Chairman, Curtis Publishing Company
Dr. Cory SerVaas—Editor and Publisher, *Saturday Evening Post*
Dee Smith—Editorial Associate
Margaret Westermaier—Editorial Associate
David Wood—Curator, Old Corner House (Stockbridge, Mass.)
Irwin H. Avis—Art Consultant

mjf

Published by MJF Books
Fine Communications
Two Lincoln Square
60 West 66th Street
New York, NY 10023

Library of Congress Catalog Card Number 94-77-495
ISBN 1-56731-062-1

Dedicated to

Norman and
Molly Rockwell

and

THE CURTIS
PUBLISHING COMPANY

CONTENTS

NORMAN ROCKWELL

Norman Rockwell

This set of books is a tribute, a tribute to a man whose face is familiar to many of us, whose name is known by most of us and whose creations are a part of all of us.

It is a show of appreciation to a man who is as American as Uncle Sam, as devoted as the Boy Scouts and as talented as the masters of the Renaissance.

It is a salute to one of America's most beloved men—Norman Rockwell —artist, illustrator and historian.

These books contain all the covers that Mr. Rockwell painted for *The Saturday Evening Post*. It is the first time that a complete, full-size, full-color collection of Norman Rockwell's *Post* covers has been assembled and made available to all collectors. The covers are a truly remarkable history. They are a storybook of our country, encompassing over sixty years of everyday happenings, a living, vibrant, unvarnished documentation of America.

In 1943 a fire in Norman Rockwell's studio in East Arlington, Vermont destroyed many of his original canvases, memorabilia and *Saturday Evening Post* covers. In 1969, *"The Post"* temporarily ceased production (it was reorganized in 1971 and continues today to be published monthly), and many of its archives were lost or removed. Copies of these magazines and covers are now as rare as the original oils.

To be able to accumulate, categorize, restore, edit and reproduce these covers in a fashion as close as possible to the original covers is a labor of love, and a special note of appreciation must go to Mr. Starkey Flythe Jr. of the Curtis Publishing Company, whose time, effort and incredible knowledge was invaluable to us. We also thank "The Corner House" (now the Norman Rockwell Museum) of Stockbridge, Massachusetts where many Rockwell treasures are permanently displayed for the public to enjoy.

In 1972 Bernard Danenberg Art Galleries of New York compiled an exhibit of *Post* covers, as well as original Rockwell oils and drawings, and toured the country with this collection, generating monumental interest and adding millions of new Rockwell fans to the rolls. Throngs of younger generation admirers revealed the agelessness of these artistic treasures. People hurried to their attics and basements to search for old *Post* magazines so that the covers could be preserved and enjoyed.

It was as a result of this exhibit and the massive interest of those seeing it, as well as an appeal from serious Rockwell collectors, that we decided to reproduce the original covers in three volumes, exactly as they appeared in print, thus preserving for future generations the art and illustration of this gifted American.

Seeing and reading these volumes is more than a moment's entertainment; to watch the sheer enjoyment of people getting to know Rockwell is to understand what our books are all about.

"People love studying other people." That says it all, and we hope that the pages which follow provide such a medium of love and insight to all who open these books.

Dr. Donald R. Stoltz

"Hot Pursuit"

Times were bad in 1928 and unemployment was rampant. Hobos, or "Kings of the Road" as they called themselves, were common and they were a favorite subject of authors, artists, and cartoonists. Financially troubled people silently envied their free and easy life on the rails, where the only problem might be an exuberant dog hot on the heels of a hobo who has just pilfered a hot apple pie from someone's window sill.

Rockwell enjoyed painting such colorful characters and this is the fifth one to grace the cover of *The Saturday Evening Post*. And we're sure he'll make it back to his associates in the freight car just as soon as the pup gasps for breath.

Two of Rockwell's earlier tramps, September and October, 1924, had a better experience when they encountered friendly pooches who were willing to share their experiences and join them in their travels.

THE SATURDAY EVENING POST

Volume 201, Number 7

AUG. 18, 1928

For ... lin

5c. THE COPY
10c. in Canada

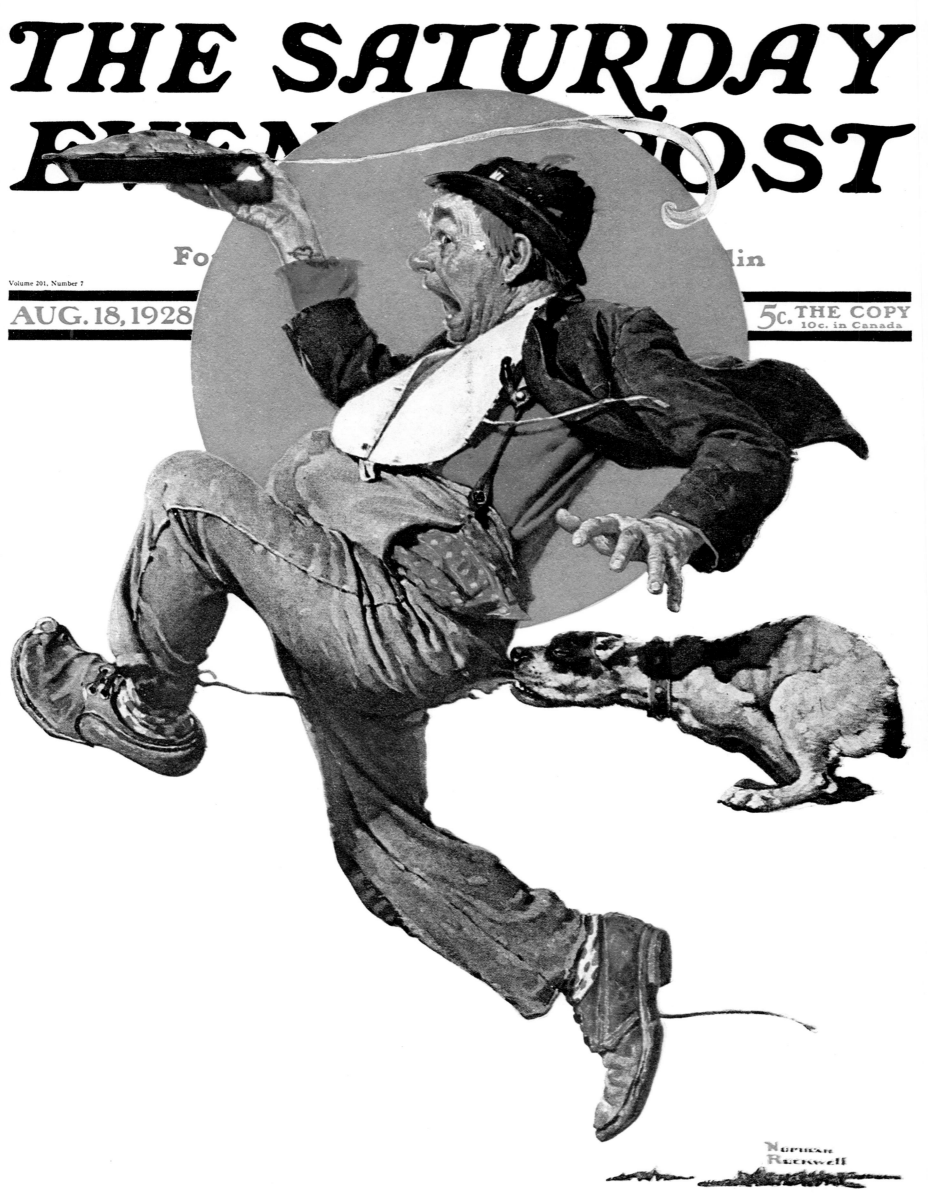

"Strummin' the Guitar"

A successful artist must not only be well versed in palette, paint, and brush, but should also have a smattering of knowledge in music, history, and literature. In this picture, we see everything combined. The "Bard of Avon" (being used as a hat rack) watches a young musician serenade his girl friend on their way home from the library.

This cover bears a striking resemblance to the August 30, 1924, *Post* cover, but styles of dress have improved, and our vocalist has traded his accordion for a guitar. A nearby lamppost casts a warm glow on the scene, and we hope it warms the heart of our young lady as well in this midsummer night's dream.

Most models appeared in Rockwell's studio in fine attire and were given appropriate costumes for the painting, but this couple were allowed to pose in their Sunday best.

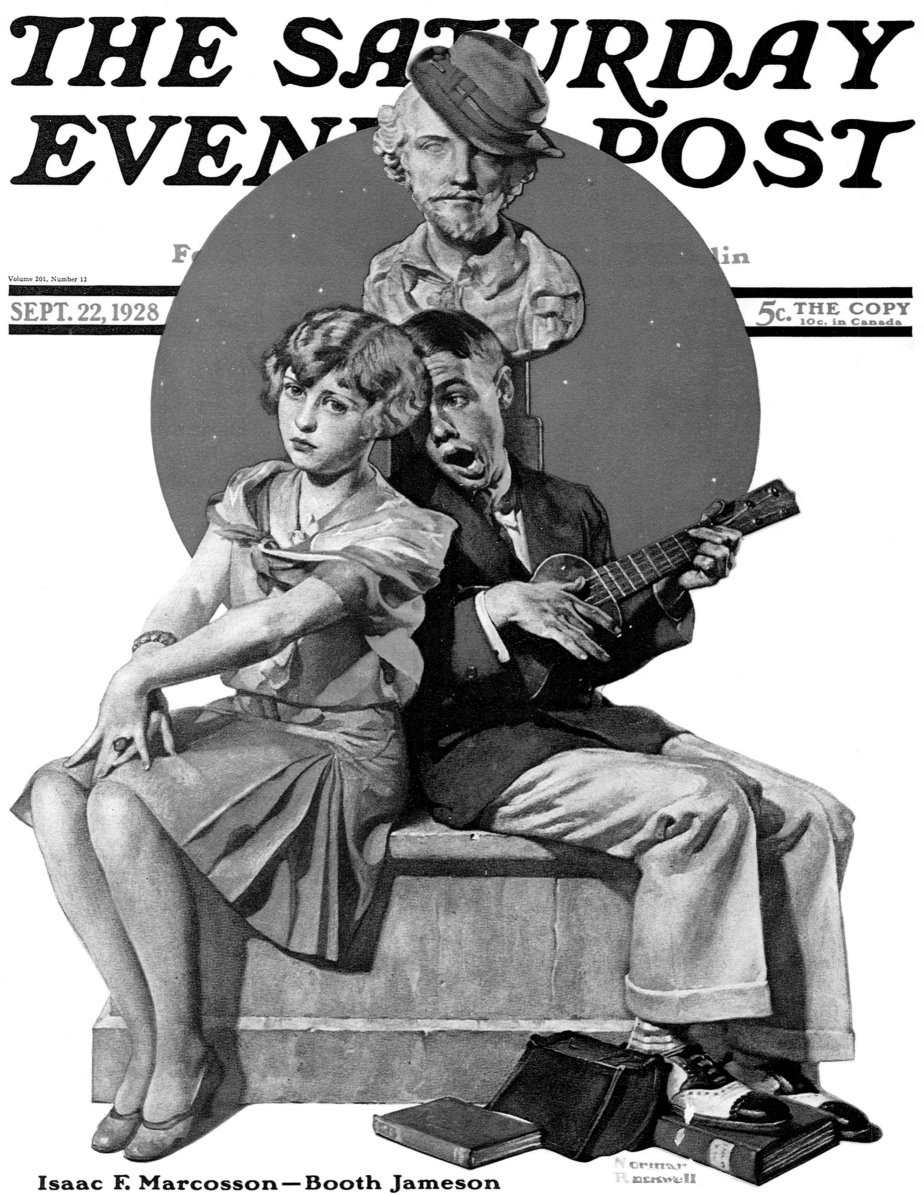

"Follow Me in Merry Measure"

Although most of Norman Rockwell's Christmas covers depicted winter scenes, kids, toys, and Santas, a few had historical backgrounds, and several had Dickensian themes. Christmas was a happy time in the Rockwell house, since it was one of the few days out of the year that Norman took some time off. Christmas also brought back pleasant memories of his own youth and the stories read to him by his father.

This plump and jolly couple are prancing about to an old-fashioned dance step. The gentleman has maneuvered his lady under the mistletoe, where the gleam in his eye portrays the thought in his head.

THE SATURDAY EVENING POST

Volume 201, Number 23

DEC. 8, 1928

5c. THE COPY
10c. in Canada

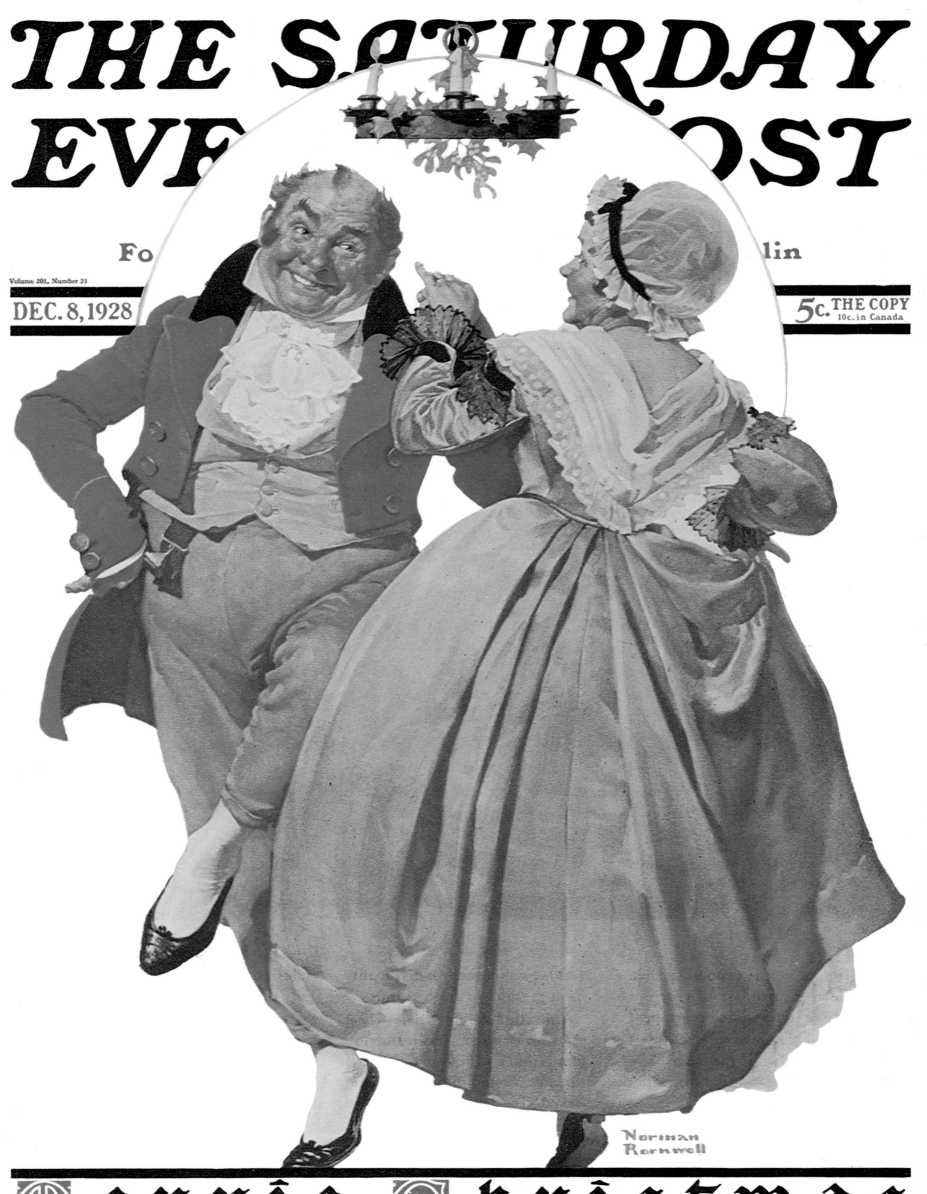

Merrie Christmas

"Busybodies"

In addition to the attractive, interesting, intelligent, and fun people in town, Mr. Rockwell was also fascinated by the newsmakers. Rumors abound in small towns, and every day little groups would gather—either to start some exciting gossip or to magnify an already circulating story.

These three prim and proper ladies are having a wonderful gossip session, and soon they will take their news to other friends.

Unfortunately, Mr. Rockwell couldn't find a lady who looked "funny" enough to meet the requirements for this trio, so he went back to his old friend, James K. Van Brunt (minus his mustache), for two of the old busybodies.

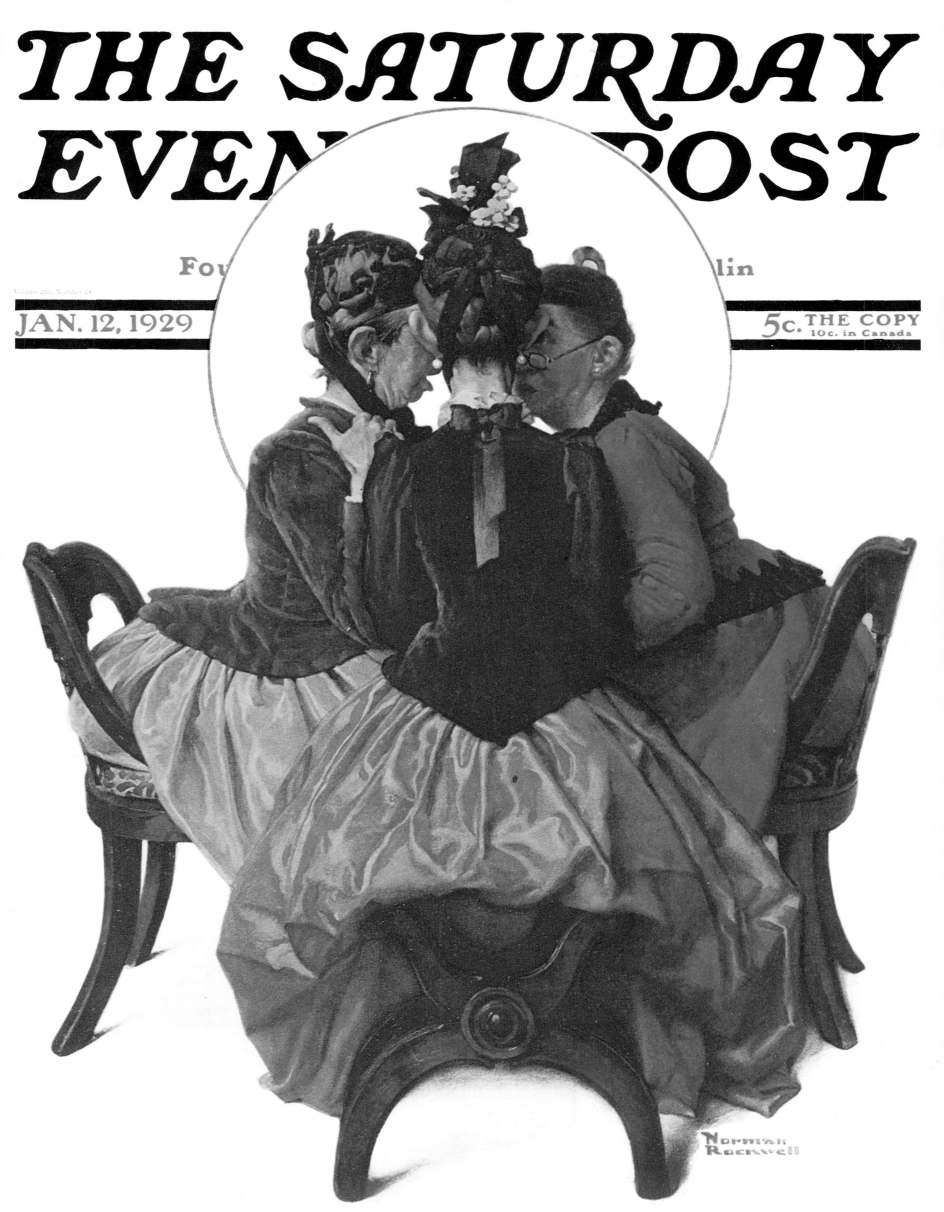

THE SATURDAY EVENING POST

Volume 201, Number 24

JAN. 12, 1929

Fou...lin

5c. THE COPY
10c. in Canada

Booth Tarkington—Corey Ford—Hugh Mac Nair Kahler—Edith Fitzgerald
Horatio Winslow—John Chapman Hilder—Will Payne—Ben Ames Williams

"Chivalry"

Before the advent of television, people loved the luxury of escaping into the magic world of books. All of us delighted in the fanciful scenes which floated through our minds. And despite outward appearances, such was the inspiration behind this picture.

It's not that the book was dull, but that adventure and excitement abounded as our gentleman closed his eyes to be transported to a long-ago land of knights in shining armor. The parlor lamp that lit the scene was just not enough to keep Robin Hood, Ivanhoe, King Arthur, and Sir Galahad from creeping up from the shadows.

Norman Rockwell also appreciated those rare, quiet, free moments when he put aside his paint brush to sit in a big plush chair and enjoy a good book. Like so many others, was Rockwell merely escaping from reality? Or was he searching for new ideas for his pictures?

THE SATURDAY EVENING POST

Founded A·D·1728 by Benj. Franklin

Volume 201, Number 33

FEB. 16, '29

5 cts.

10c. in Canada

Garet Garrett—Mary F. Watkins—I. A. R. Wylie—Horatio Winslow—Kennett Harris
Ben Ames Williams—Clarence Budington Kelland—Rear Admiral T. P. Magruder

"The Doctor and the Doll"

March 9, 1929, was a milestone in Rockwell's *Post* covers as one of the all-time favorites hit the newsstands. Who cannot remember the anguish of a little girl when her doll begins to break, fray, or just look sick? And if the family doctor can fix up "real" people, mending the doll should be easy. Who wouldn't put their trust in this kindly country doctor, who looks so concerned? And which doctor wouldn't do all he could to come to the aid of a forlorn little girl and her best friend?

Once again, Norman Rockwell combined the innocence of youth and the wisdom of maturity, showing us that a generation gap is bridged when mutual need is realized.

Although most of Rockwell's earlier works were outdoors, this very successful scene took place inside. With minimal props, he didn't miss a thing of importance: the diploma, the medical texts, the black bag, the picture of earlier men of medicine.

Pop Fredericks posed as the doctor. Although he never succeeded in his ambition to be an actor, Fredericks reached fame on Norman Rockwell canvases as a politician, a hobo, a tourist, a cellist, Ben Franklin, Santa Claus, and this wonderful and beloved old doctor.

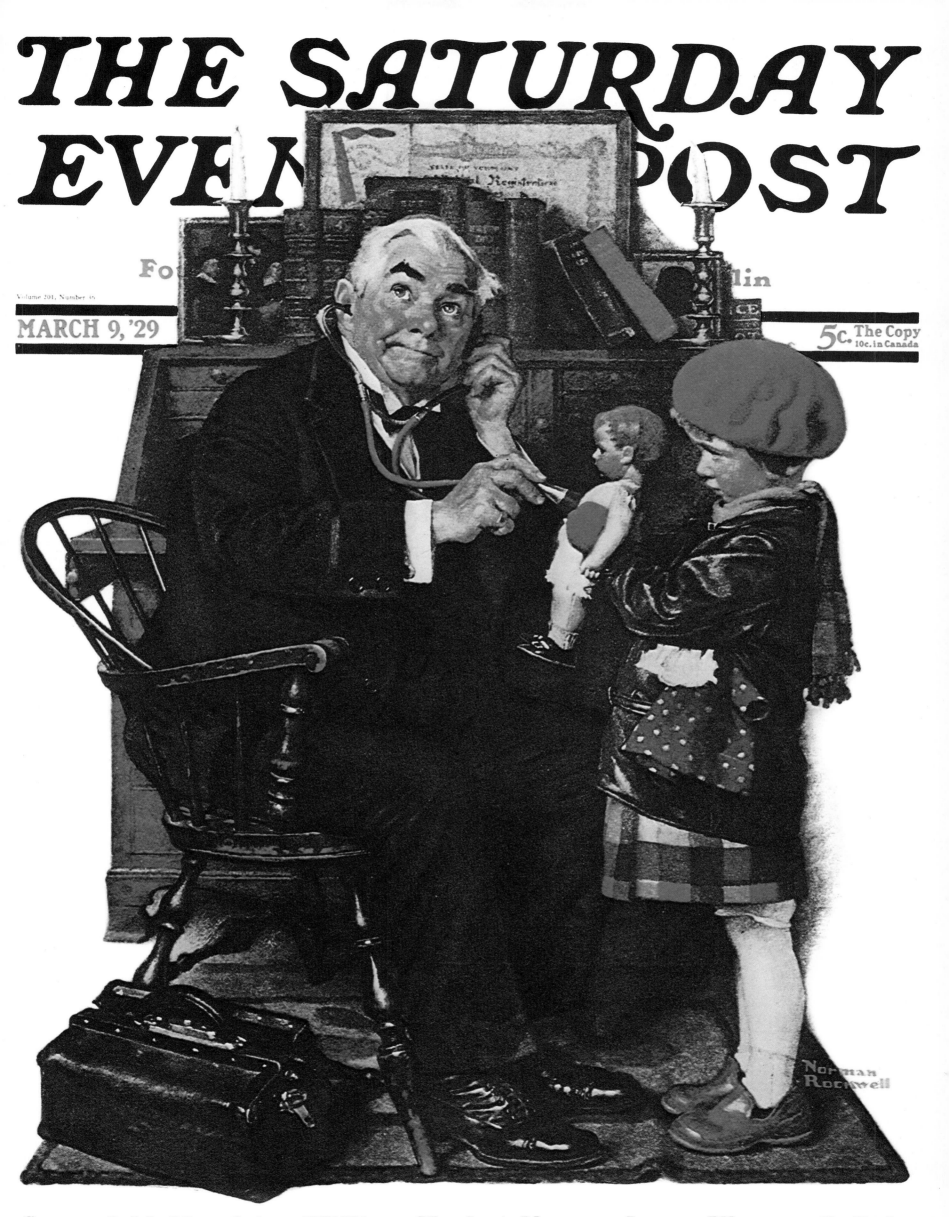

"Welcome to Elmville"

Dave Campion took some more time off from his newsstand to pose for this humorous *Post* cover. Here, the humor is certainly in the eyes of the reader rather than in those of the driver. The local sheriff, with badge, watch, and whistle, hides behind the town sign and gives unwary travelers anything but a hearty welcome.

This cover idea came from a true-to-life incident which happened to Mr. Rockwell as he was driving through Amenia, New York. "That was back in the days when towns paid their taxes with speeders' fines, and the Amenia cop really nailed me—right along the welcome sign!"

Years later, another policeman stopped Mr. Rockwell in Philadelphia and asked him to sign an affidavit that he had just witnessed a traffic accident. Norman actually saw very little of the incident and was reluctant to get involved. The policeman insisted, however, most probably to get an autograph on the document.

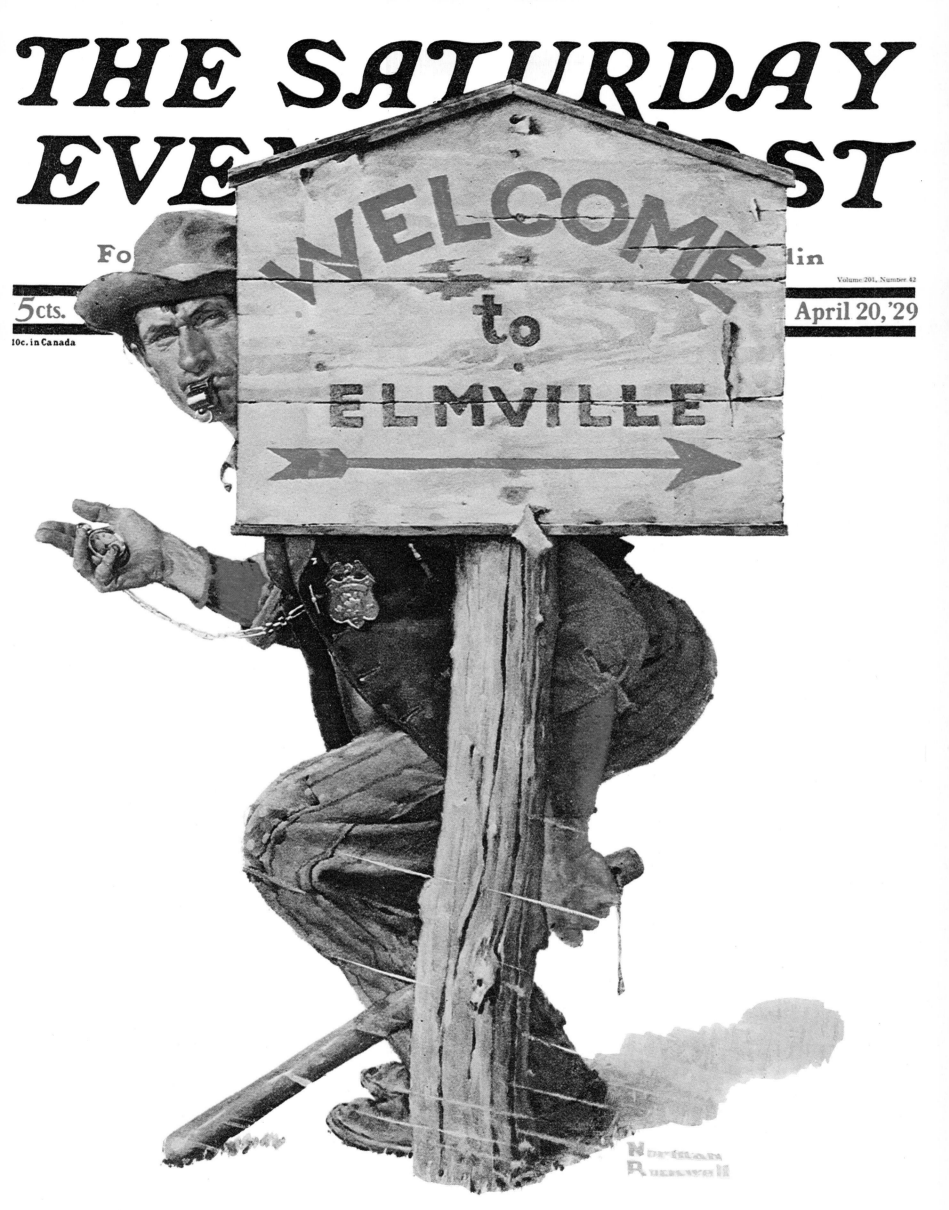

"Tough Choice"

Along with patriotism, growing up, Christmas, and sports, love is a recurring theme in the art of Norman Rockwell. From "The Suitor" (January 13, 1917) to "The Marriage License" (June 11, 1955) the subject appears again and again without losing feeling or interest.

In this cover, love has become a dilemma. Which one of the twin sisters will be our suitor's companion for the evening? Both are beautiful, both are expressionless, and both are admiring the flowers of their handsome caller.

The flowers in this picture are much nicer than those on the June 19, 1920, cover, but of course this handsome fellow went to the florist for his bouquet and the little fellow in 1920 picked his bouquet from a nearby field.

THE SATURDAY EVENING POST

MAY 4, 1929

5c. THE COPY
10c. in Canada

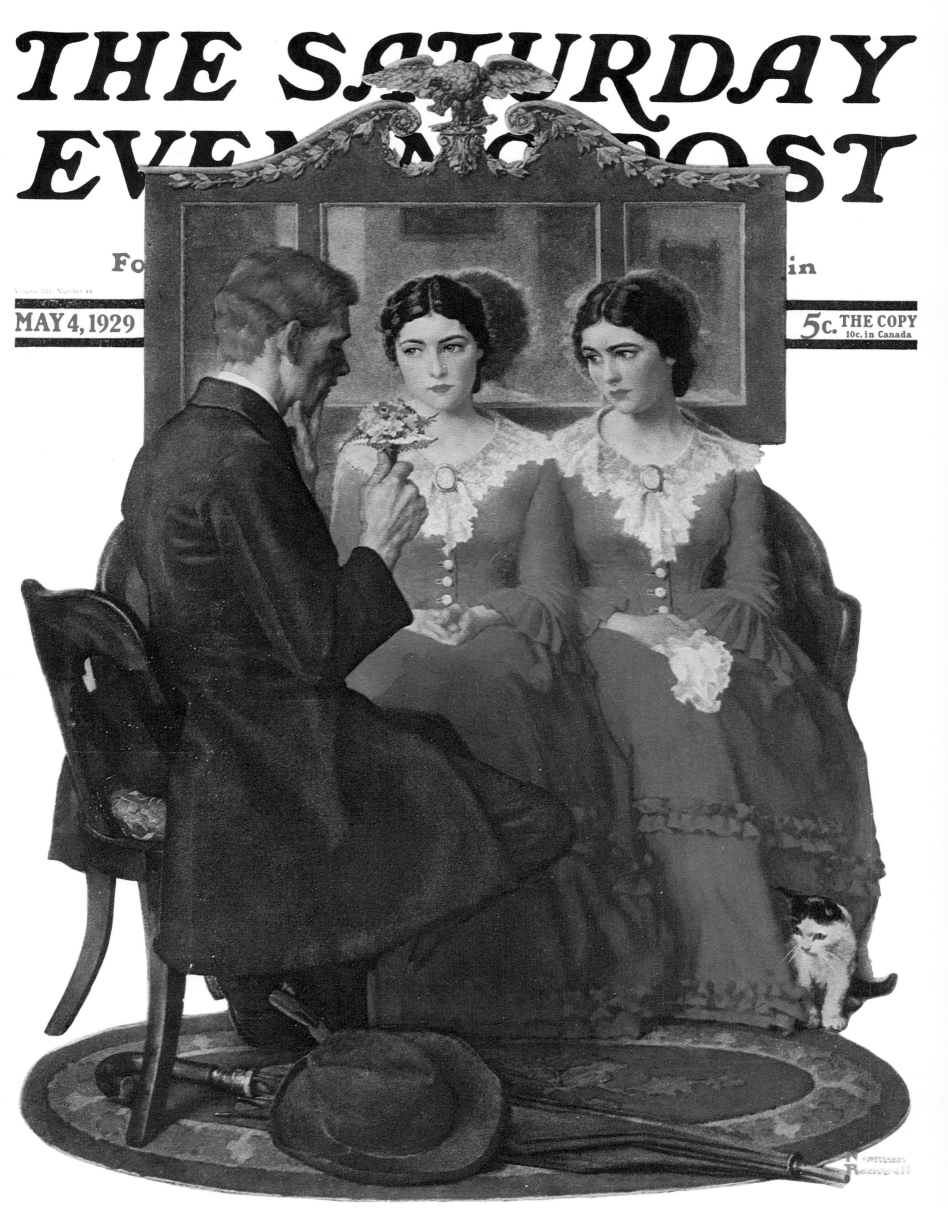

C. E. Scoggins—Garet Garrett—Vittorio Emanuele Orlando—J. P. Marquand
Charles Brackett—Edith Fitzgerald—Fanny Heaslip Lea—F. Britten Austin

"Hide Your Eyes"

On the June 4, 1921, *Post* cover, Norman Rockwell caught three half-bare boys and their pooch making a successful getaway from the man who put the "No Swimming" sign on his fishing pond. Kids will be kids, though, and one week and eight years later, they try it again. This time they run into a more difficult adversary—a girl!

Our cute little miss spots the boys' clothes and weapons on the sign and decides that if she doesn't look at them, they might not see her. If they do, someone is going to be very embarrassed. We hope that our proper young lady remembers what to get at the market after such a mind-boggling experience.

THE SATURDAY EVENING POST

Volume 201, Number 50

5 cts.

10c. in Canada

JUNE 15, 1929

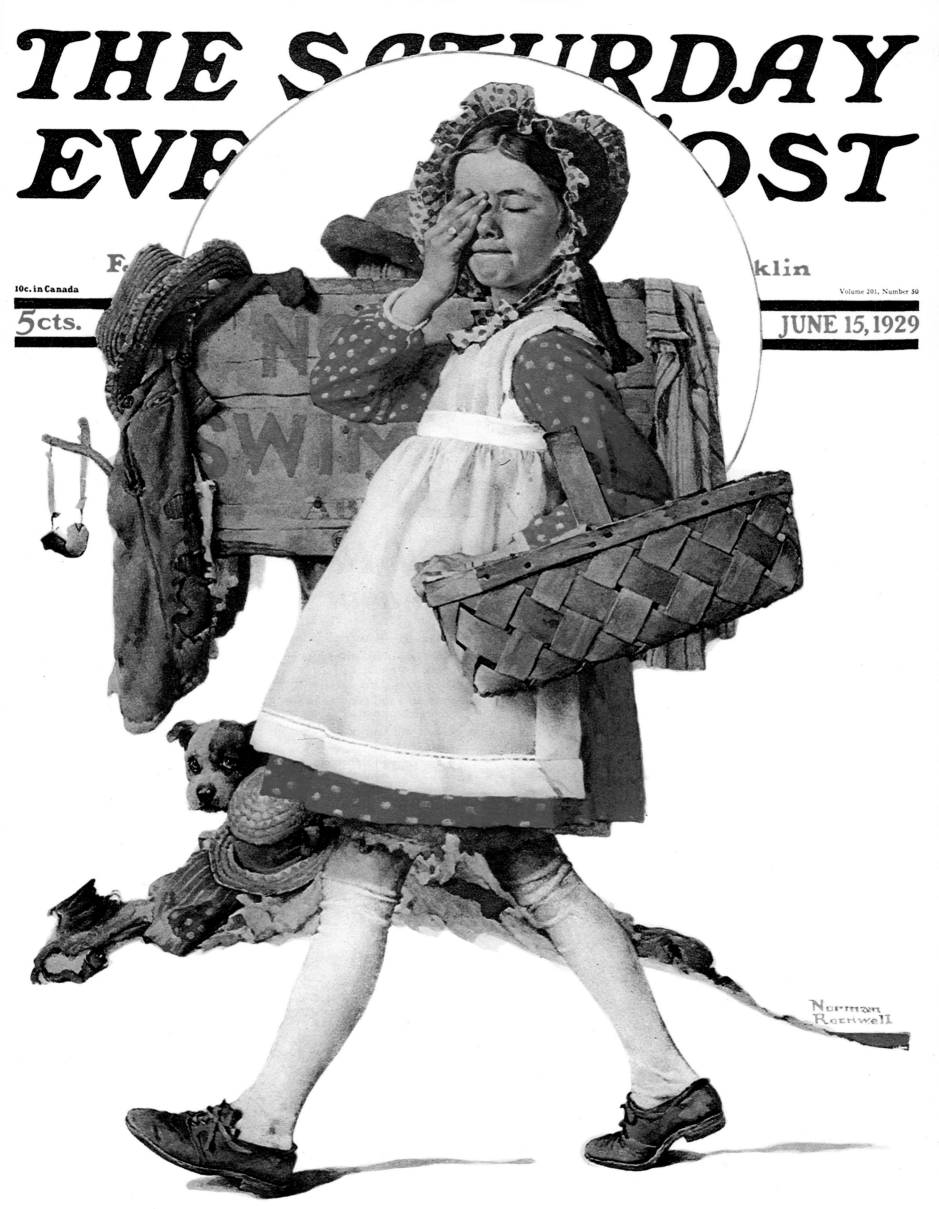

"The Mule Ride"

Rockwell portrayed many forms of transportation in his *Saturday Evening Post* covers. People traveled by car, train, boat, airplane, soapbox, and stilts, but there was only one way to observe the mountainous terrain of the West successfully—on the back of a mule.

Our well-to-do cigar-smoking gentleman is getting a first-class look at America, and if the mount continues under its heavy load the fellow may have many interesting stories to tell.

Mr. Rockwell traveled through the West and instead of painting its awesome magnificence he preferred to tickle his audience with this fun-filled fat fellow, as he did in many *Post* covers.

Rockwell, who loved America, tried a slightly different theme on the April 23, 1938, cover, where he depicted a man who really saw America first.

THE SATURDAY EVENING POST

Volume 202 Number 2

JULY 13, 1929

Fo lin

5c. THE COPY
10c. in Canada

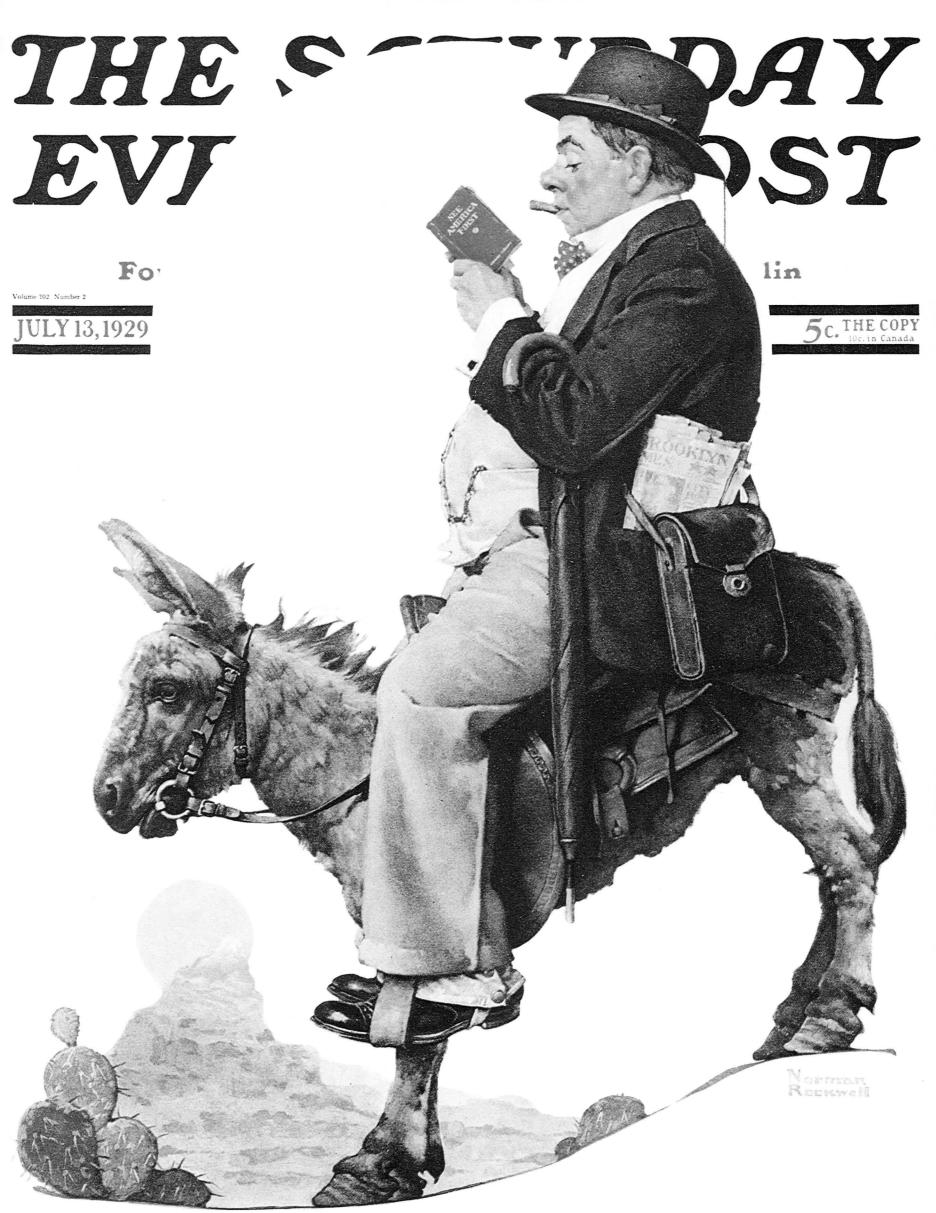

"Snagging the Big One"

Rockwell enjoyed painting real people doing real things. He wanted his audience to identify with something, whether it be at home, school, work, or church. Frequently, when a picture was not just right, he would call in his neighbors and have them try to solve the problem. But on this August cover, there really was no problem to solve.

Our barefoot fisherman has a bandage on his toe (as do many friends on earlier covers) and a pretty nice catch of fish in tow. But Grandpa has come along on his way home from work to try his luck also. As we can see, experience prevails, and a "whopper" is being pulled in from the lake. Naturally, Gramps is thrilled. And we're sure that he'll delight in repeating the story of his fish, which will get bigger and bigger with each passing year.

THE SATURDAY EVENING POST

Volume 202, Number 5

Aug. 3, '29

5c. THE COPY
10c. in Canada

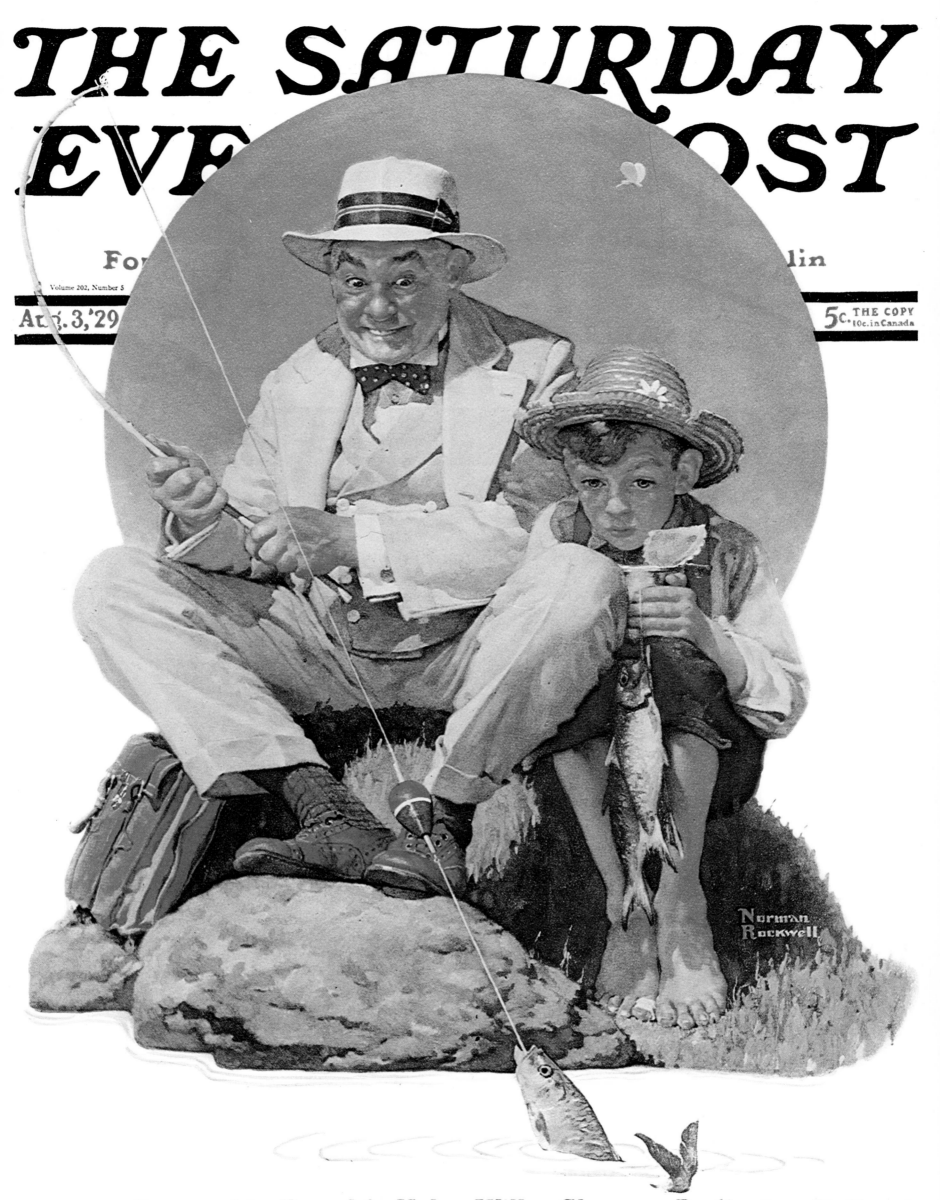

Norman Rockwell

"Raleigh Rockwell Travels"

The editor of the old *Life* magazine, John Ames Mitchell, once told Norman Rockwell that the most popular subject for a magazine cover was a beautiful woman. The second most popular was a kid, and the third, a dog.

Until this cover, Rockwell had used dogs in twenty-eight of his previous covers, and each one met with wide acceptance. Readers would write, "I love that little boy, but oh, that dog with those human-beseeching eyes!"

Rockwell used many varieties of dogs, from mongrels to pedigrees. Some folks thought, as he was wandering through town looking at the various pups, that he was either a dog catcher or just plain crazy.

The Rockwell home always had a dog. It wouldn't take Sir Arthur Conan Doyle (who wrote a story in this issue of the *Post*) long to figure out which one of these fine fellows is the Rockwell family pet.

About this time, Norman and Irene were having some difficulties, and Norman found that he could always rely on his beloved dog, Raleigh, for companionship. The two understood each other and were always unhappy when apart.

THE SATURDAY EVENING POST

Found

Volume 202, Number 13

September 28, 1929

5c. THE COPY
10c. in Canada

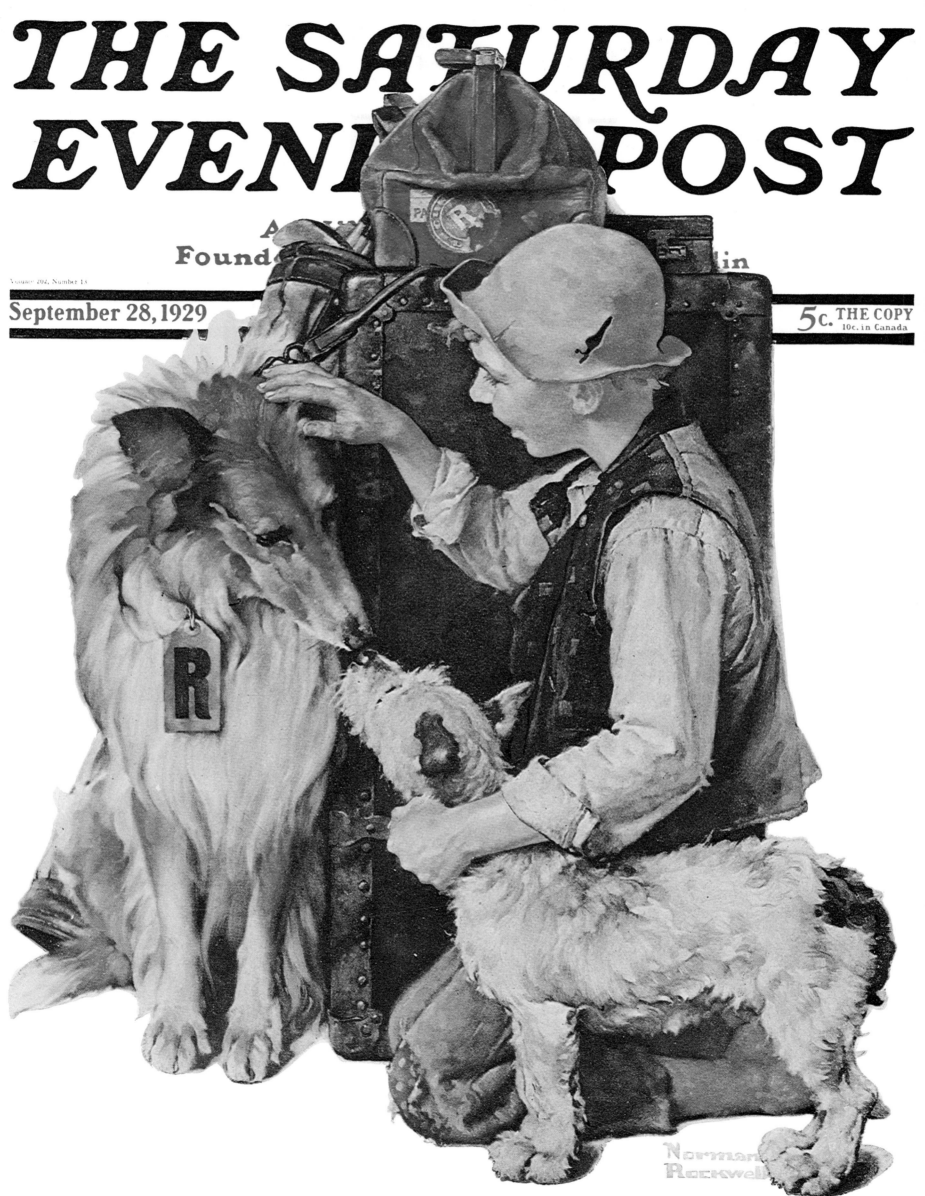

A. Conan Doyle—Margaret Weymouth Jackson—Edith Fitzgerald
Frederick Irving Anderson—Don Marquis—Gilbert Seldes—Sophie Kerr

"Jazz It Up with a Sax"

It was 1929. The country was experiencing hard times and so was Rockwell's marriage. Irene was unable to cope with the life Norman had been leading for the past two years: country clubs, beach clubs, night life, constant parties, and two prolonged trips to Europe. He was neglecting his work, and it was beginning to show.

Then suddenly everything collapsed! Irene asked Norman for a divorce. She had fallen in love with another man. Shortly afterward, Norman moved out of his house and took an apartment in the Hotel des Artistes on Sixty-seventh Street (off Central Park) in New York City. But despite his woes, Rockwell still had pictures to paint and deadlines to meet. Ideas were harder to come by, and he was forcing himself.

In this cover, we see a gentleman of professional caliber contemplating a change in style. These newer times dictate giving up the life of a contemporary violinist to "Jazz it up with a sax."

Norman Rockwell surely never toyed with the idea of giving up art, but he may have projected some drastic changes in his life as does this pensive musician. The sheet music covers also give away some of Rockwell's innermost thoughts.

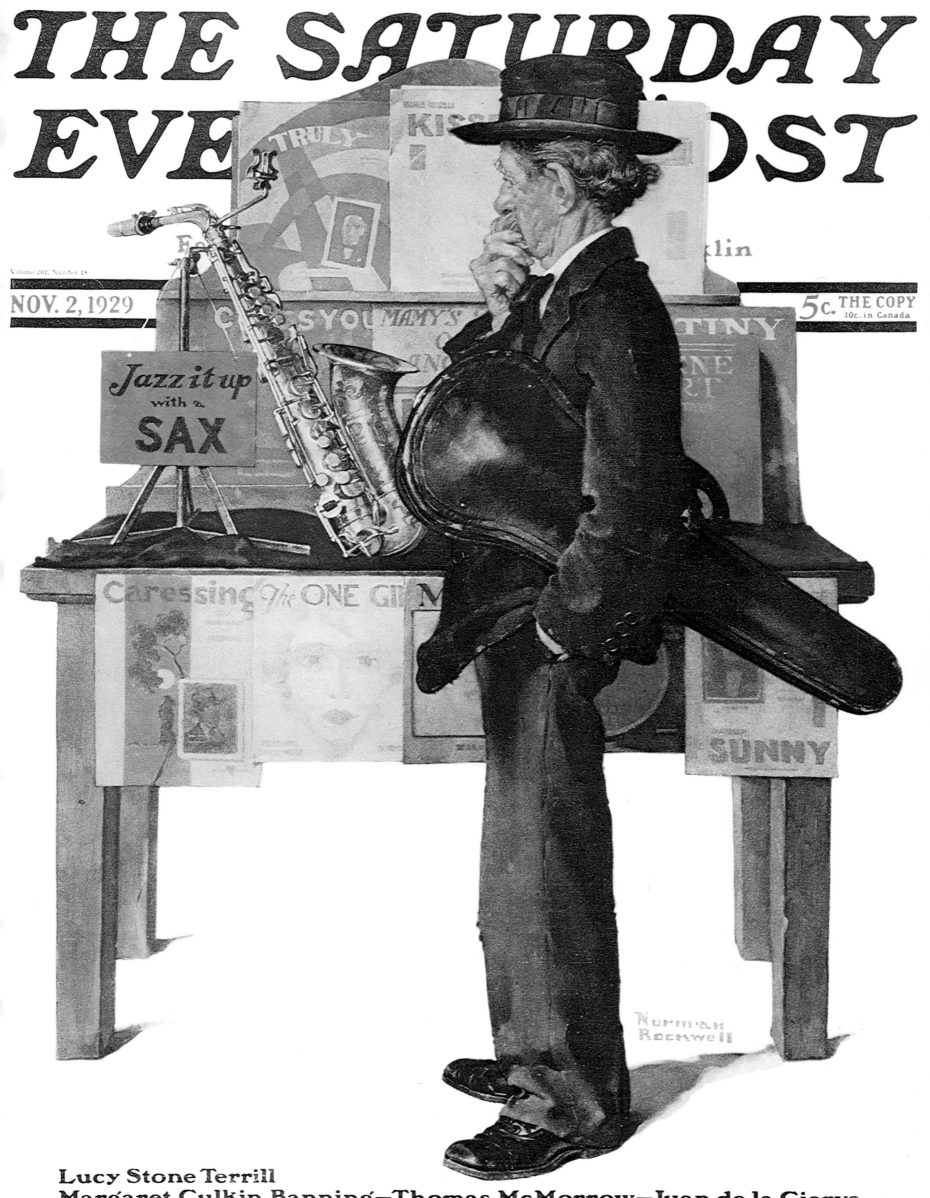

"The Merrie Old Coach Driver"

Christmas was a happy time in "Merrie Old England," and the coach driver vigorously directed homebound passengers to their destinations. Afterward, he himself would return home to a sumptuous feast of roast goose and Yorkshire pudding, adding a few more inches to his already rotund frame.

This was an especially unhappy Christmas for Norman Rockwell. He was alone in his New York City apartment, and creative ideas came slowly. He called this his "Dark Period," and during this time produced some pictures which never really pleased him.

THE SATURDAY EVENING POST

Illustrated

Volume 202, Number 23

DEC. 7, '29

10c.
in Canada

5 cts.

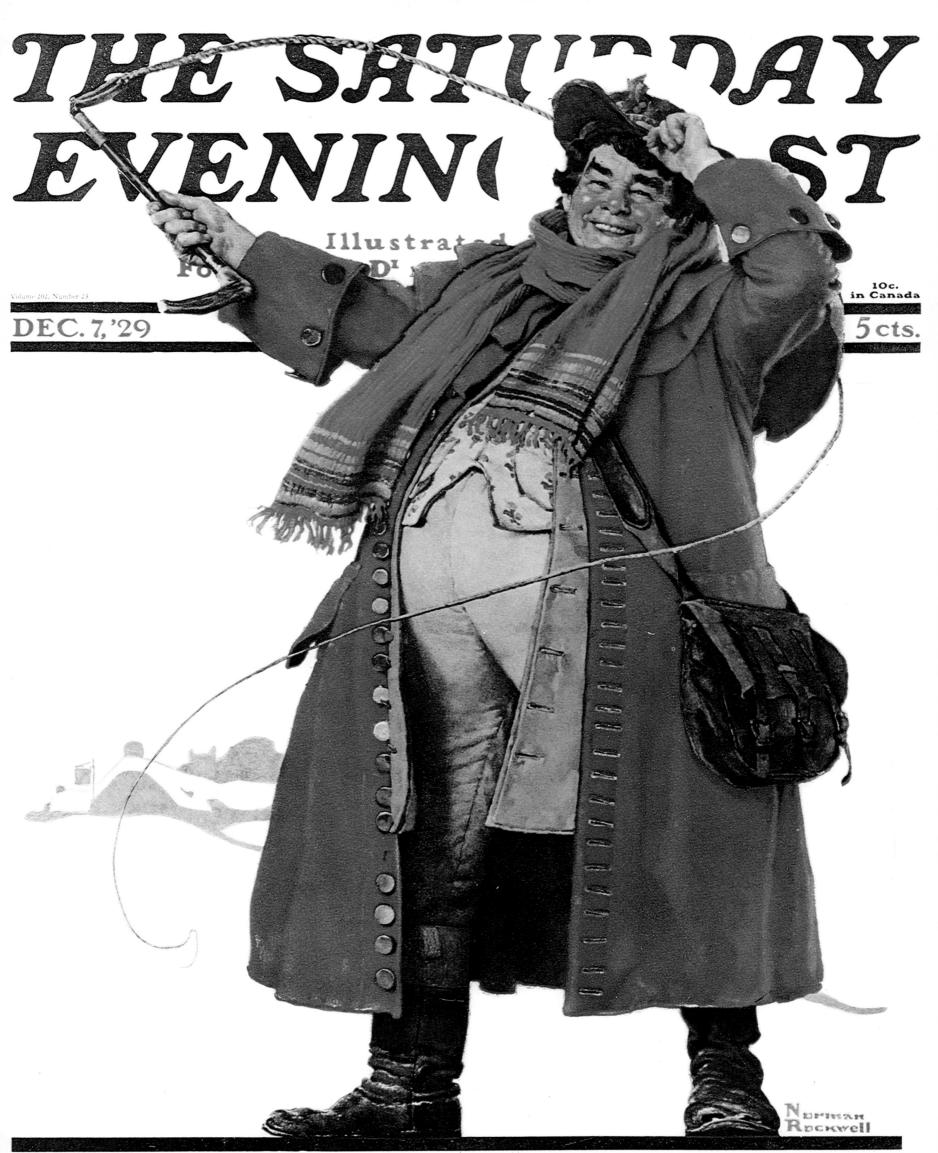

Merrie Christmas

Norman Rockwell

"Stock Exchange Quotation"

Things were getting worse and people from all walks of life were suddenly interested in the country's financial situation. Norman Rockwell, by this time a man of means, also had a great deal of interest in the stock market and studied the quotations each day.

In this 1930 *Post* cover he depicts a man of wealth, a grocery clerk, a fashion model, an elderly lady, and an interested dog contemplating the Wall Street activities of the day.

It is interesting to note that because Rockwell was troubled by family stress and world financial concerns, this cover bore the consequence of a rare Rockwell error. Upon examining the cover of *The Saturday Evening Post,* Rockwell discovered that his grocery boy with the red shirt had three legs.

At first he was troubled with the picture, but later the situation proved amusing to him and even humorous as he pointed out to friends the extra leg hidden under the apron.

THE SATURDAY EVENING POST

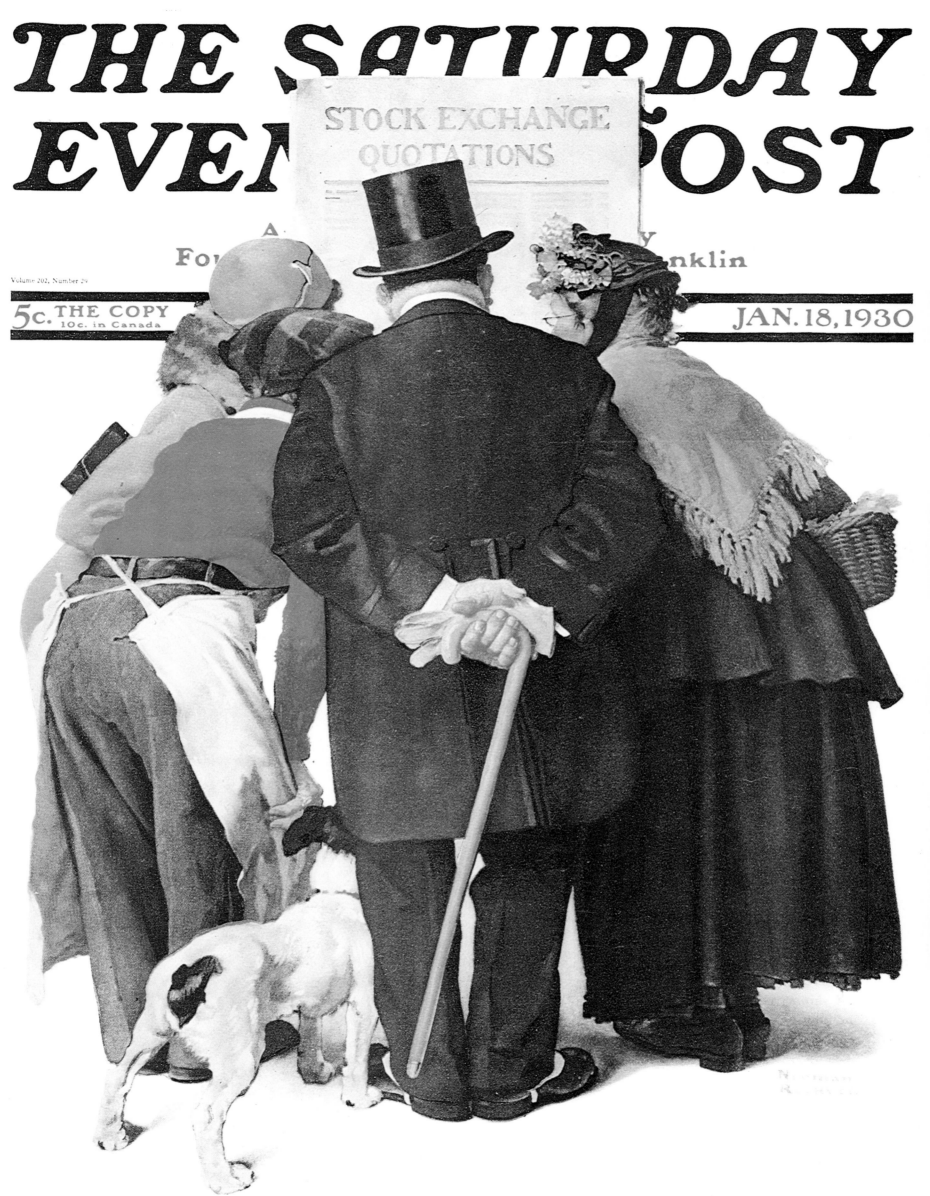

STOCK EXCHANGE QUOTATIONS

Volume 202, Number 29

5c. THE COPY
10c. in Canada

JAN. 18, 1930

"Card Tricks"

From the time he was a boy, the mystery of magic always held a fascination for Rockwell and next to circus performers and fortune tellers, magicians in particular caught his fancy.

In this picture a visiting uncle who is an amateur magician holds his young audience spellbound as he deftly displays his sleight-of-hand maneuvering cards from his shirt collar to his hand.

Will the old adage "the hand is quicker than the eye" hold true for the portly gentleman or will the attentive youngsters discover the old prestidigitator's tricks?

THE SATURDAY EVENING POST

Volume 202, Number 38

March 22.
1930

5c. The Copy
10c. in Canada

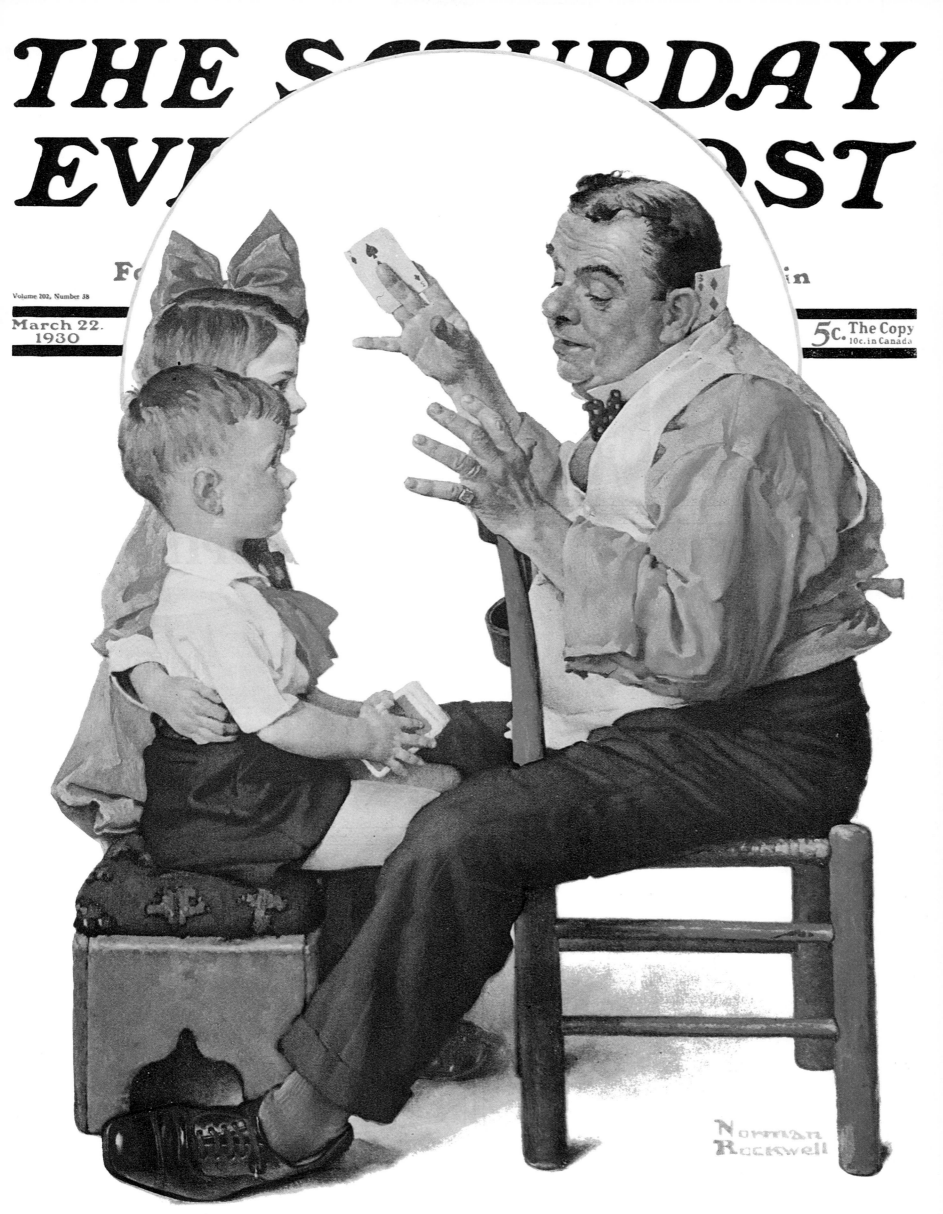

Norman Rockwell

"Wet Paint"

About this time, Rockwell was tormented by an overbearing art editor of *Good Housekeeping* magazine to illustrate a series of pictures on The Life of Christ. Initially agreeable to the project, he then agonized over his decision and following the advice of *Post* editors, who were against the series, fled to California to escape the overzealous editor.

While visiting friends in Los Angeles, he was introduced to Mary Barstow at a dinner party and within three weeks married Mary in Alhambra, California.

The April 12, 1930, cover of a young artist running to escape the raindrops appears to parallel Rockwell's present situation as he was running from his own personal storm of contention.

This picture, as several others to follow, shows Rockwell's ability to create a painting within a painting and proves that had he not been a successful illustrator, he could have been a fine landscape artist.

Our young lady, who with easel, brushes, paints, and palette is scurrying to escape April showers, depicts a situation that many an artist who enjoys painting out of doors encounters.

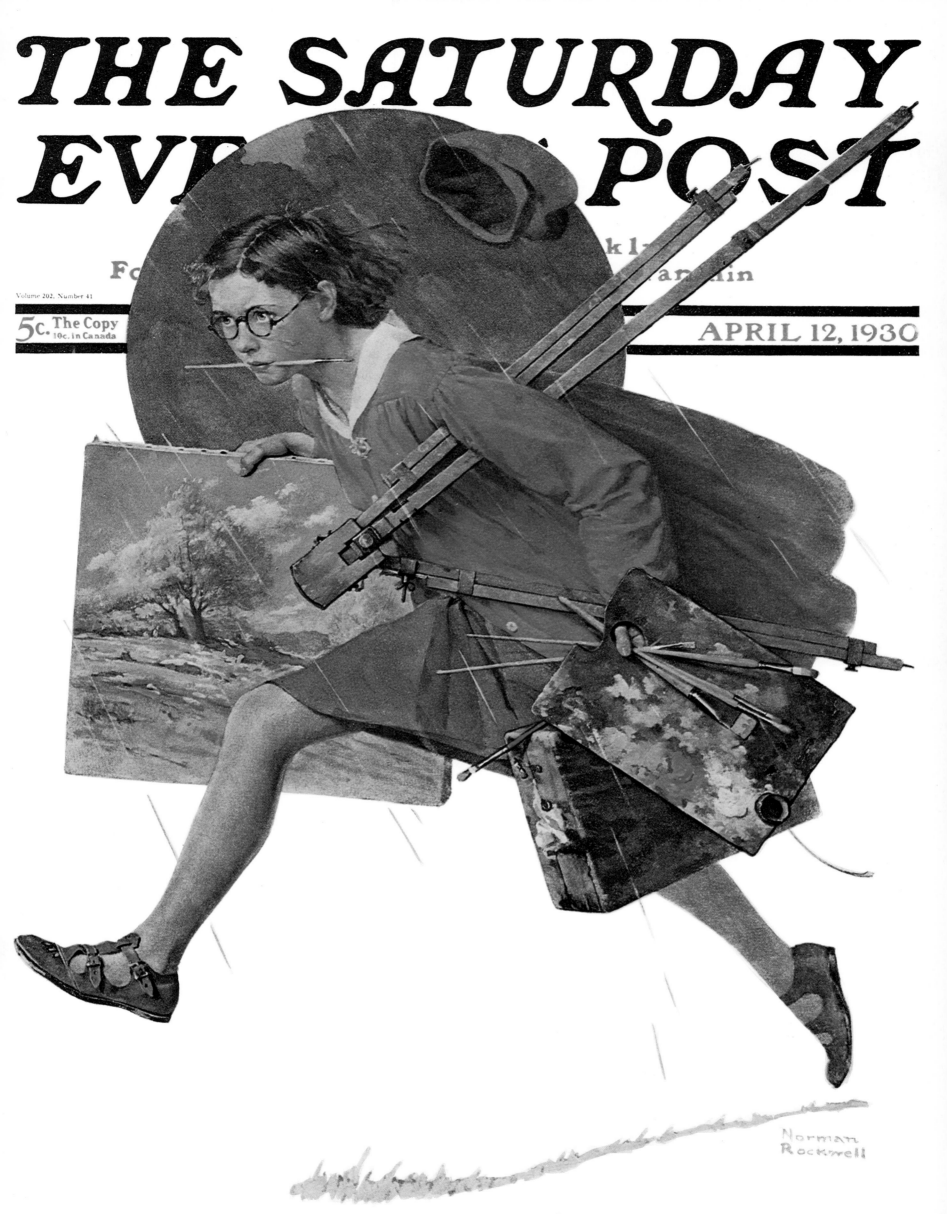

"The Texan"

My model for this May 24 movie cowboy was Gary Cooper. He was a very well-known actor at that time. He posed for me in Hollywood for three days and worked as conscientiously as any model I ever had. Everyone at the lot was crazy about him and I could see why."

California was a bonanza for Rockwell—new friends, new scenery, new props and models. In this picture, as Gary Cooper was being made up for *The Texan,* Mr. Rockwell didn't want to miss an iota of the excitement of the scene. He gave great detail to the ten-gallon hat, the gun and holster, the boot and bandanna, and the cigar-smoking make-up man only to highlight the importance of Mr. Cooper, the star.

Rockwell said that fellow artists back home like Flagg and Christy would have dropped their eyeballs to see the beautiful young girls and handsome men that abounded in California. And Hollywood was equally impressed with him. Getting one of their stars on the *Post,* where millions of readers would notice him, was important and Rockwell had his choice of stars to paint.

Norman never regretted choosing Gary Cooper. They had a wonderful time together and although only one cover was produced, it was always a favorite of his.

Years later he made a cameo appearance in a movie while doing some advertising art for the Hollywood classic *Stagecoach.*

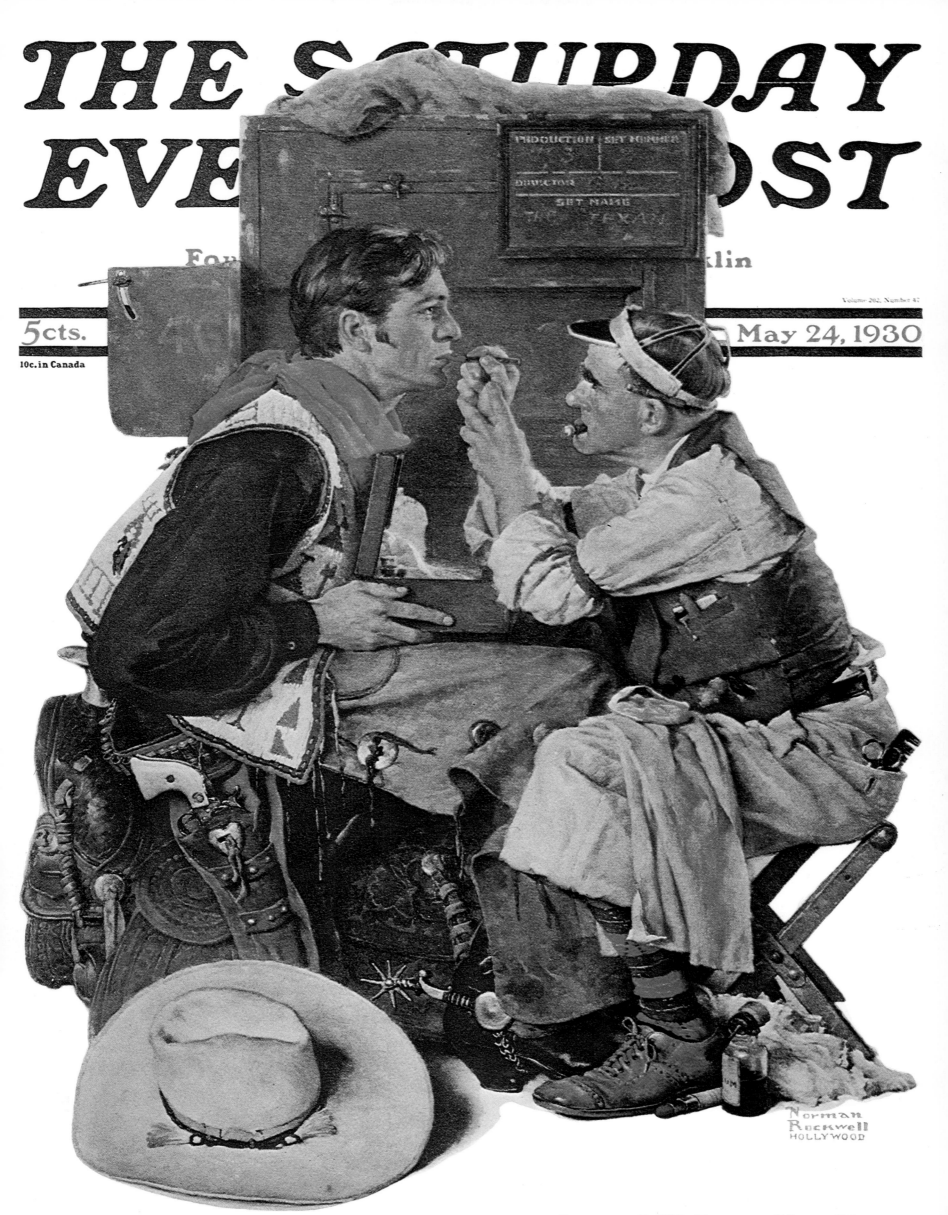

"Golden Days"

Happy days were here again. Rockwell was happily married and back in New York, and thoughts of better times prevailed. Summer was here and good old lazy hot afternoons made everyone think of vacation.

Here we see Grandpa shaded from the hot summer sun by a tattered umbrella and his ever-present pooch, fascinated by the bobber bouncing on the water. With a jug of cider keeping cool in the lake, Gramps is more interested in a snooze than the fish that are nibbling at his several fishing lines.

This type of cover brought universal satisfaction from the men of America; however, the ladies had other ideas.

THE SATURDAY EVENING POST

Fo klin

10c. in Canada Volume 203, Number 3

5c. JULY 19, '30

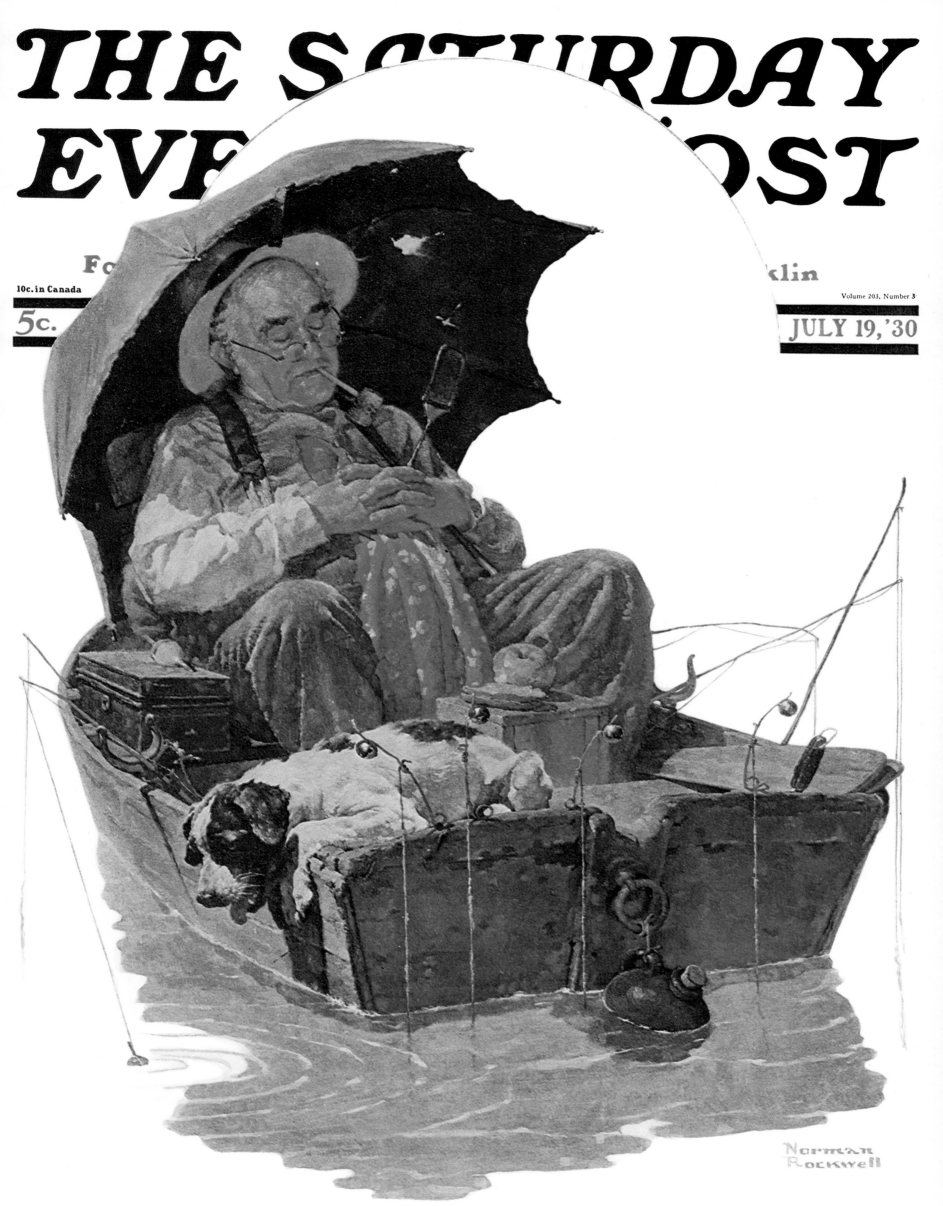

"The Morning News"

With his hat and business reports ready to go and his face buried in the morning paper, the gentleman in the August 23, 1930, cover is playing with very volatile material. Any moment his temporarily abandoned wife is going to explode and when she does, this situation probably won't happen again—for at least a week.

This cover, like so many others, really needs no explanation, and now that Rockwell's marital situation was on solid ground, he could poke fun at one of the many reasons that divorces occurred.

However, once again, instead of getting the underlying message, most people looked at the cover, laughed approvingly, and continued on with their bad habits.

Rockwell visited the breakfast table again on October 30, 1948, when another family altercation occurred over a presidential election.

Mary Rockwell posed for her first cover in this painting and, shortly after its publication, received a letter from a friend in California sympathizing with her on her unhappy marriage.

THE SATURDAY EVE**ST**

Volume 203. Number 8

Fou ... lin

August 23, '30

5c. THE COPY
10c. in Canada

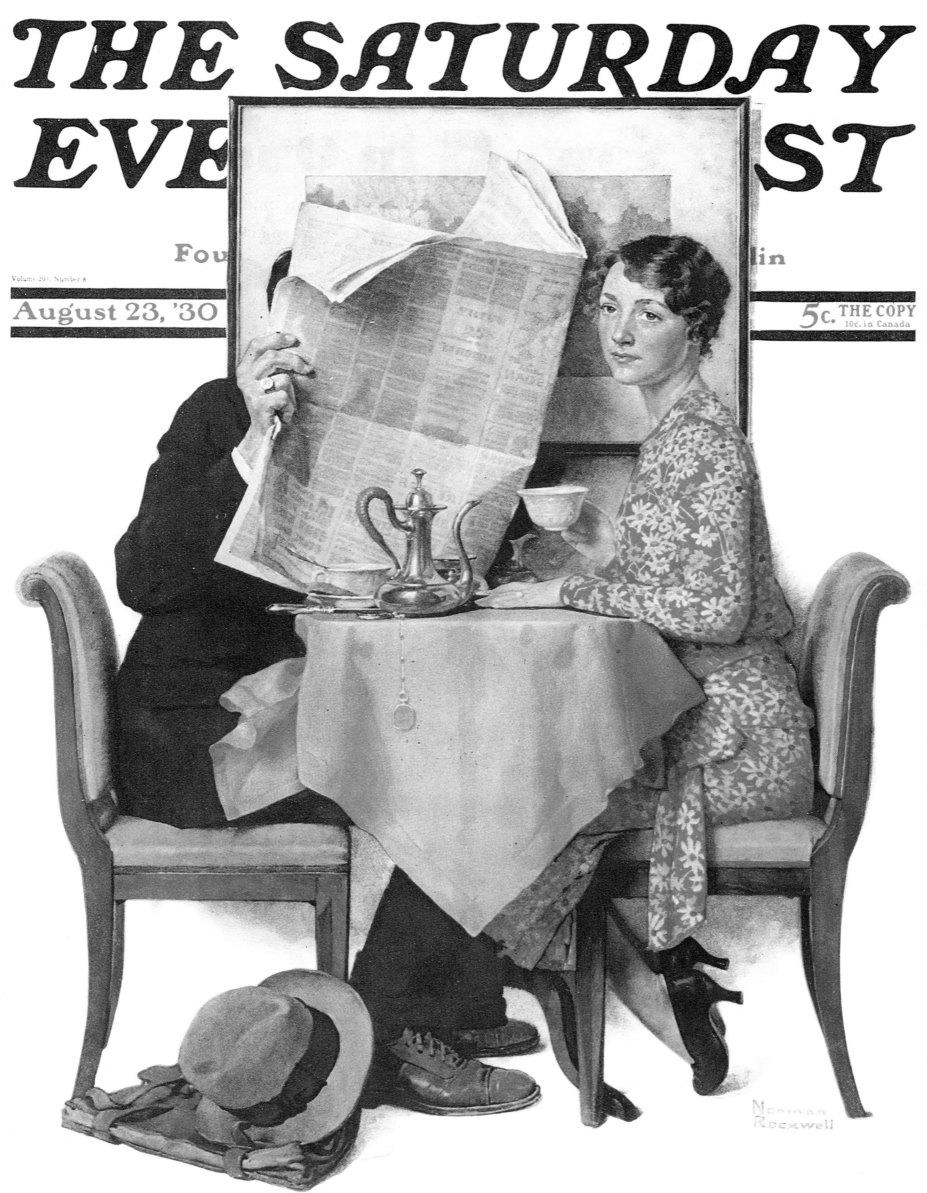

Norman Rockwell

Sir Arthur Conan Doyle—William Hazlett Upson—George Wharton Pepper
Mary Pickford—Barrett Willoughby—Benito Mussolini—Robert Winsmore

"Weary Travelers"

Summer is over and weary vacationers slowly plod their way back to reality. Vacation posters always illustrate excitement, adventure, and fun, but the other side of the paper is blank, revealing transportation delays, improper accommodations, lost luggage, and just old physical fatigue.

This tired family has about as much enthusiasm left in them as there is air in the little boy's balloon, but tomorrow is another day and after a good rest they will be sparkling as they relate their adventures and look forward to next year's vacation.

Fred Hildebrand was the model for the devoted father of the family and played the part so convincingly that he received a proposal of marriage from a woman in Australia. Fred refused the offer and never got married.

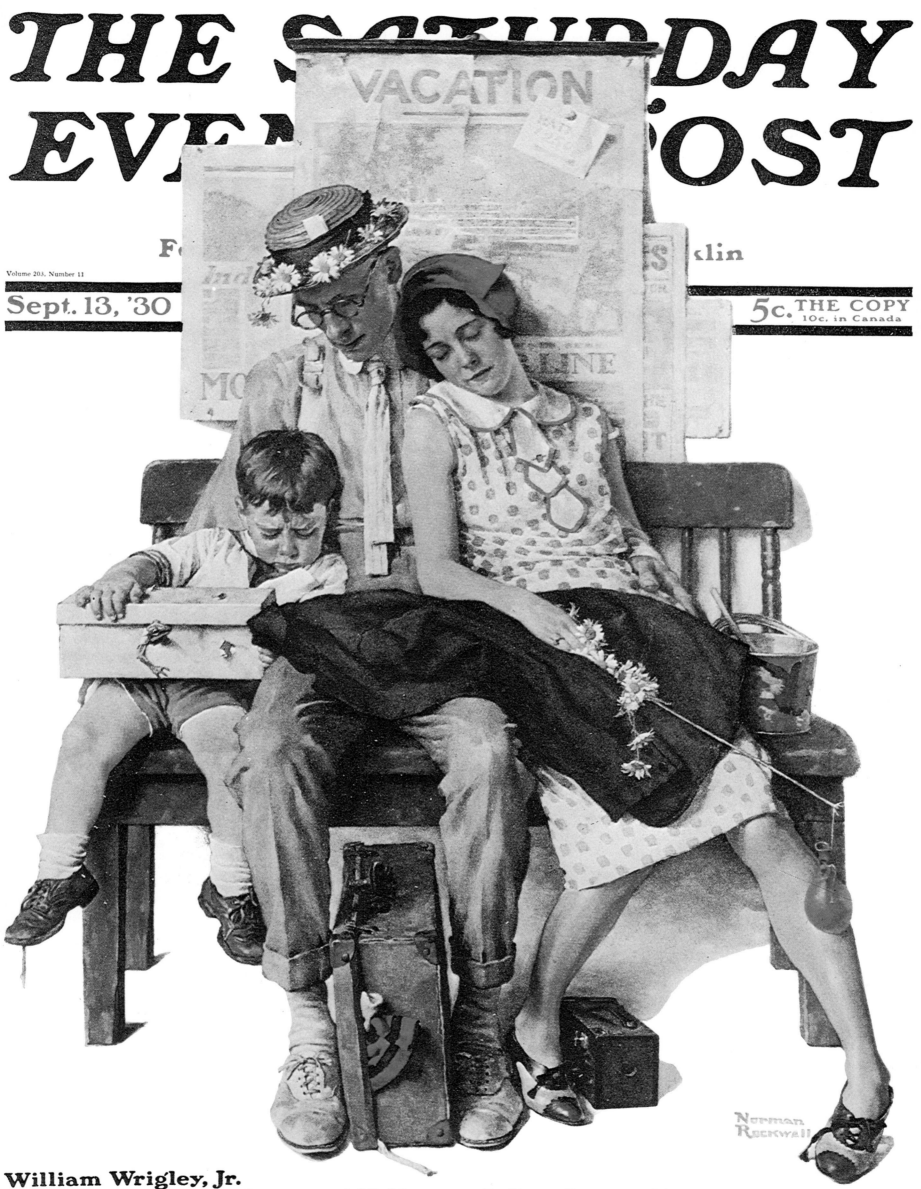

"The Yarnspinner"

By this time, the *Post* had a distribution of 2.8 million magazines, and it was virtually impossible for a cover artist to satisfy all readers. Norman Rockwell decided that in order to appeal to as many people as possible, his ideas must vary greatly. Contemporary scenes must alternate with those from previous eras and, most of all, universally accepted themes must prevail. "Love" fit all of these conditions.

In this picture, we see a sailor with his parrot, pipe, and bundle of worldly belongings trying to woo a pretty young maid with exciting tales of seafaring adventures. Who could refuse his advances in such a romantic setting complete with a beautiful and stately clipper ship and handsome wardrobe?

THE SATURDAY EVENING POST

Founded A.D. 1728 by Benj. Franklin

Volume 203, Number 19

NOV. 8, 1930

10c. in Canada

5 cts.

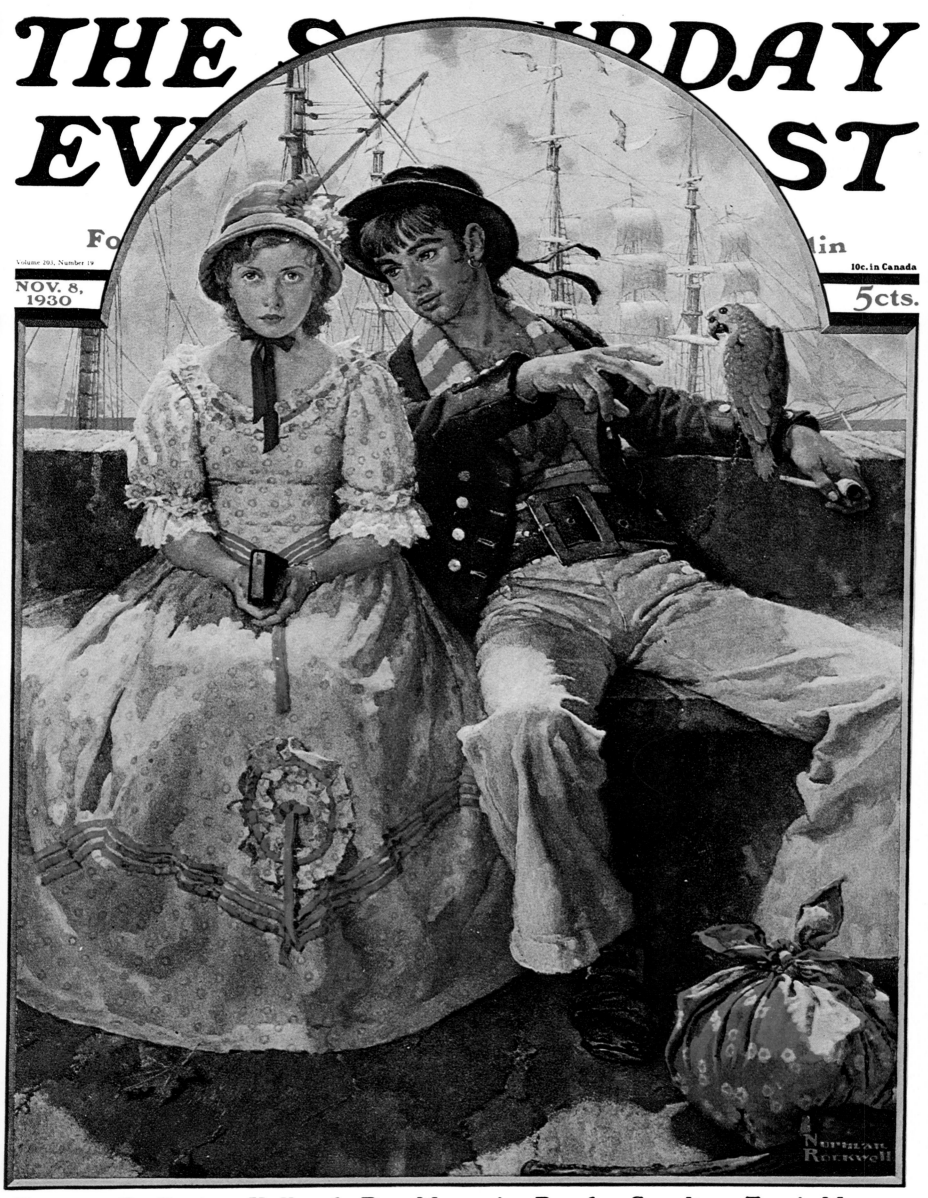

Norman Rockwell

"Joy to the World"

One day Norman mentioned to Mary that one of his fondest memories was of his father reading Charles Dickens' stories to him as he sketched. Mary, who took a deep interest in her husband's work, volunteered to read aloud while he painted. This slight diversion provided huge benefits for Norman; not only did he enjoy listening to these stories, but artistic ideas came more spontaneously. New inspirations shoved aside the old standards.

Christmas 1930 was a special time. Rockwell decided to break away from the commonplace and try something different. How did medieval folks revel during the holidays? Rockwell shows us in this picture that the answer was the same for that time as it would be for most of us today.

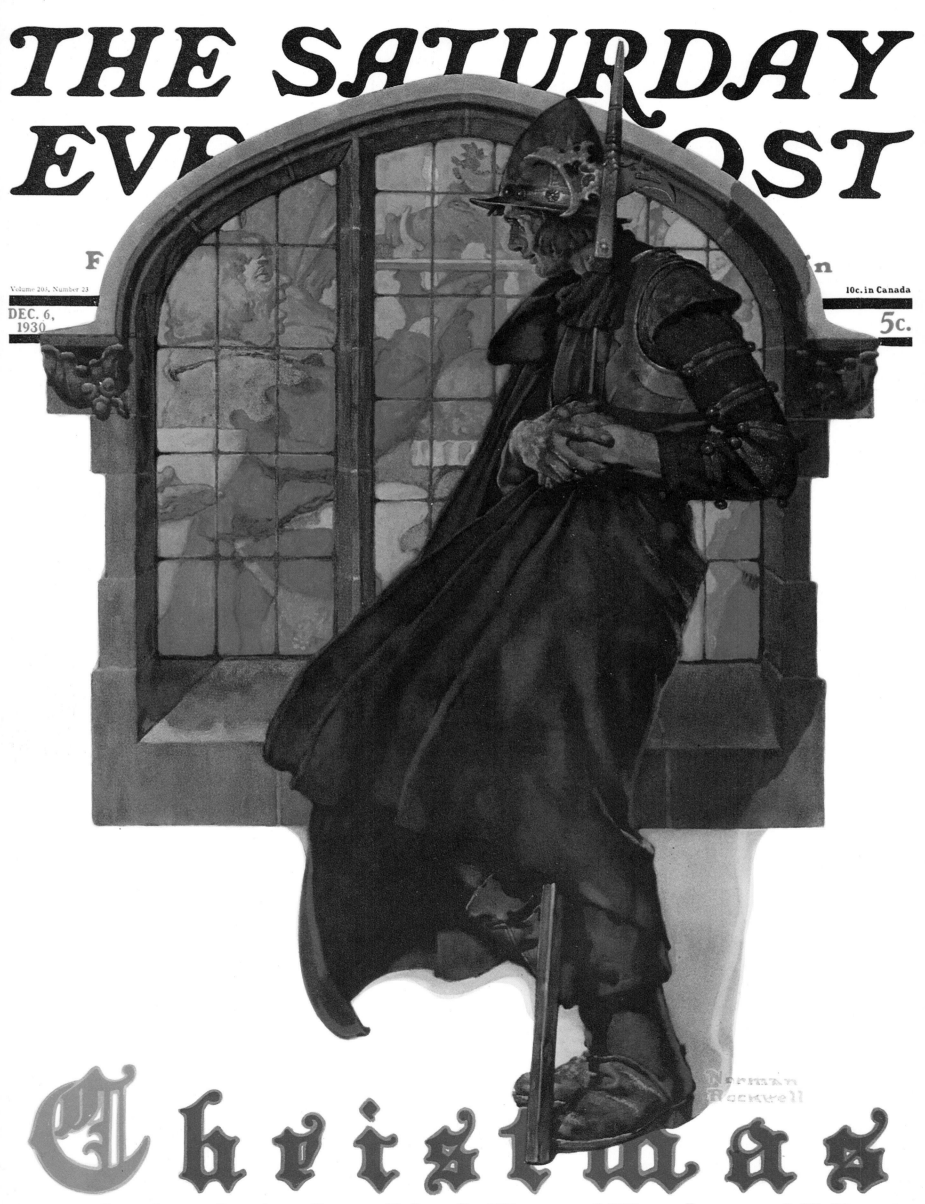

THE SATURDAY EVENING POST

Volume 203, Number 23

DEC. 6, 1930

10c. in Canada

5c.

Christmas

Everett Sanders—Lucian Cary—Edna St. Vincent Millay—Leonard H. Nason
William Hazlett Upson—Ben Ames Williams—Louis H. Cook—Marie Kimball

"Dressing for the Ball"

Norman and Mary were now settled in their new house at 24 Lord Kitchener Road in New Rochelle, New York. They were extremely happy, and his work was going well. His pictures—light, airy, and colorful—reflected his optimistic frame of mind.

In this cover, an elegant young woman, with the milliner's patient help, is trying on bonnets that will complement her colorful gown. Her mask hangs on the mirror as she carefully appraises her outfit.

On March 6, 1954, Rockwell tried another "girl at the mirror" idea and came up with one of his most successful covers.

THE SATURDAY EVENING POST

Volume 203, Number 31

Jan. 31, 1931

Fo... ...lin

5c. THE COPY
10c. in Canada

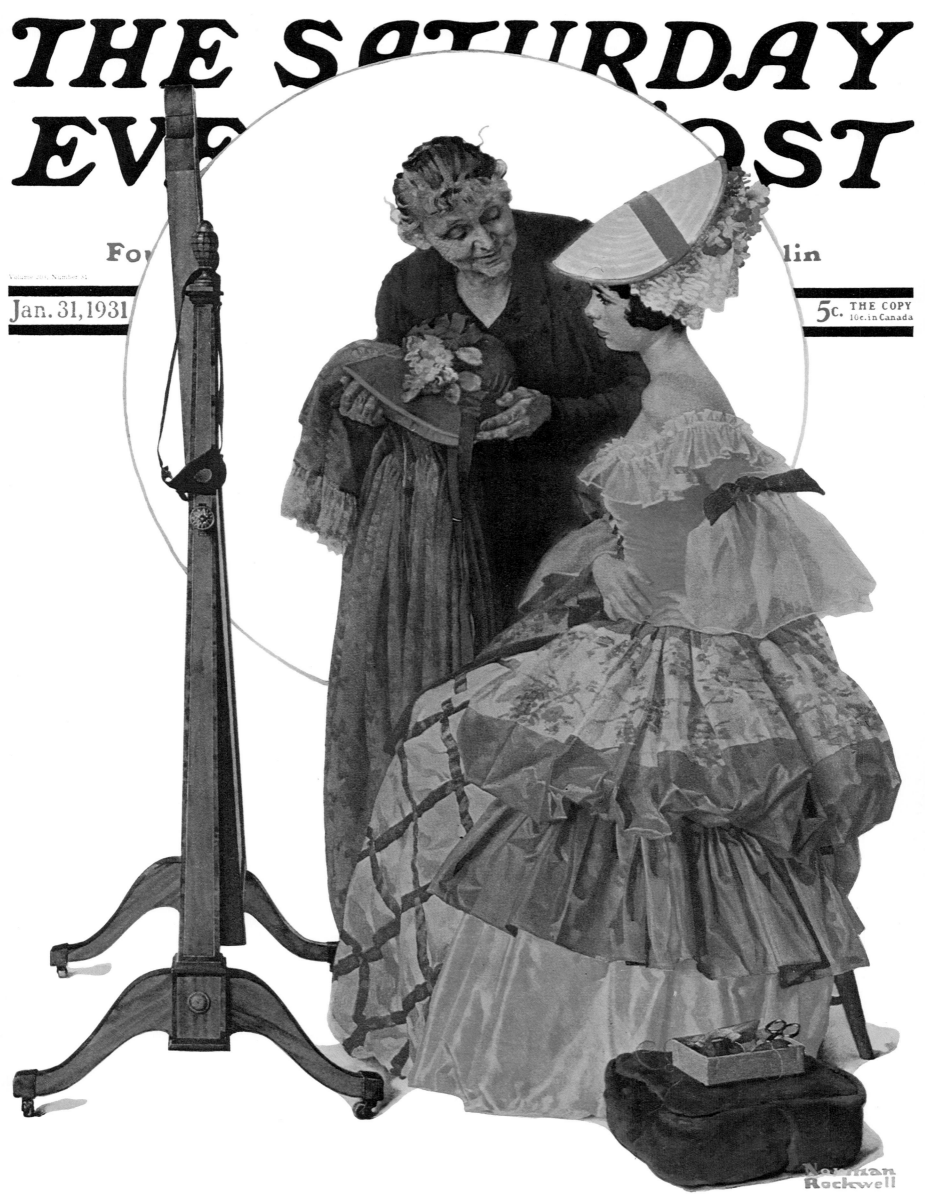

Clarence Budington Kelland—Mary Roberts Rinehart—Charles Brackett
F. Scott Fitzgerald—Edward Hungerford—Julian Street—Hugh Wiley

"Off to the Fire"

A new approach to painting— "dynamic symmetry"—was emerging, and Rockwell's artist friends told him that he had better begin using it or his work would crumble. His next painting, using this technique, was a disappointment. It depicted a stone-faced fireman with an excited lad and his dog rushing to a fire as flames lit the scene. This newfangled idea, developed by Jay Hambridge (an illustrator with a scientific background), was a failure. Rockwell gave the painting to a cousin who lived in Philadelphia, and vowed never to wander from the time-tested formulas that had worked so well in the past.

THE SATURDAY EVENING POST

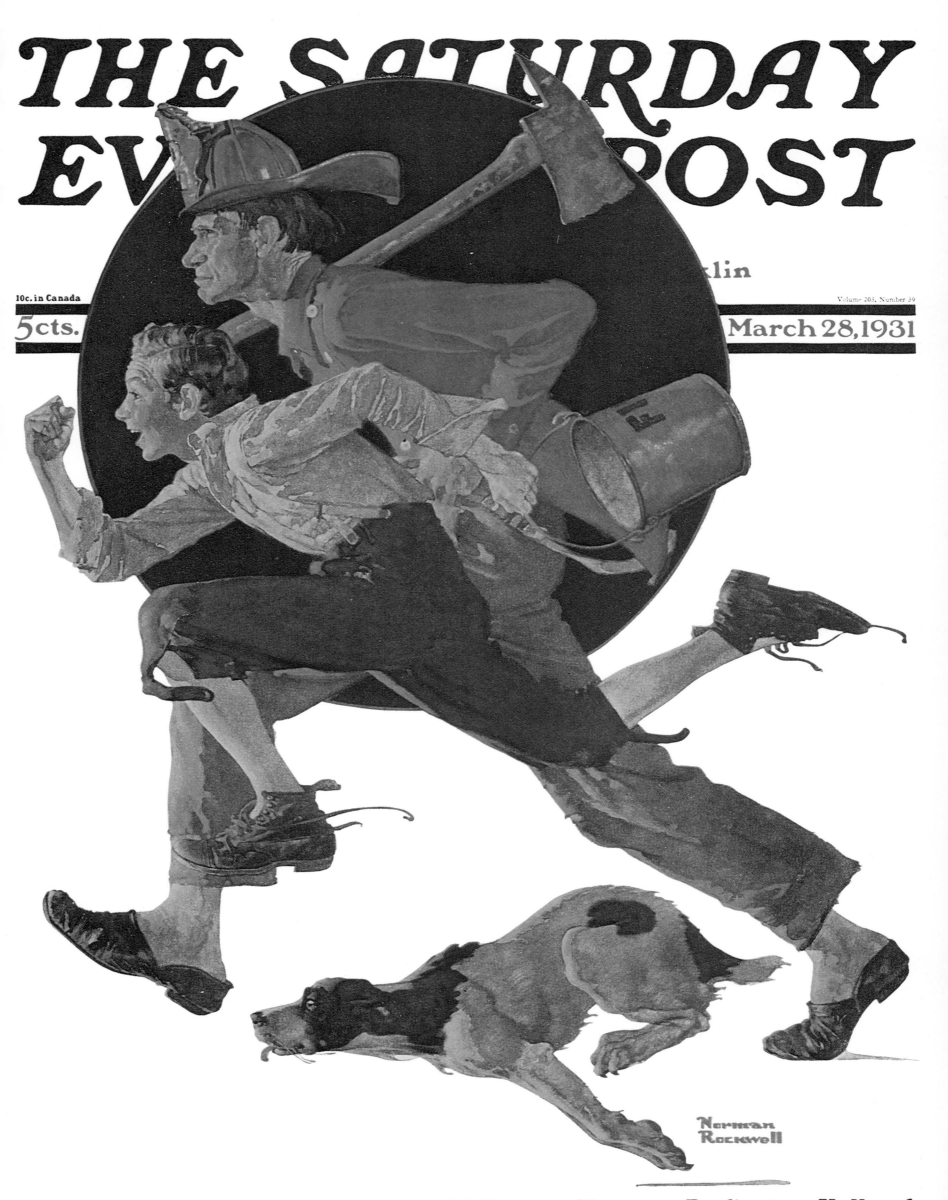

Founded A° Dᵢ 1728 by Benj. Franklin

10c. in Canada

5 cts.

Volume 203, Number 39

March 28, 1931

Norman Rockwell

Myron C. Taylor—Alfred Noyes—Ida M. Evans—Clarence Budington Kelland
Isaac F. Marcosson—Struthers Burt—Bernard DeVoto—Ben Ames Williams

"Special Delivery"

Throughout the years, Norman Rockwell portrayed the working people, full of vitality and energy, in many different ways. Occasionally, though, his subjects became tired and lackluster as his own work became overburdensome.

Here, a delivery man with the awesome responsibility of delivering two valuable marble busts sits down for a breather. The objects are quite heavy, and Rockwell succeeds not only in making us sympathize with the weary man, but also in making him look like one of a trio of classic expressions. As the Greeks and Romans have immortalized men with their statues, so has Norman Rockwell in his canvases.

THE SATURDAY EVENING POST

Founded

Volume 203, Number 42

APRIL 18, 1931

5 cts.

10c. in Canada

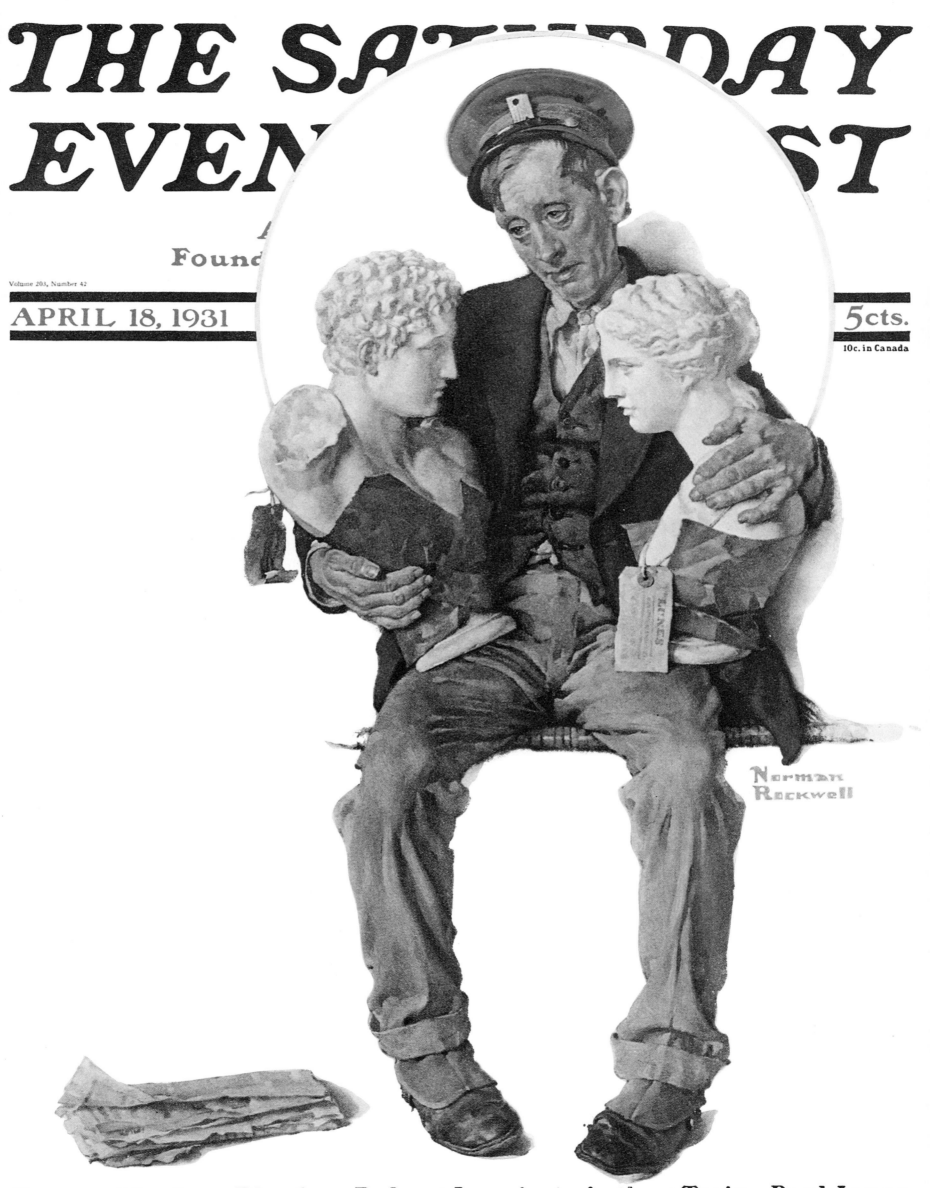

Norman Rockwell

Eugene Manlove Rhodes—Robert Lansing—Arthur Train—Paul Jones
Guy Gilpatric—Leonard H. Nason—Kenneth Roberts—Sophie Kerr

"Cramming"

June is a special time of the year for everyone. We know that as the weather gets warmer and the days get longer, summer is not far behind. For students, though, it can be an agonizing month. The advent of June brings with it dreaded final examinations.

As seen from this cover, young men and women, nationwide, must barricade themselves in dormitory rooms in the company of heavy textbooks and plenty of black coffee as they try to ignore the temptation of a beckoning warm weekend outside. Even the superheroes of the gridiron, the diamond, and the court cannot escape the burning of the midnight oil.

Mr. Rockwell, who himself only went up to the tenth grade in school, placed great value on education.

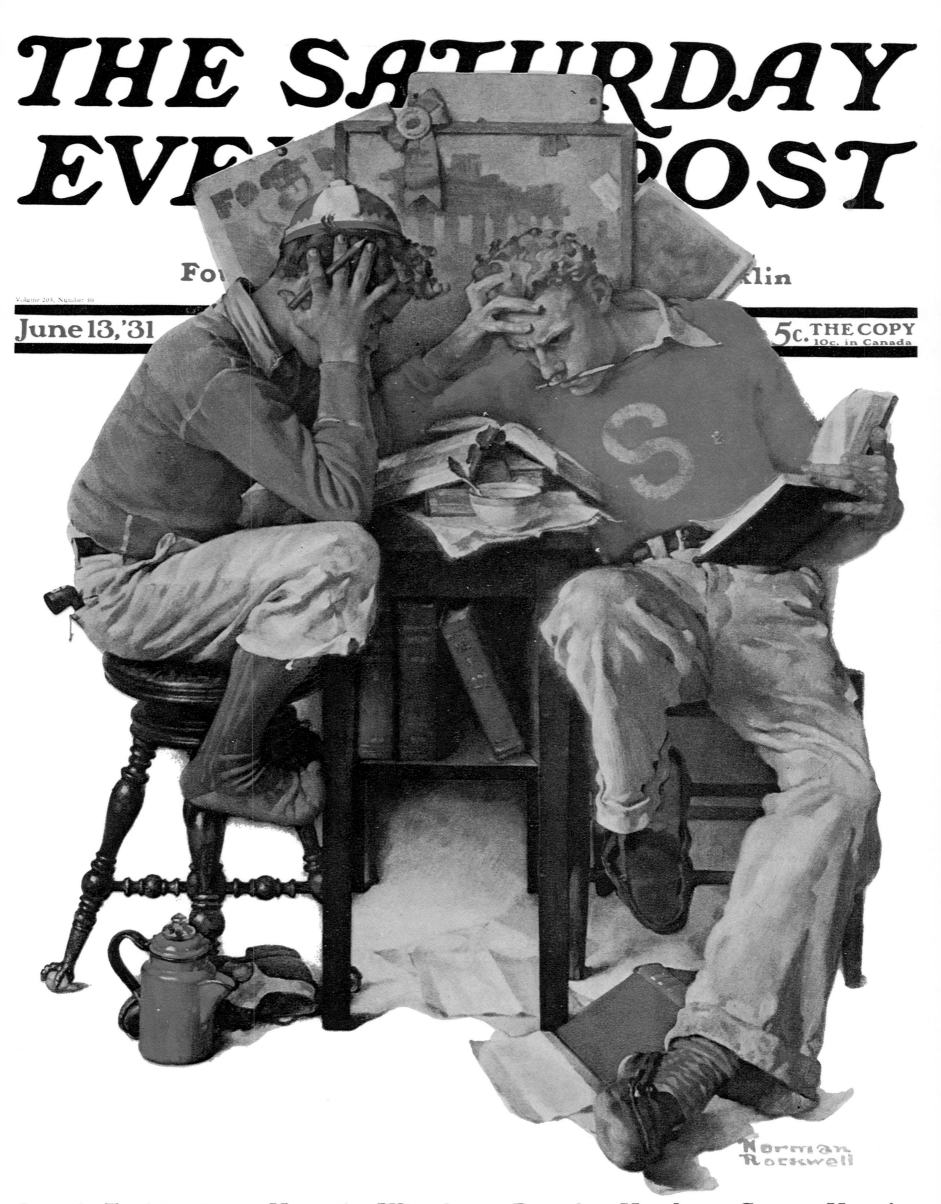

"The Milkmaid"

Ideas for *Post* covers were becoming more and more scarce, and Norman was becoming less and less satisfied with his work. Yet, his admirers eagerly looked forward to every magazine with a Rockwell cover, and few were ever disappointed.

On this July 25 cover, Rockwell dipped into his Americana bag of tricks and pulled out a romantically picturesque scene. On this beautiful summer morning, a young colonial lad is stealing a sweet kiss from a pretty milkmaid, while both of them are gingerly balanced on a small bridge.

Rockwell had Fred Hildebrand pose for this lucky boy, as once again, he knew he couldn't miss with another picture about love. He was absolutely right.

THE SATURDAY EVENING POST

Volume 204, Number 4

July 25, '31

5C. the Copy

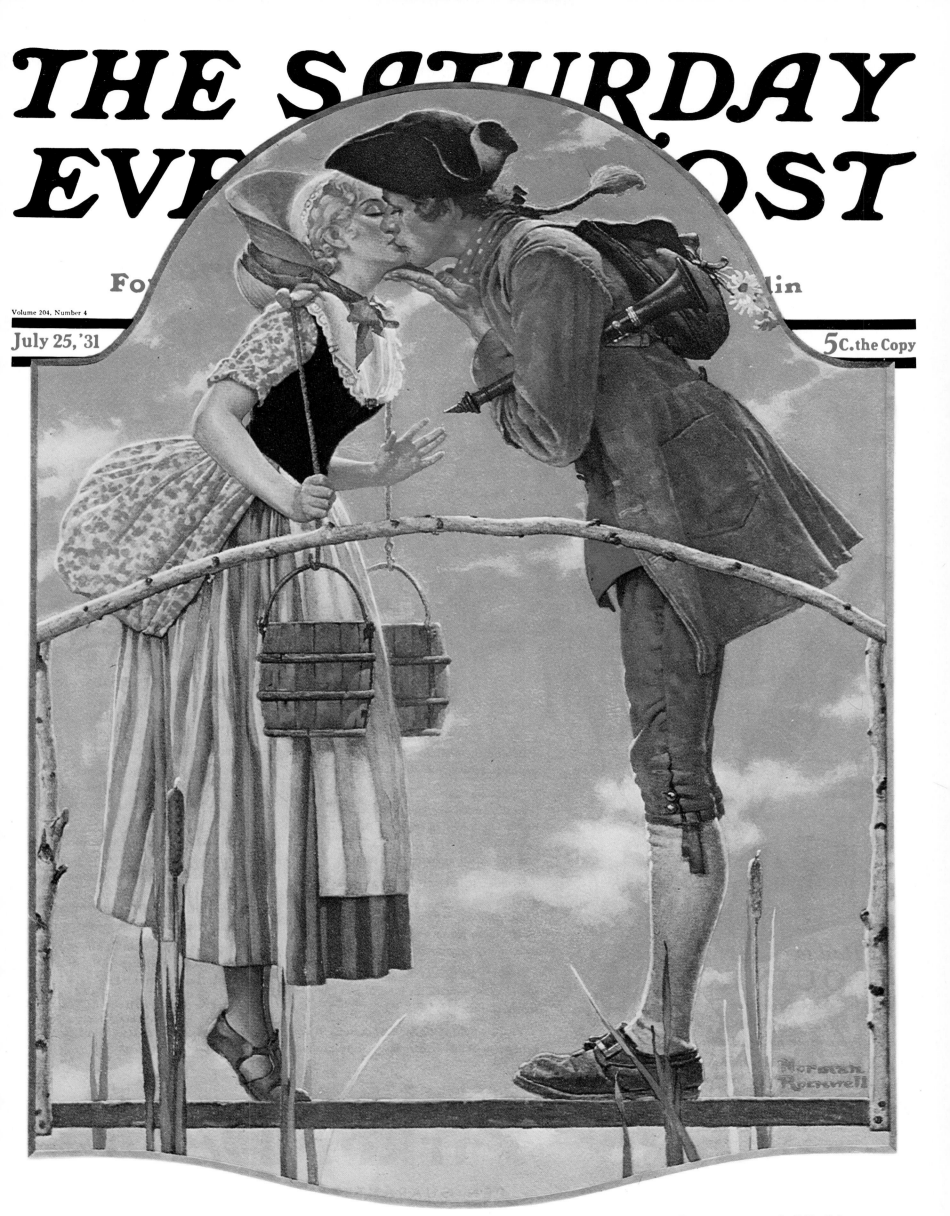

"Wicket Thoughts"

Croquet was now in fashion among folks in society. It didn't take long before everyone with a thick and neatly trimmed lawn had a set of wickets, mallets, and wooden balls.

In this picture, we see a dapper young fellow who appears more engaged in the dame than in the game. But judging from the concentrated look of the heroine, winning the game is her first interest.

Rockwell often processed his art through a series of phases in the development of a picture. First came a loose sketch of an idea. Second came the gathering of models, props, costumes, and scenery. Next, an individual drawing preceded the preliminary drawing, which was done in water colors or oil. Last, after all of these steps, the final rendition in oil emerged.

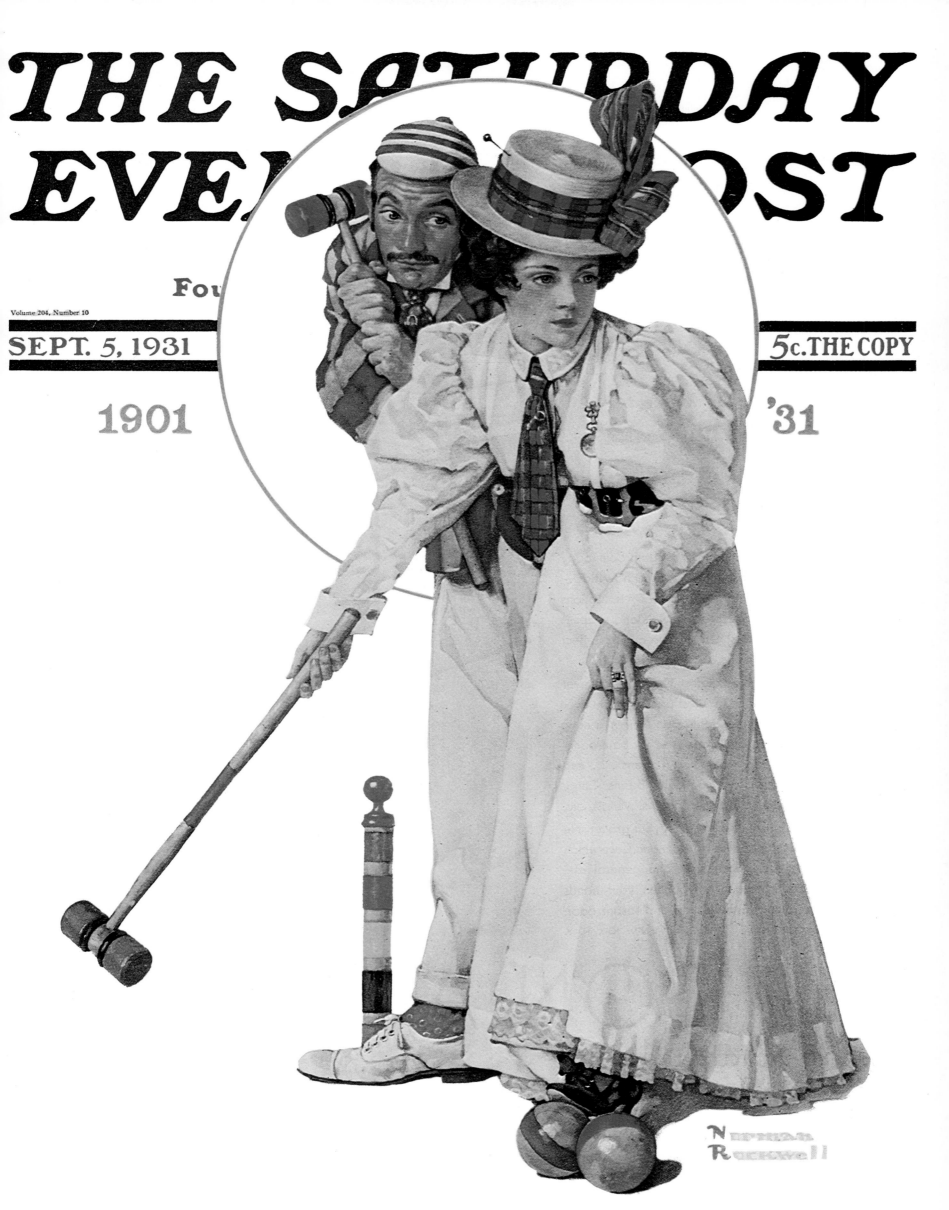

"Practice Makes Perfect"

This colorful scene was Rockwell's seventh entry into the world of music on *Saturday Evening Post* covers. This grocery clerk appears to be taking a few moments off from the menial chore of sorting potatoes to practice his cornet for the upcoming Saturday afternoon band concert. Unknown to him, however, his solo performance is about to become a duet. The "noise" is less than music to the ears of his pet, who is about to add to this musical scene with his own howls of anguish. Noting the look of devotion and determination, and despite the critique, we are sure that the clerk will shed his apron in favor of a spit-and-polish uniform as he prepares to join his fellow band members in concert on the village green.

THE Saturday EVENING POST

Volume 204, Number 19

Nov. 7, 1931

Fo[...]lin

10c. in Canada
(INCLUDING TAX)

5c. THE COPY

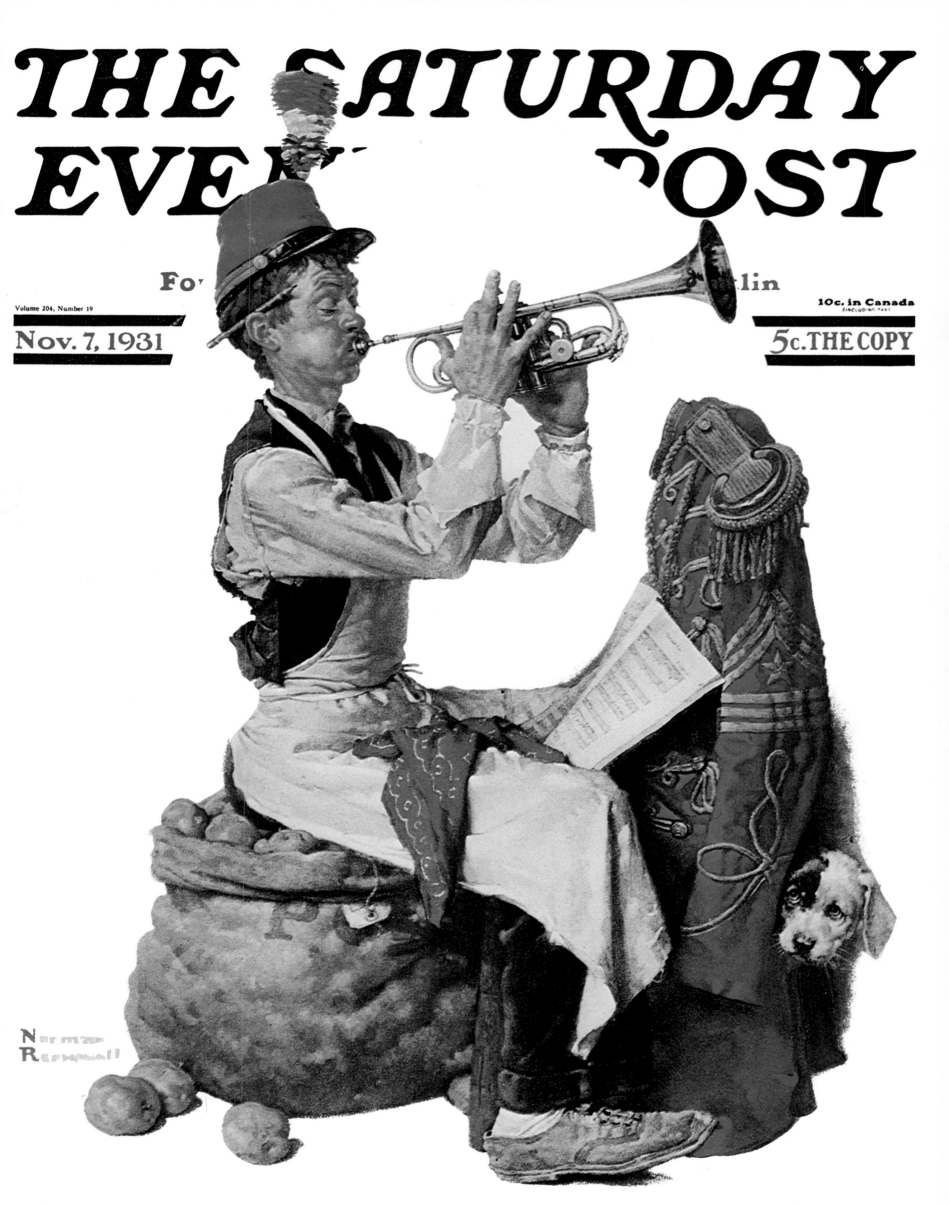

Elizabeth Alexander—Edwin Lefèvre—J. P. Marquand—Samuel Crowther
Margaret Weymouth Jackson—Vincent Sheean—Paul Jones—Fannie Hurst

"Yuletide Merriment"

In 1923 Rockwell painted a successful Christmas cover of a trio singing and playing in merry, old London town. In this picture, another trio is used at a gala holiday ball to deliver the Christmas spirit.

In the mirror decorated with mistletoe, we notice the sprightly dancers skipping the light fantastic. There is so much gaiety and music in the air, we can actually see the musicians keeping time by the tapping of their toes.

One summer in his youth, Rockwell worked as a supernumerary at the Metropolitan Opera in New York City, where he had a delightful encounter—with Enrico Caruso. From that time on he had a fondness for music in all forms.

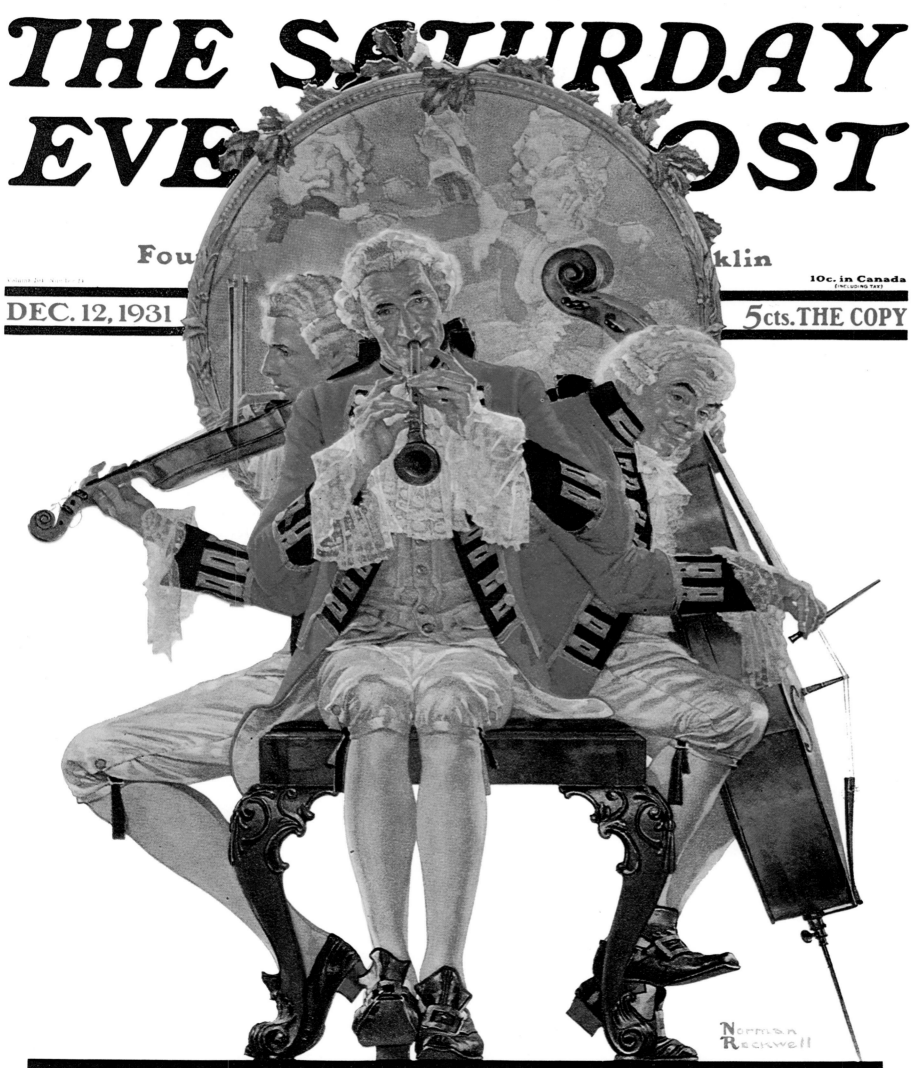

THE SATURDAY EVENING POST

Fou... ...klin

Volume ... Number ...

DEC. 12, 1931

10c. in Canada (INCLUDING TAX)

5 cts. THE COPY

Merry Christmas

"Language Barrier"

This cover was painted in the fall of 1931, and Rockwell's mind was not content. He was unhappy with his work and wished to broaden his horizons. He dreamed about traveling to Europe, but Mary was pregnant, and he was afraid to subject her to the journey.

Here we see Rockwell's thoughts in focus: a young woman with a guidebook of Paris is holding on to the cloak of a bewildered French gendarme. As is so often the case in a Rockwell canvas, the picture is self-explanatory, but it is the policeman's wonderfully animated hands that are the center of attraction.

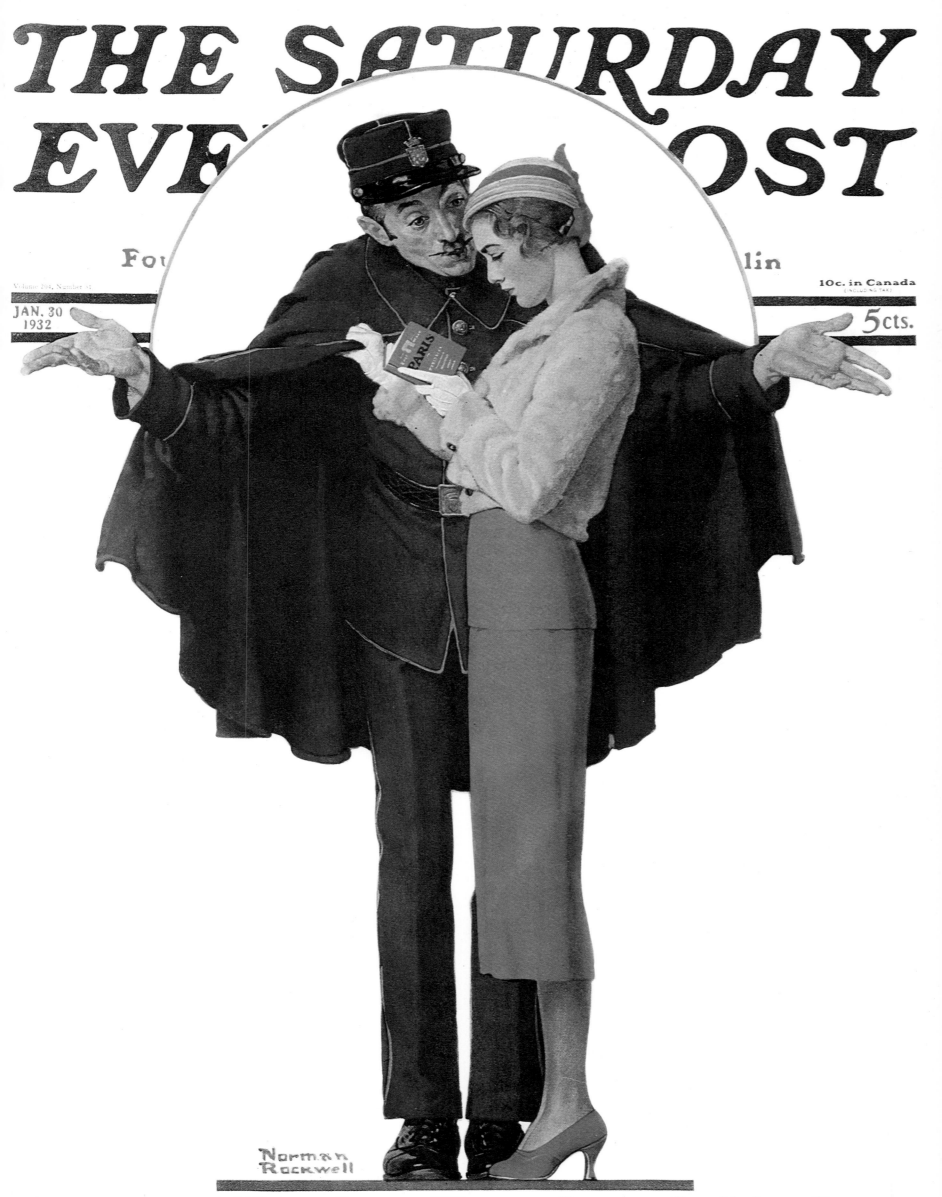

"The Puppeteer"

In 1932, Jarvis Rockwell, named after Norman's brother and grandfather, was born. Norman thought that the birth of his first child would spark him out of the doldrums, but his anxiety and depression continued. In early spring, the family packed up and left for an extended stay in France.

While in Paris, Rockwell took several art courses and talked to many professors in his search for a fresher outlook. He even tried a few abstract pictures (which were rejected by the *Post*), but contentment and inspiration continued to elude him. After seven months abroad, he returned to the States with the knowledge that he had the ability, but he alone must find the enthusiasm to succeed.

Only three Rockwell cover pictures were painted for the *Post* and accepted in 1932. This one, of an old puppeteer with two newly carved dolls, surely has a touch of the effect that France had upon Rockwell.

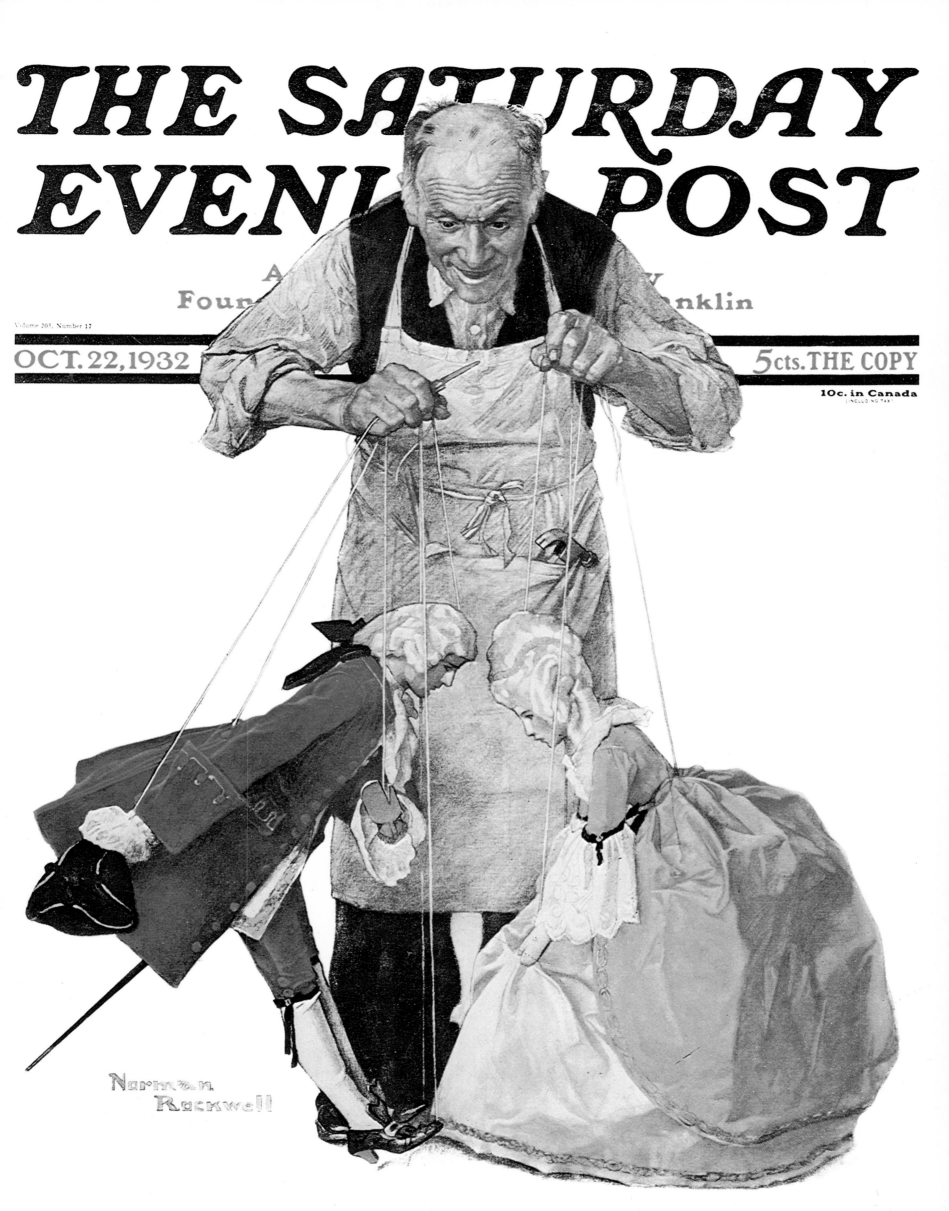

"The Spirit of Christmas"

Norman Rockwell always felt that illustrating a story or designing an advertisement was an easier task than creating a magazine cover. The story illustration had a theme to follow, and the advertisement a product to sell.

A cover, on the other hand, was a tremendous challenge. The idea for such a picture had to be born and then nurtured from the spark of the initial thought through the fires of creation to the embers of the warm glow of an artist's satisfaction at seeing its completion.

Christmas cover ideas came somewhat easier to Rockwell; the theme was simple and impressions were abundant in every store, street, church, and school. Every child's face captured and portrayed the delights, expectations, and often surprises of the holiday season. This cover again returns to the Dickensian era, when an abundance of food at Christmas was rare and such treats as fruit, fowl, and drink brought a wide smile to the receiver and the giver as well.

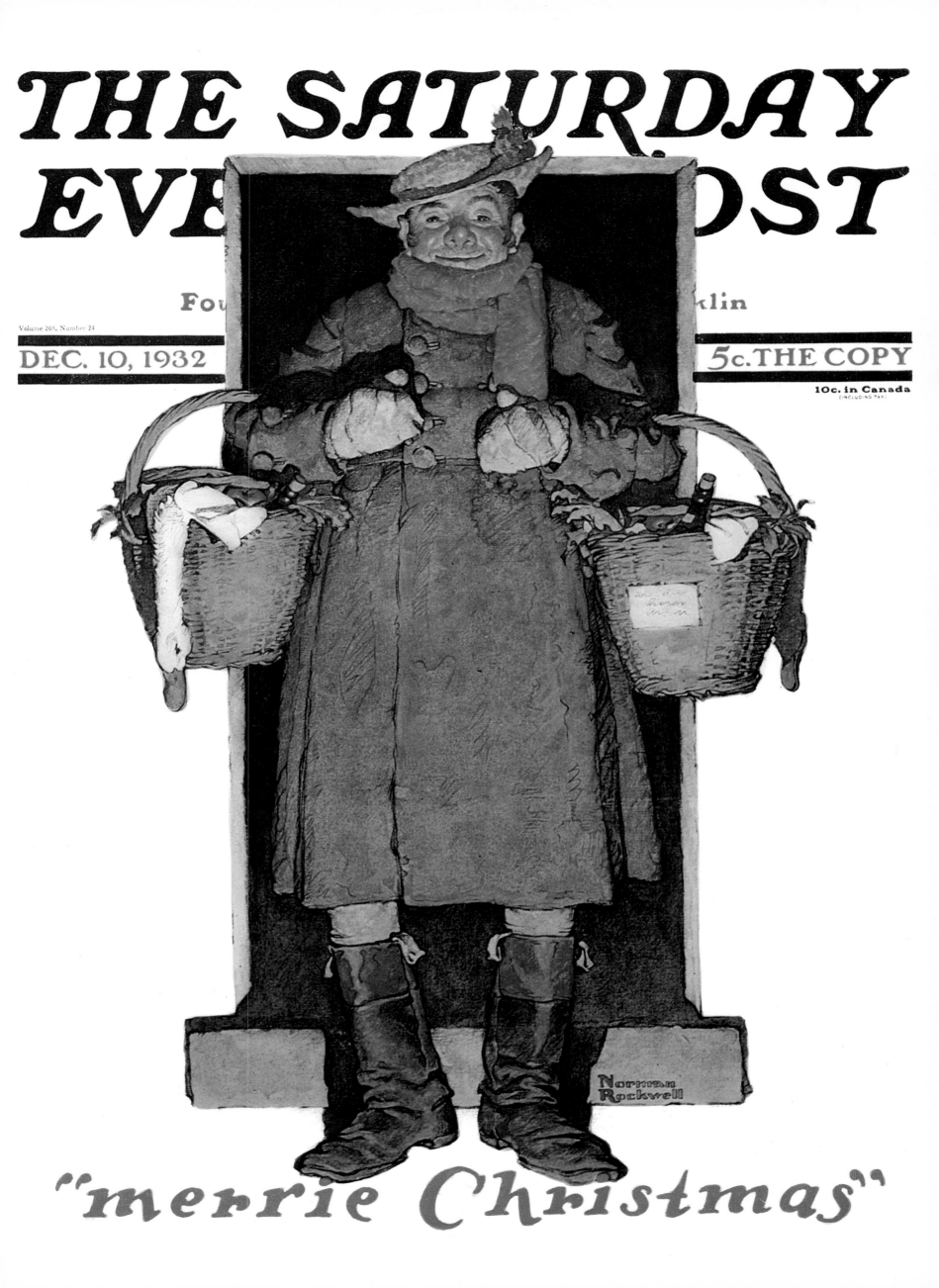

"A Breath of Spring"

In spring, a young man's fancy turns to thoughts of love." What boy of any age has not been mesmerized when he is kissed by the first warm day in early spring?

Although the boy and dog on this cover are positively Rockwell, the picture itself is a totally unusual format. Still trying to improve his work, Rockwell painted this whimsical scene in the style of Maxfield Parrish, a noted illustrator of the day.

Even though Parrish subscribed to the theory of dynamic symmetry, which failed for Rockwell, his work was so successful that many artists tried to copy his free and flowing style.

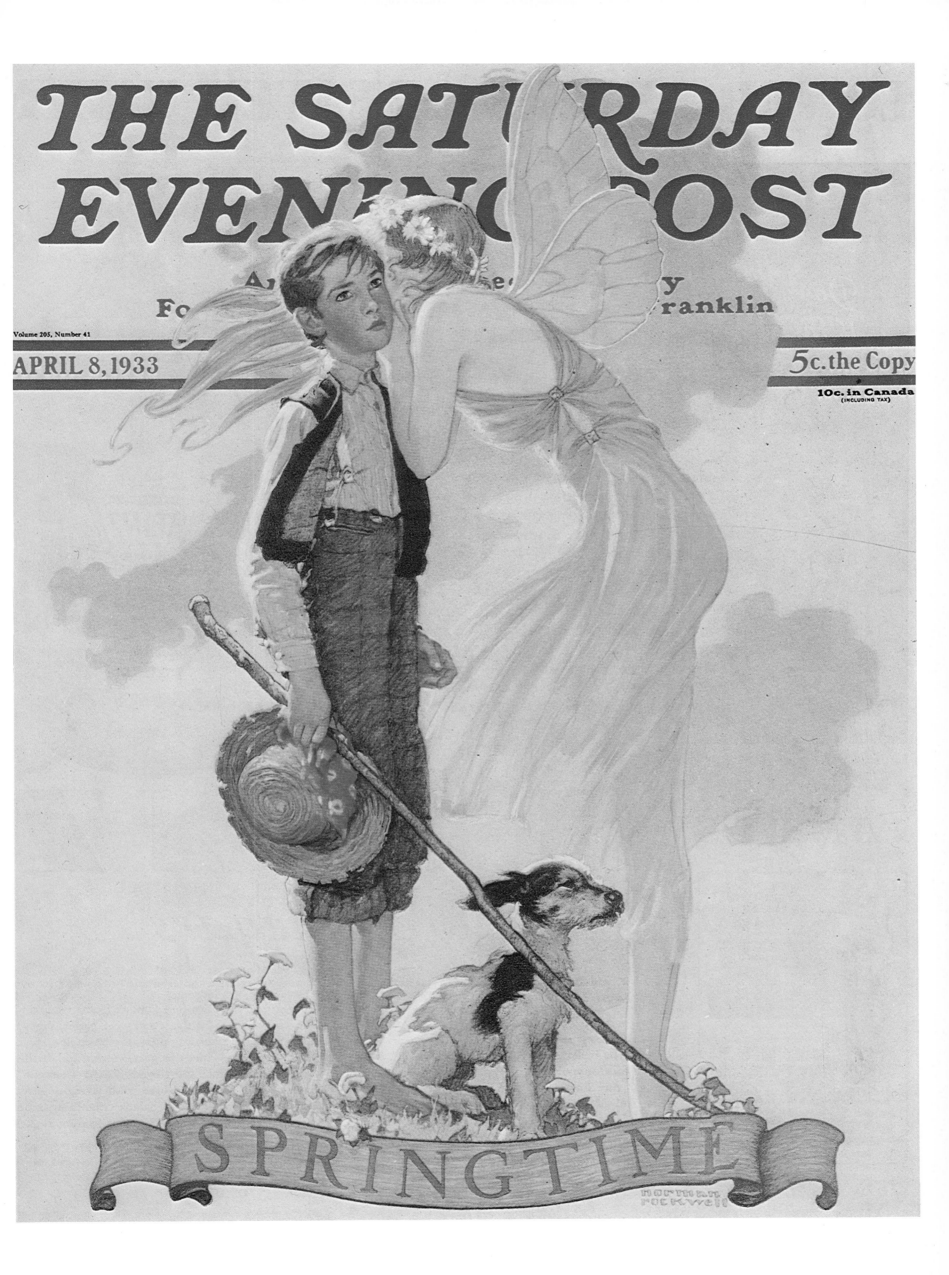

"Dear Diary"

The prom is over, and the evening was marvelous." Following the most important event of the year, how many girls arrive home on a beautiful June evening and, after removing a slightly wilted corsage and kicking the shoes off their aching feet, take a moment to record the historic event in their diary?

Rockwell tried his new style again in this picture, and although the painting was well executed and the idea was good, the cover was not one of his most successful efforts. Even the *Post* editors tried to assist him with a new cover format by deleting the authors from the bottom of the page. Nonetheless, they quickly returned to the popular previous format on the next cover.

By this time, Rockwell was well entrenched in the social circles of New Rochelle. He and Mary were very happy, and their second child was expected. Despite this joyful environment, he still struggled with his work.

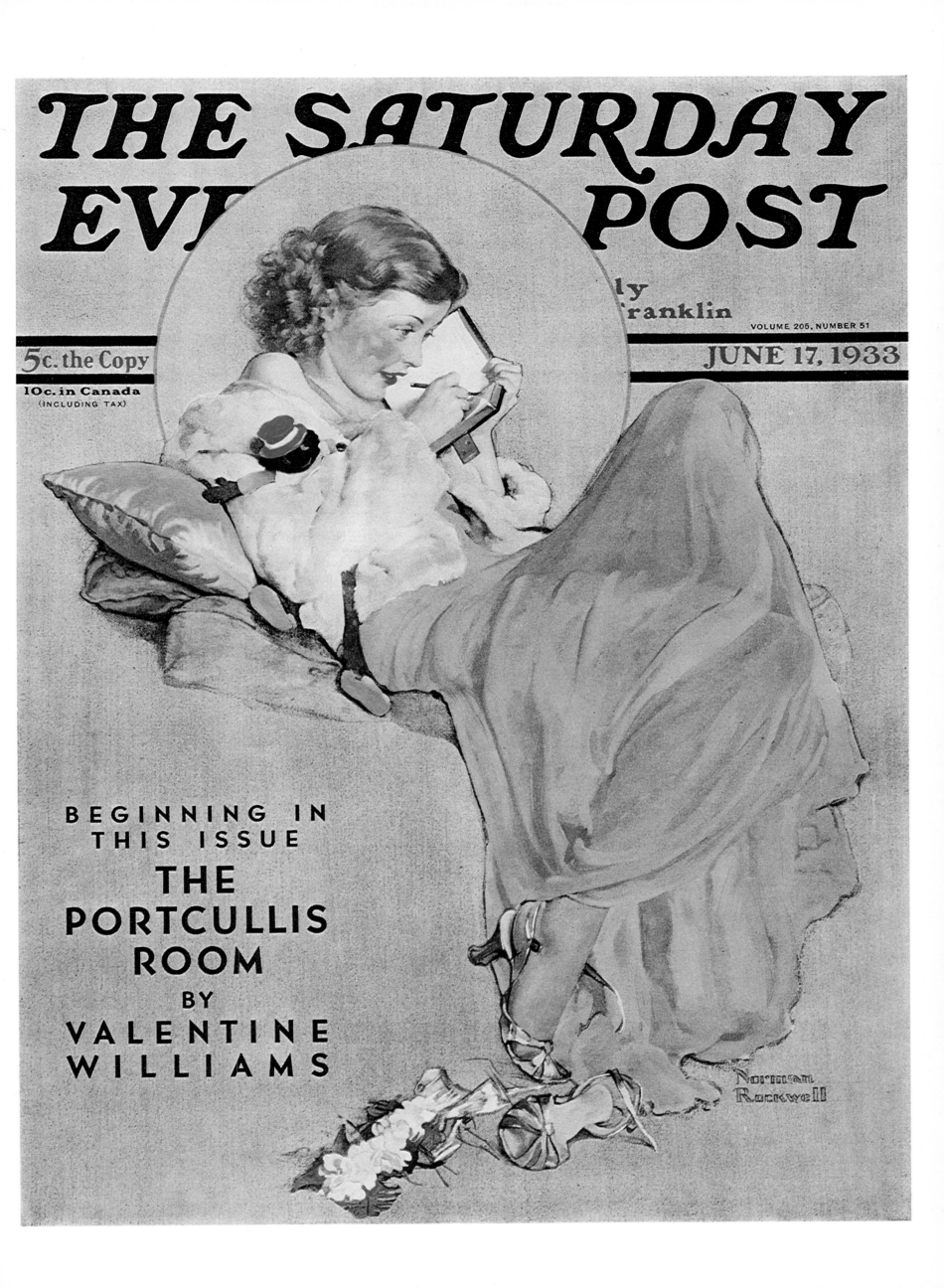

"Idyllic Summer"

What busy man, with multiple problems, schedules to keep, deadlines to meet, and other assorted worries, has not yearned for that time long ago when he had nothing to do but sit by an old tree trunk near a lazy stream in midsummer and fish? Yet that same boy was probably thinking of the future—the successes he will have, the name he will create, and the fortune he will acquire.

In this picture, Rockwell, a self-educated man with a broad knowledge of literature, used the famous nymphs of wood and water (dryads and nereids in Greek mythology) to try to enchant the boy away from the worries of the past and future. These fabled beings are trying to coax the lad to stay young and carefree forever and to enjoy the wonders of nature and the beauty of the forest and the stream.

The pose of the young boy fishing (used by Rockwell on several occasions) was extremely successful in a few Coca-Cola advertisements.

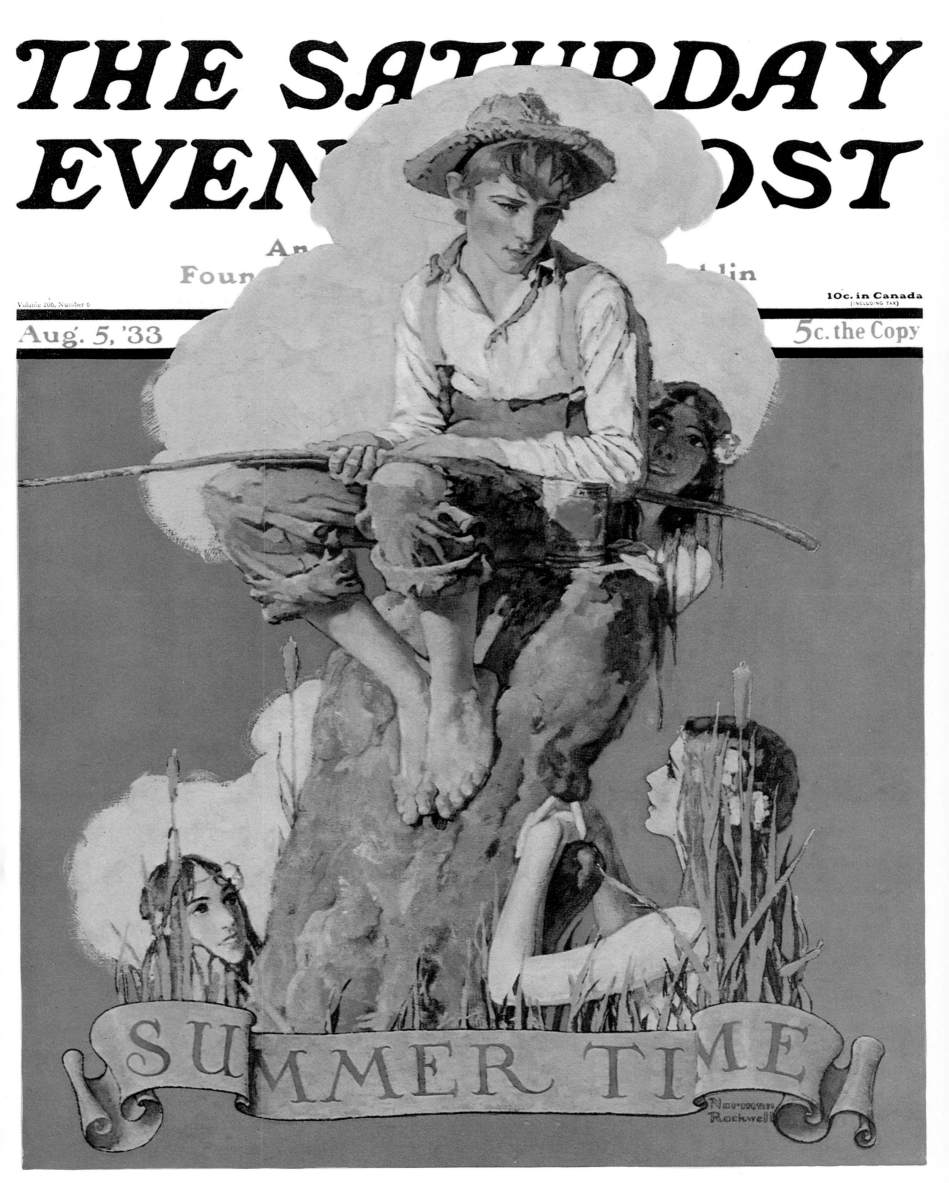

"Saturday Night Out"

When this picture on the *Post* was published, almost every little girl identified with it. What excitement it was to watch a big sister or mother admiring herself in the mirror before going out. Is her makeup on just right? Is every hair in place? Does her gown look presentable? Are her shoes the right color? How nice it was to primp and pamper oneself before going out on the town, and what fun it was for a little lady to imagine herself doing just this a few years from now.

When this cover was distributed in 1933, a neighbor of the Rockwells in New Rochelle thought that the little pig-tailed lass looked from the back just like her own daughter. She removed the cover from the magazine, framed it, and hung it in her home. Sometime later, Mr. Rockwell heard of her love for the picture and presented her with the original oil painting. Everyone knew of Norman Rockwell the great artist, but such was Norman Rockwell the man, the warm human being, the helpful neighbor, the sincere friend.

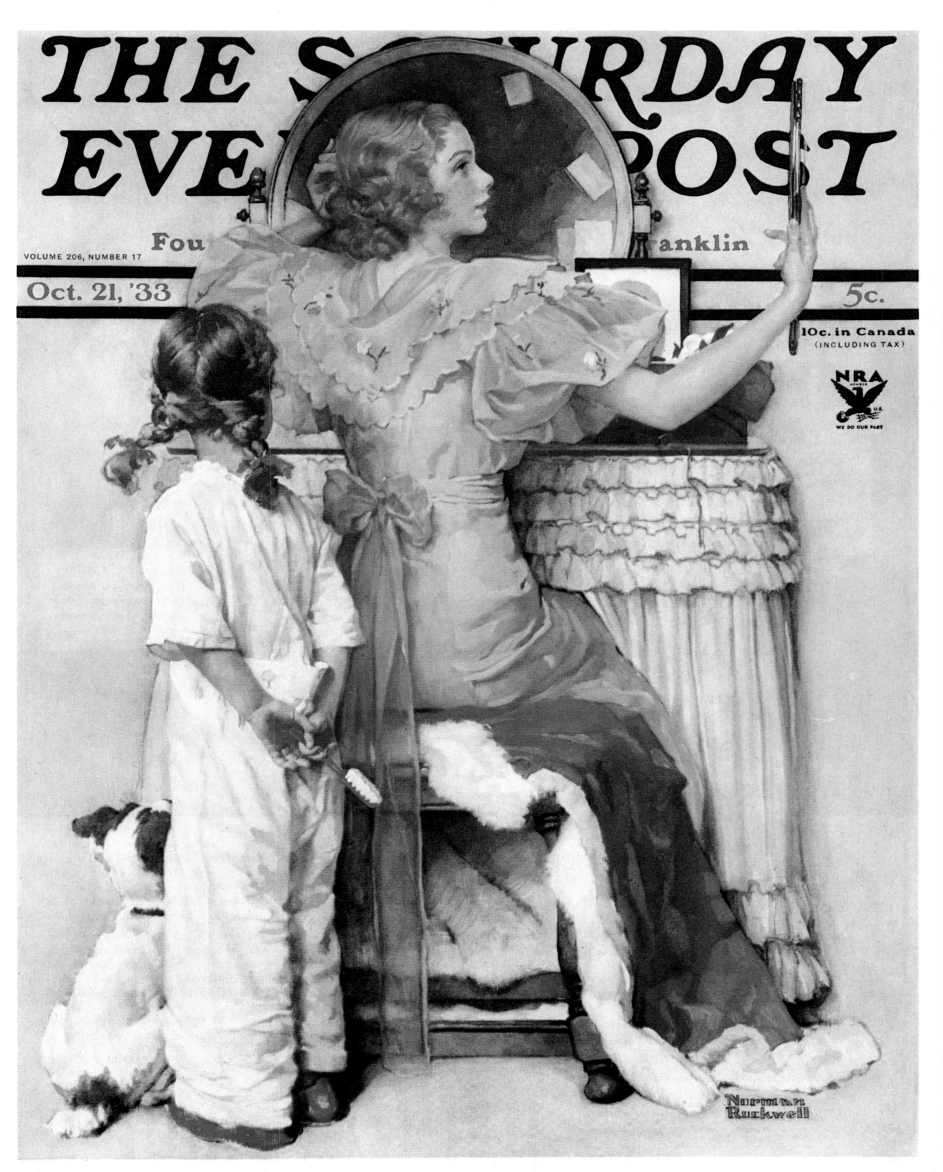

"Child Psychology"

Rockwell was trying to get back on the beam, and his pictures were showing his effort. Second son Thomas was born, and Jerry was a member of the "terrible twos." Fatherhood created new, interesting, and universally understood dilemmas, and the *Post* readers loved them.

This exasperated young mother has just found her mechanically-minded son doing research with a hammer on some important household items. Her first inclination is to grab a hairbrush and wallop him. But on second thought, being a modern, well-educated lady, she explores a text on child psychology in an attempt to find a solution to the problem. Despite the book, however, her anger grows and her boiling point lowers. It is doubtful whether the book does have an answer, unless it is meant to be used to paddle the boy's bottom.

Rockwell wasn't too terribly happy with this cover, but then neither was the little lad with his bottom up!

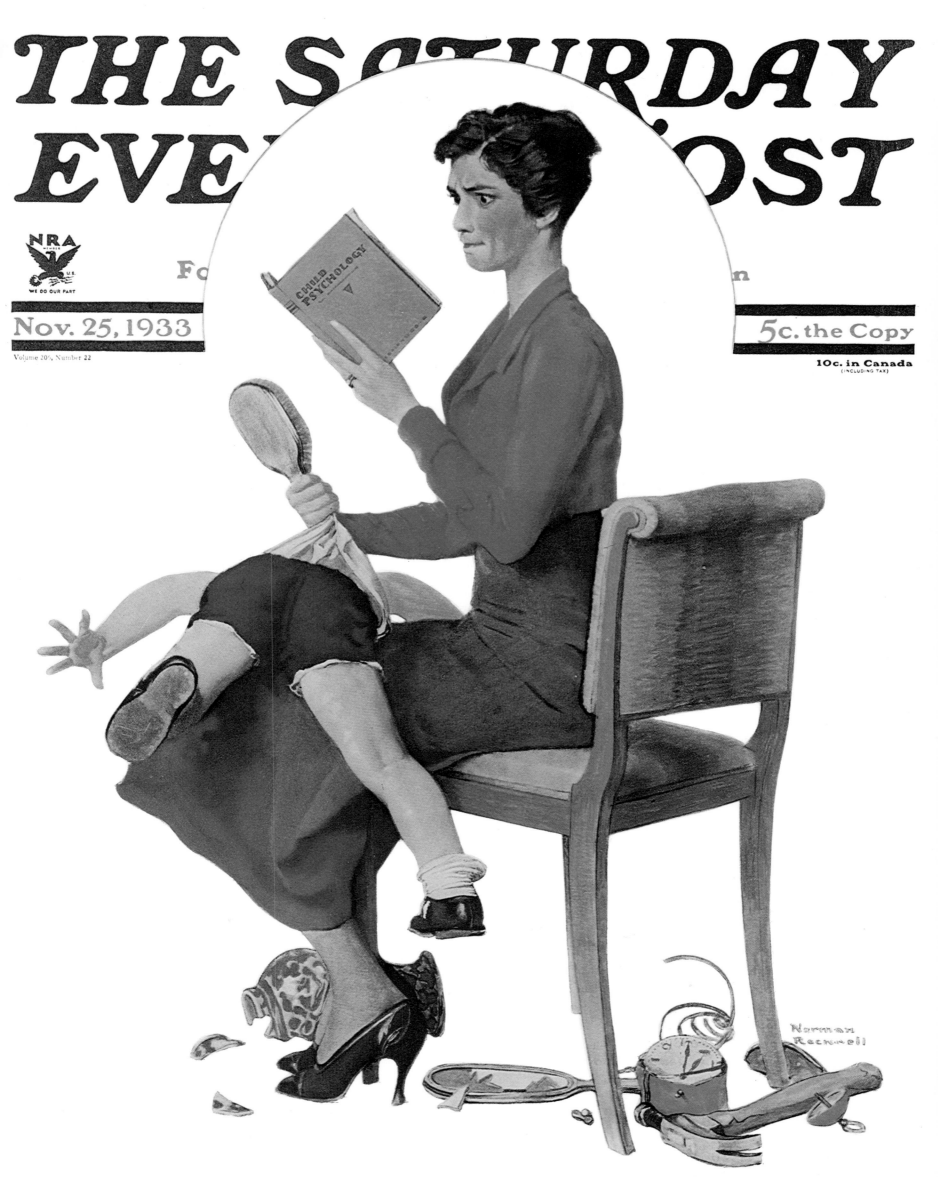

"Ride 'em, Cowboy"

After using medieval or Charles Dickens-type themes on several Christmas covers, Rockwell again comes back with what he does best—kids. This time he brings Grandpa into the picture, and the excitement generated by the Western partners brings a smile to every viewer. Grandpa is galloping along like a rodeo star, and Junior, with his entire Western outfit, is holding on for dear life.

Rockwell loved putting affection into his covers because he knew his readers could identify with them. He was right; his readers across America did identify with him. As they anticipated, saved, and cherished his *Saturday Evening Post* covers, they also developed an affection for the man who painted them. Later on, the *Post* decided to print several thousand extra copies of the magazine each time a "Rockwell" appeared on the cover.

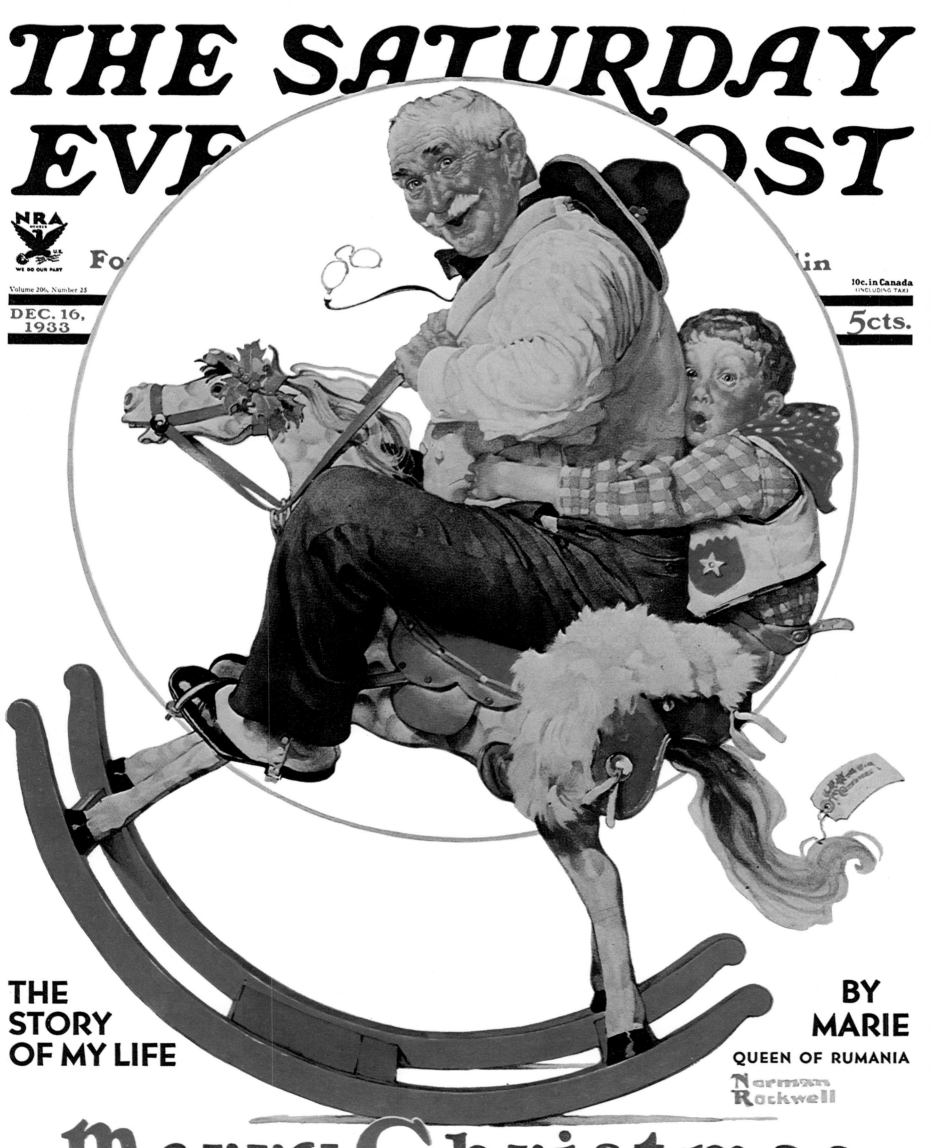

"Thataway"

This lovely equestrienne has just fallen off her mount. Half-dazed and fully embarrassed, she is attentively listening to a little passer-by and his dog as they give her the direction taken by her steed. Now, after she regains her composure, she has the choice of following her horse or returning to the stable if she can do either in her high riding boots.

This picture was inspired by a true-to-life adventure Rockwell had a few years earlier. He decided to take riding lessons while living near Central Park. After a few moments of a slow trot during his first experience, his spirited filly suddenly broke into a gallop through the trails of the park and circled the bridle path in record time. Norman was numb from the experience, but he tried several times thereafter and hated every moment.

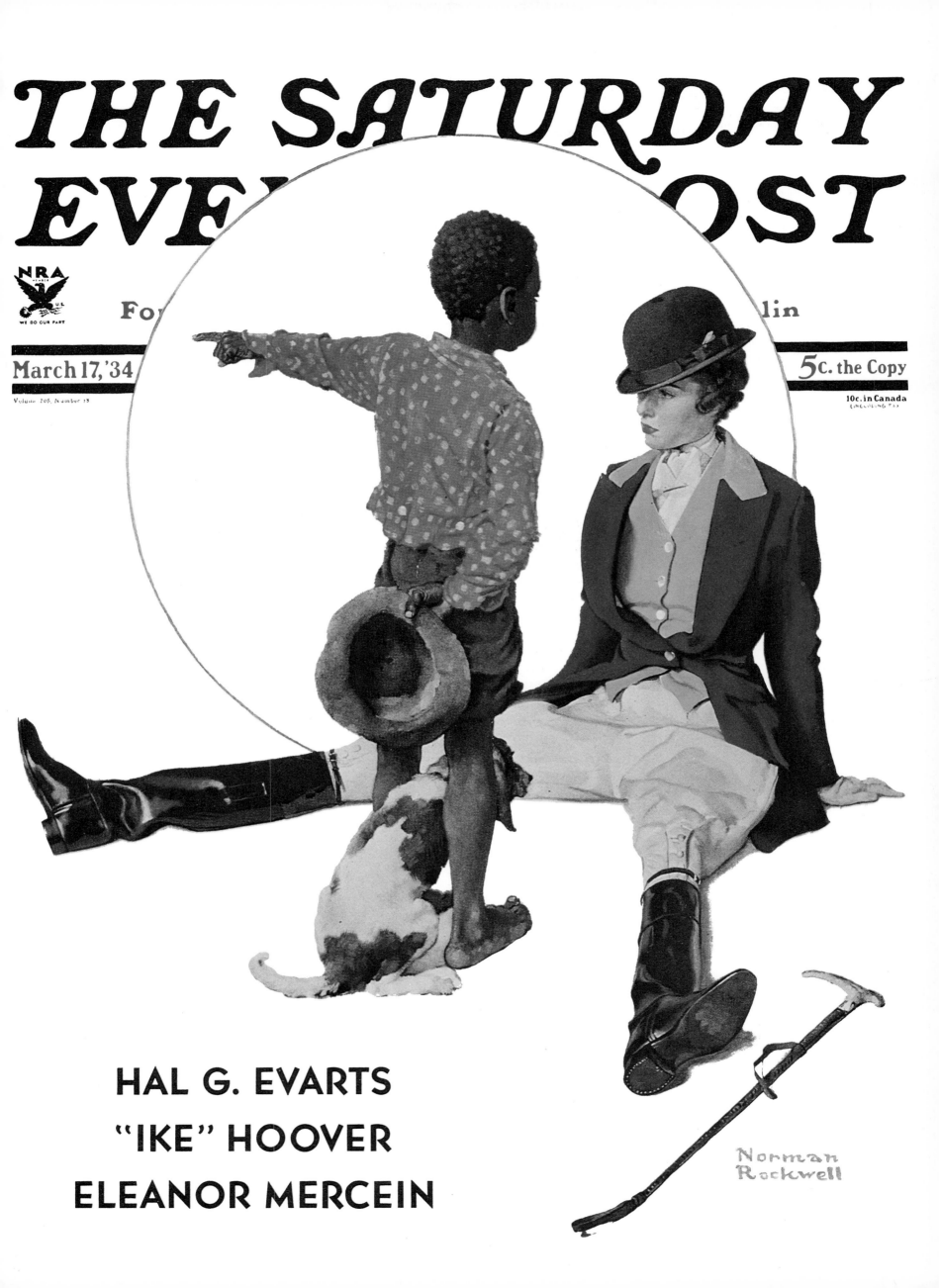

© SatEvePostCo. 1934

"Spirit of Education"

What humiliation for a boy to have to wear a sheet and sandals—not to mention makeup—in front of all his friends. The show must go on, however, and we are sure that our little fellow will make his mother proud and carry on the spirit of education.

Norman Rockwell, a self-educated man, was a strong proponent of education, as was Booth Tarkington, one of the highest-paid writers for the *Post*. Tarkington wrote much like Rockwell painted, portraying life in small towns and the joys of boyhood. His famous book *Seventeen* characterizes the joys and problems of young people and is still required reading in many schools.

THE SATURDAY EVENING POST

April 21, 1934

Volume 206, Number 43

5c. the Copy

10c. in Canada
(INCLUDING TAX)

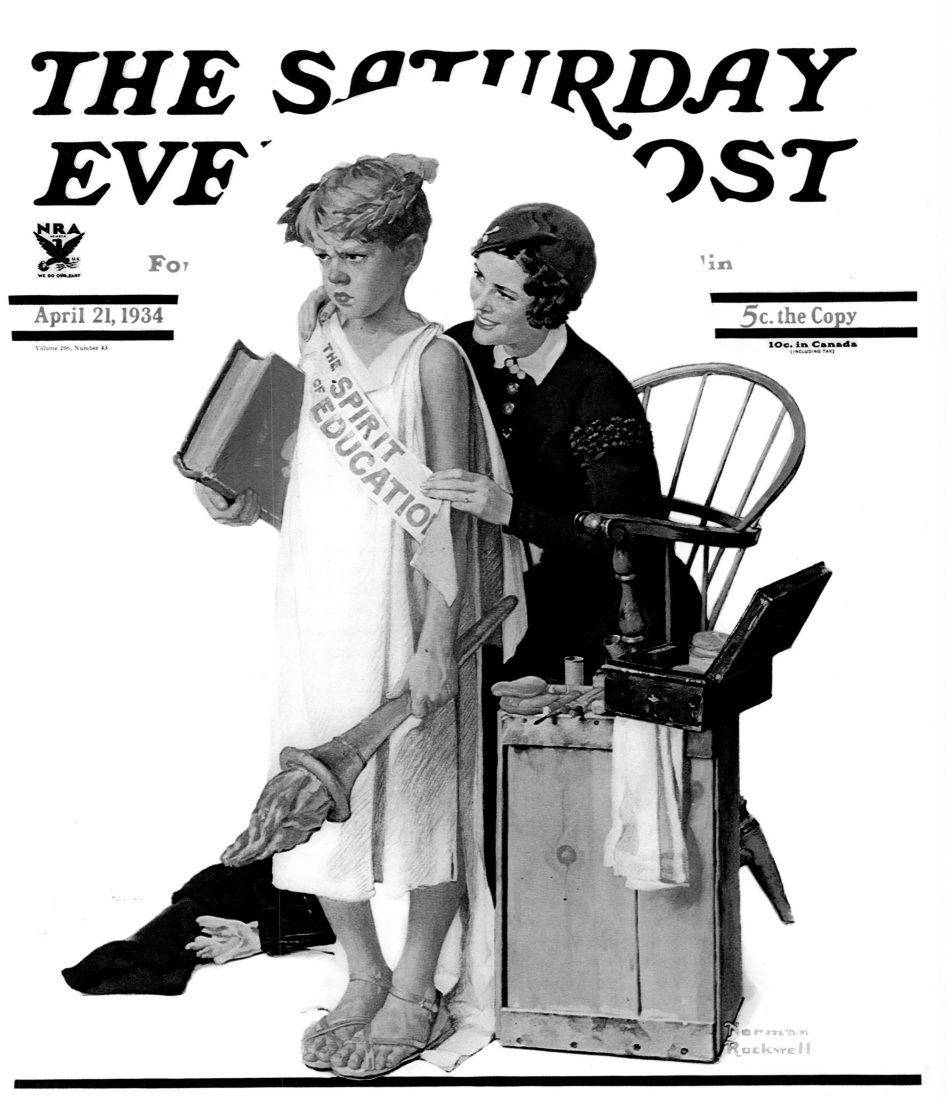

THE SPIRIT OF EDUCATION

Norman Rockwell

BOOTH TARKINGTON · COREY FORD · JOHN T. FOOTE

"The Antique Dealer"

Rockwell was always searching for props for his pictures, and often a single object would spark an idea for a canvas. In this issue, we are witness to an entertaining and amusing scene: a well-dressed lady of apparent means is haggling with a disheveled antique dealer (of probably better means) over an object of art. The large coffee urn near the antique dealer's feet was a favorite of Rockwell's; for years it stood filled with brushes in his studio.

Before his studio burned in 1943, Norman Rockwell had a tremendous collection of props, which he acquired at junk shops, barn sales, and on trips. He said that on at least one occasion, he was even taken for a junk dealer.

From the very beginning, Rockwell gave extra attention to faces. Capturing just the right expression has been one of his great, if not unique, strengths. This technique has proved to make his pictures classics and his models timeless.

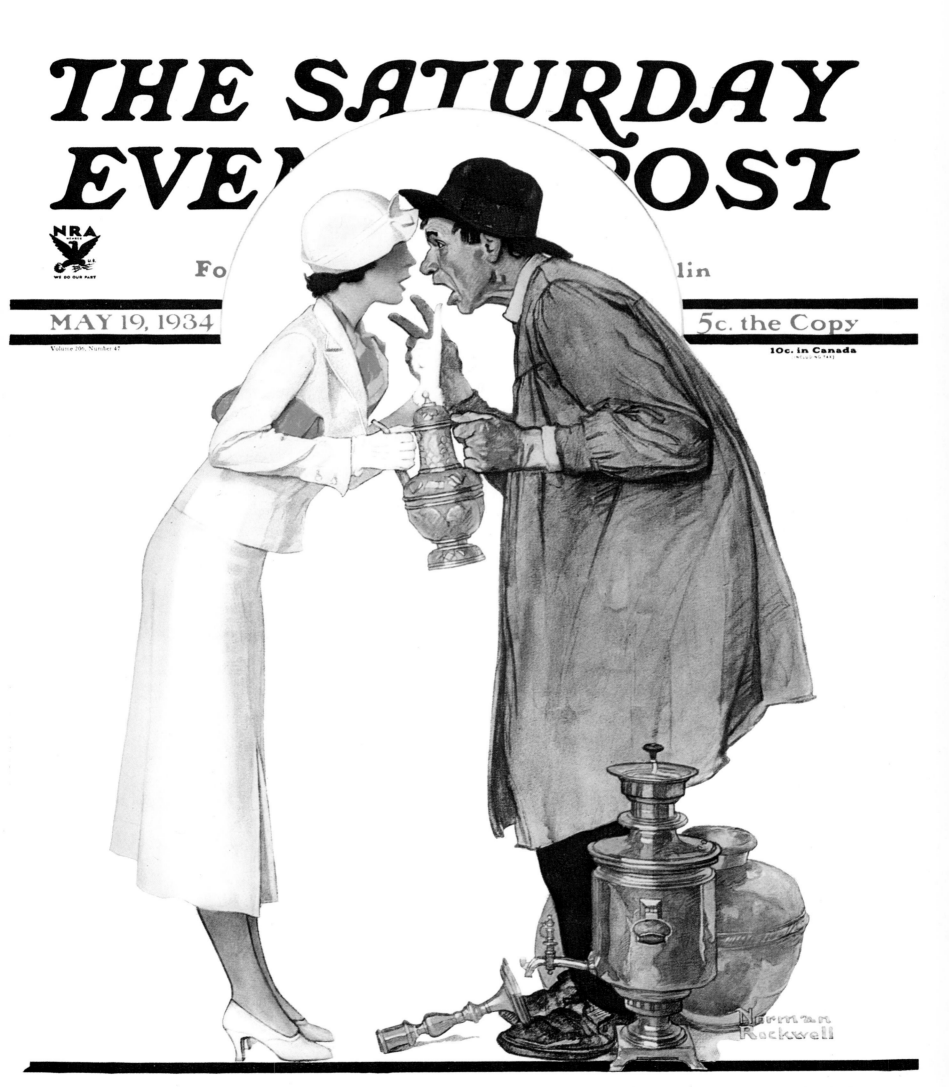

"No More Pencils, No More Books"

School's over for the summer, and kids are as free as the birds. Homework, studying, and tests are all finished for two months, and thoughts of swimming and fishing are paramount.

Rockwell loved watching kids having fun, and his magic pen and brush could capture their joy and enthusiasm better than a camera. For this reason, he was commissioned to do covers for *Boys' Life, St. Nicholas, The Youth's Companion,* and *American Boy* as well as for the *Scout Handbook* and *Hikebook*. Even his best story illustrations were of youngsters such as Tom Sawyer, Huckleberry Finn, and Louisa May Alcott's *Little Women*.

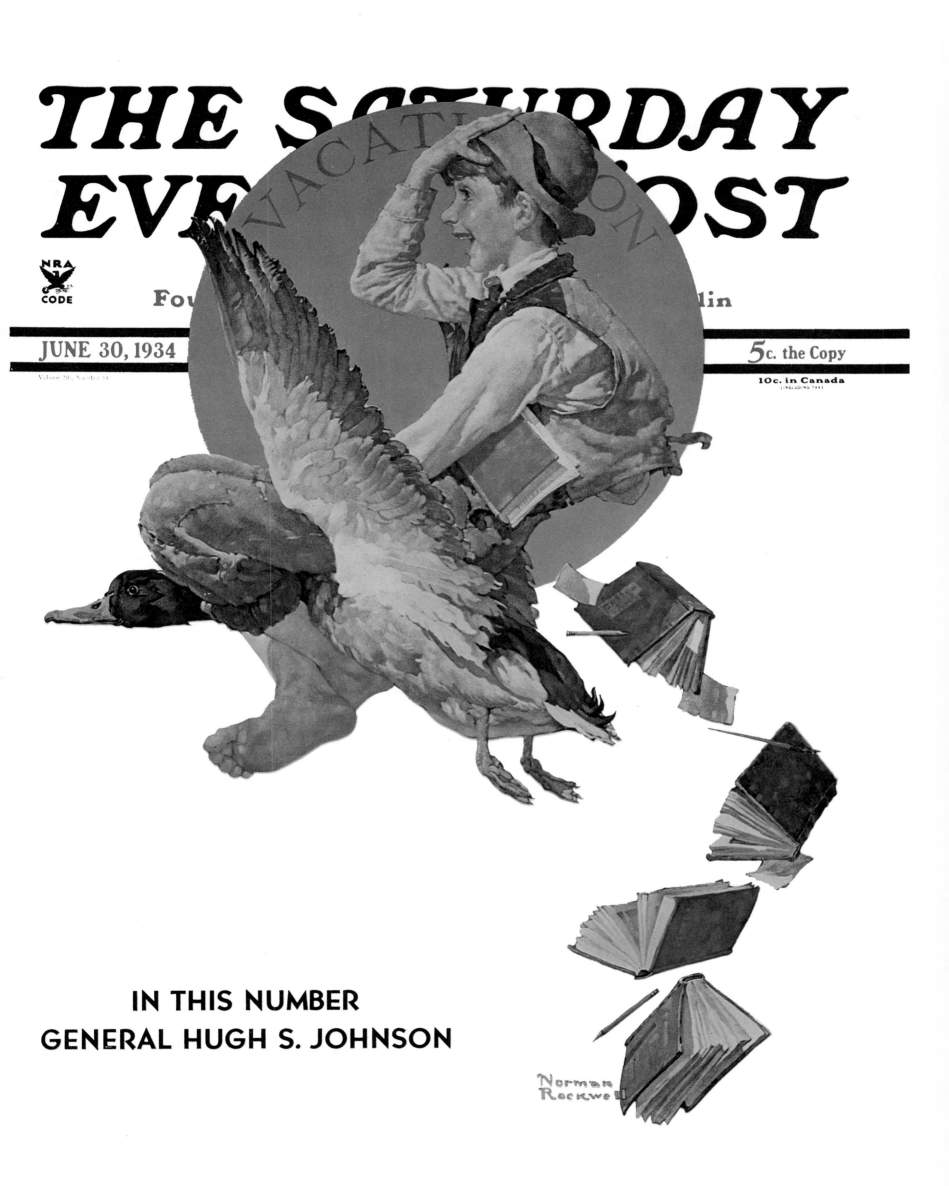

"Starstruck"

With baseball mitt and ball at his side and his favorite companion begging him to come out and play, our star-struck young man is many miles away. While his present thoughts are turned toward Hollywood, California, this coming Saturday afternoon he will be faced with a very difficult decision indeed: should he play in the sandlot game or go see one of his new-found loves at the movie theater?

Rockwell used this theme again on February 19, 1938, when two star-struck girls sit and idolize some of Hollywood's leading men and again on March 6, 1954, with the fabulous "Girl at the Mirror."

THE SATURDAY EVENING POST

NRA CODE

Fo Veekly enj. Franklin

5 cts. THE COPY

10c. in Canada (INCLUDING TAX)

SEPTEMBER 22, 1934

Volume 207, Number 12

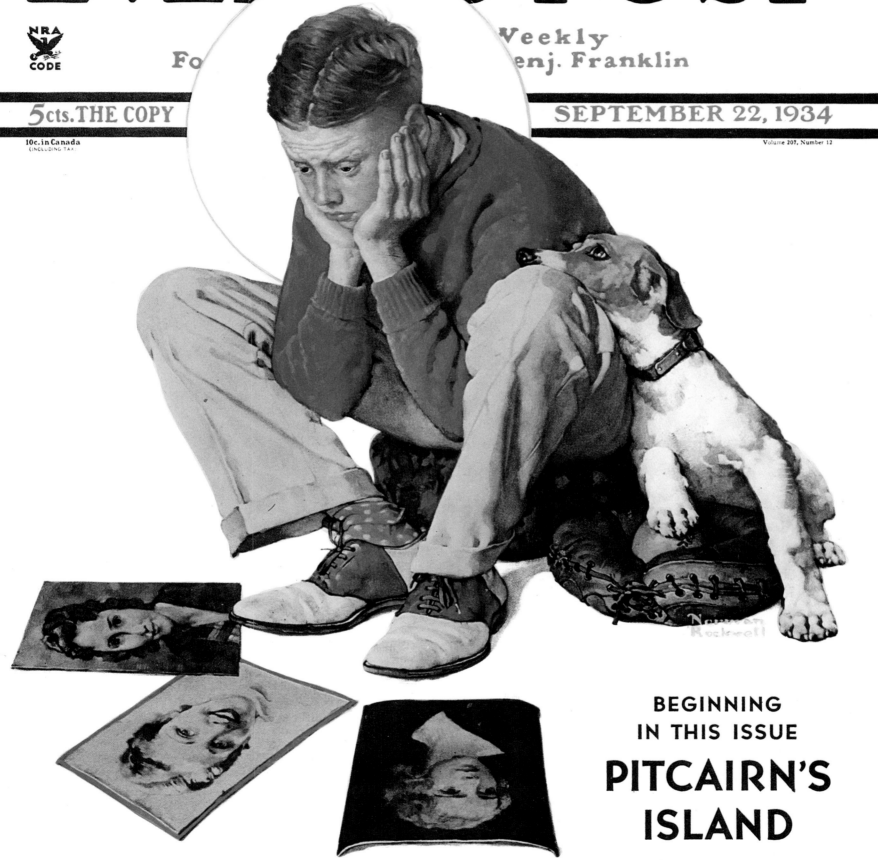

BEGINNING IN THIS ISSUE
PITCAIRN'S ISLAND

By JAMES NORMAN HALL and CHARLES NORDHOFF

"The Lure of the Sea"

High on a rooftop, cautiously perched, and supported only by a sturdy weathervane, an adventurous young man looks toward the bay with the hope that some day he will be sitting high on the mast of a giant schooner.

In 1918, Rockwell painted another picture using a similar theme: an old man, a boy, and his dog are longingly looking out to the sea and her sailing ships. That particular picture, rejected by the *Post,* was published on another publication magazine cover. It was one of the few oversights that Curtis Publishers made. The picture became a classic and remained a favorite of Rockwell fans through the years.

THE SATURDAY EVENING POST

NRA CODE

Volume 207, Number 16

Oct. 20, 1934

10c. in Canada (INCLUDING TAX)

5c. the Copy

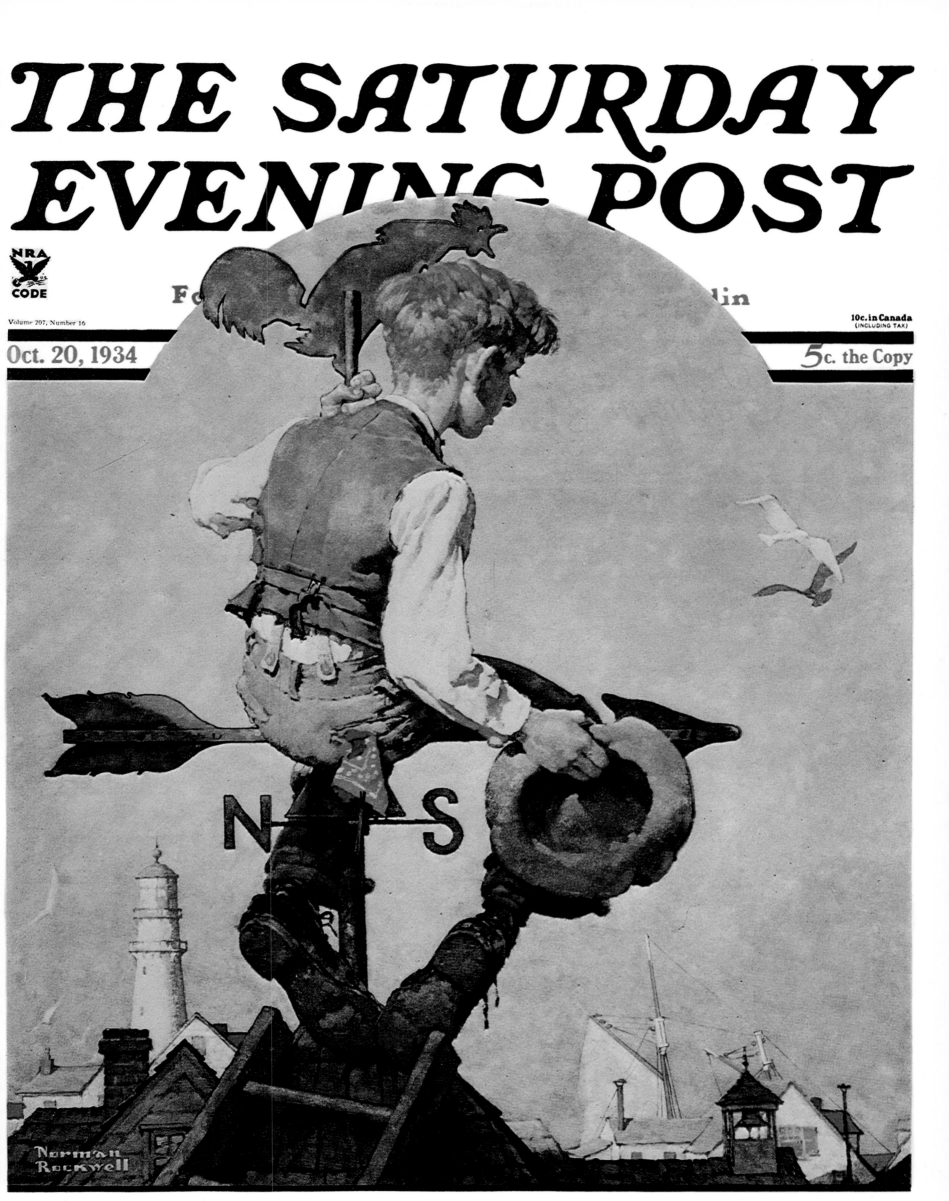

MAURICE WALSH · BOOTH TARKINGTON · RED GRANGE

"Tiny Tim"

Rockwell once said that when he ran out of ideas, he would eat a light meal, sharpen twenty pencils, lay out ten or twelve pads of paper on the dining room table, pull up a chair, and draw a lamppost. "After a while, I got to be the best darn lamppost artist in America." He would then draw a drunken sailor thinking of his girl friend. And so he would go on for three or four hours until a viable idea would emerge.

Sometimes, though, ideas wouldn't surface, and when deadlines were fast approaching (as in holiday periods), he would again reach back into the past. Here, he decided on Tiny Tim and Bob Cratchit, the heroes of a famous Charles Dickens story. Once again he caught the true spirit of Christmas; little crippled Tim with crutches in his hand and braces on his feet is riding high on the strong shoulder of Bob. With outstretched arms and friendly smiles, they wish everyone a warm and happy Christmas.

This colorful *Post* cover has been a favorite Christmas card for the past twenty-five years.

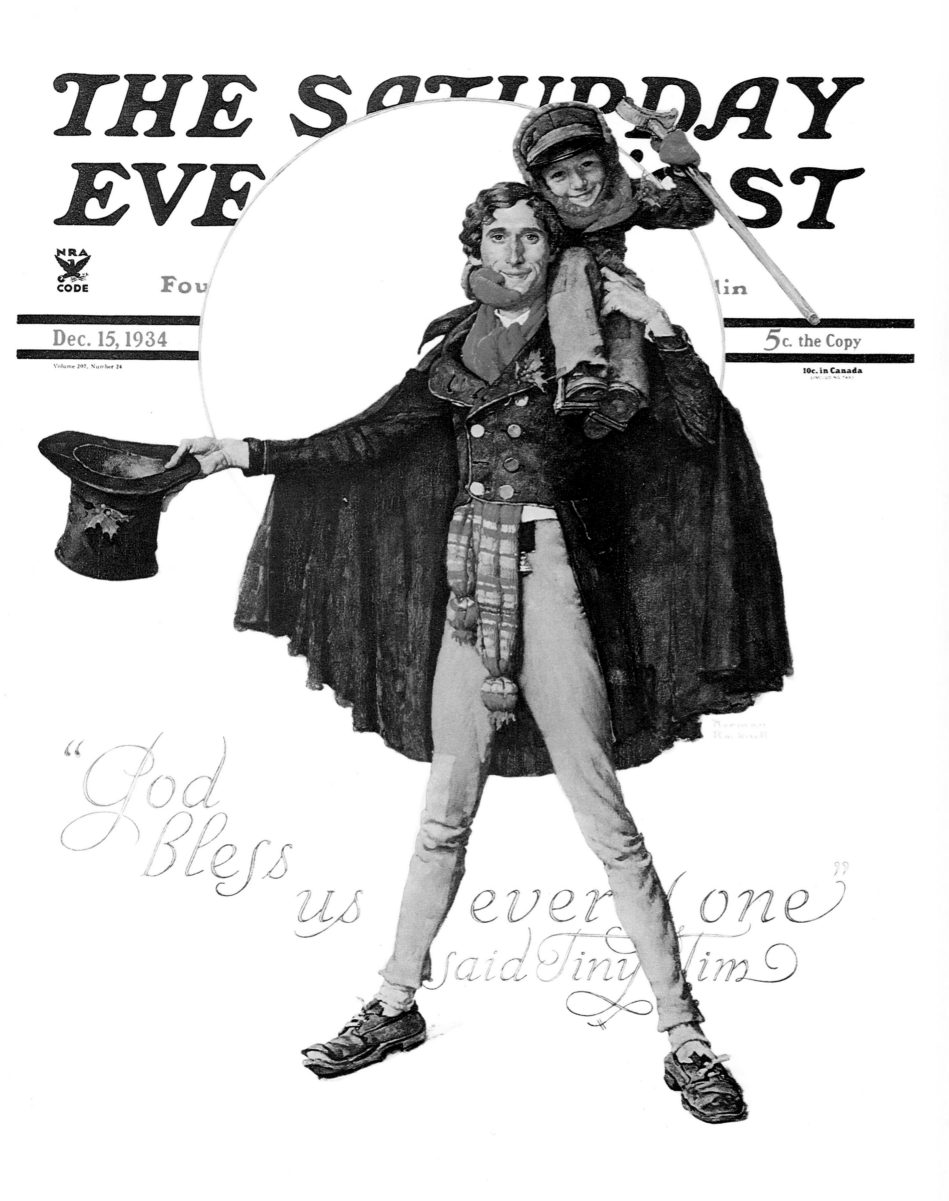

THE SATURDAY EVE[NING PO]ST

NRA CODE

Fou[nded A. D. 1728 by Benjamin Frank]lin

Dec. 15, 1934

Volume 207, Number 24

5c. the Copy

10c. in Canada
(INCLUDING TAX)

"God Bless us every one" said Tiny Tim

"The Sign Painter"

In addition to being the renowned illustrator for a nationwide magazine, art editor and top artist for the Boy Scouts of America, premier story illustrator for books, Norman Rockwell was one of the most successful advertising artists of his time. Doing work for Jell-O, Orange Crush, Post cereals, Coca-Cola, Mennen shave products, Budweiser, Swift baby foods, Fisk tires, Campbell's tomato juice, Sun·Maid raisins, and many, many more, Rockwell's work was everywhere; it was easily recognizable to his vast audience.

Although he probably never painted a billboard, he did do a few large murals, and he certainly could have tackled a large sign if so inclined. On this cover, we see a young billboard artist (who could well be a caricature of Rockwell himself) going about the herculean task of painting a woman's face while delicately balanced on a scaffold high above the city's streets.

This issue of the *Post* had a mystery by Agatha Christie, who, like Rockwell, is as popular today as she was in 1935.

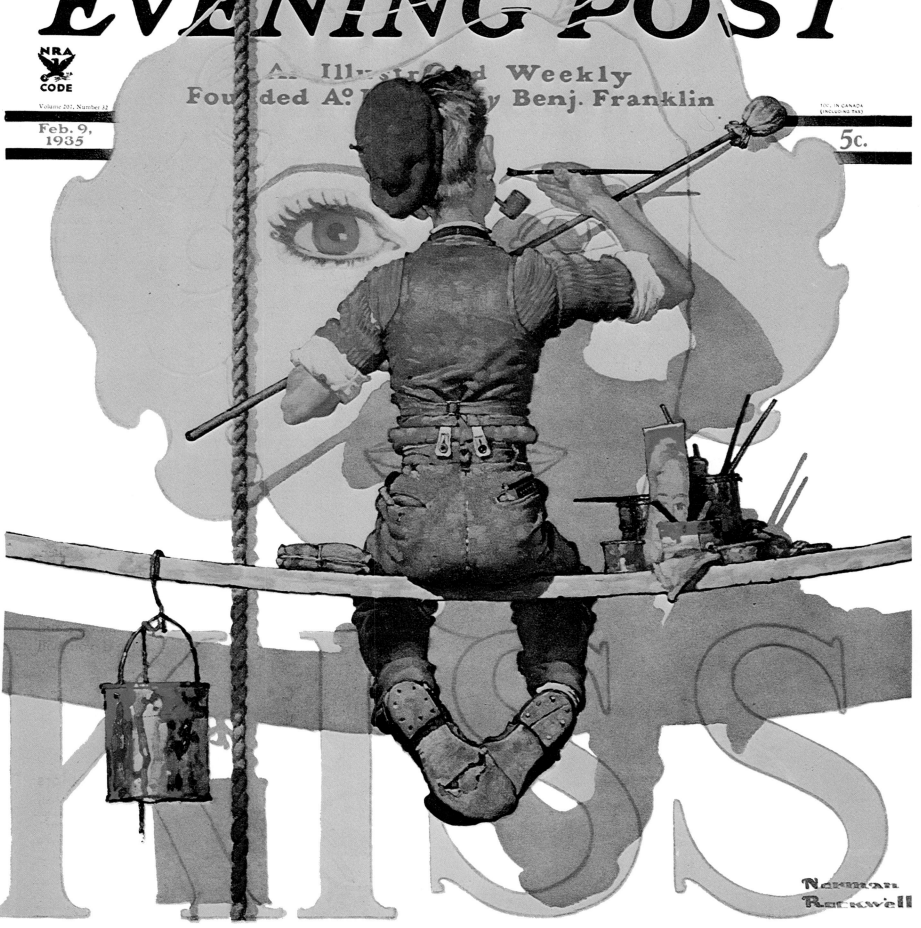

"Meeting the Milkman"

Prosperity was rising, Rockwell's work was getting better with each cover, and Broadway musicians were turning out music and shows that lit up the world. One song, "The Lullaby of Broadway," told us of the Broadway babes who didn't sleep until the milkman arrived at the break of day.

On this *Post* cover a young couple was obviously having such a wonderful time that the hours flew by and they didn't return home until dawn, when they met a very fatherly milkman still carrying his flashlight who is not reluctant to admonish the young couple for coming home so late and making their parents worry.

Rockwell used this delightful theme again in the seventies for the cover of a Top Value stamp catalogue. This couple, however, was not so fortunate and ran into the girl's father, who sternly reprimanded the young lovers.

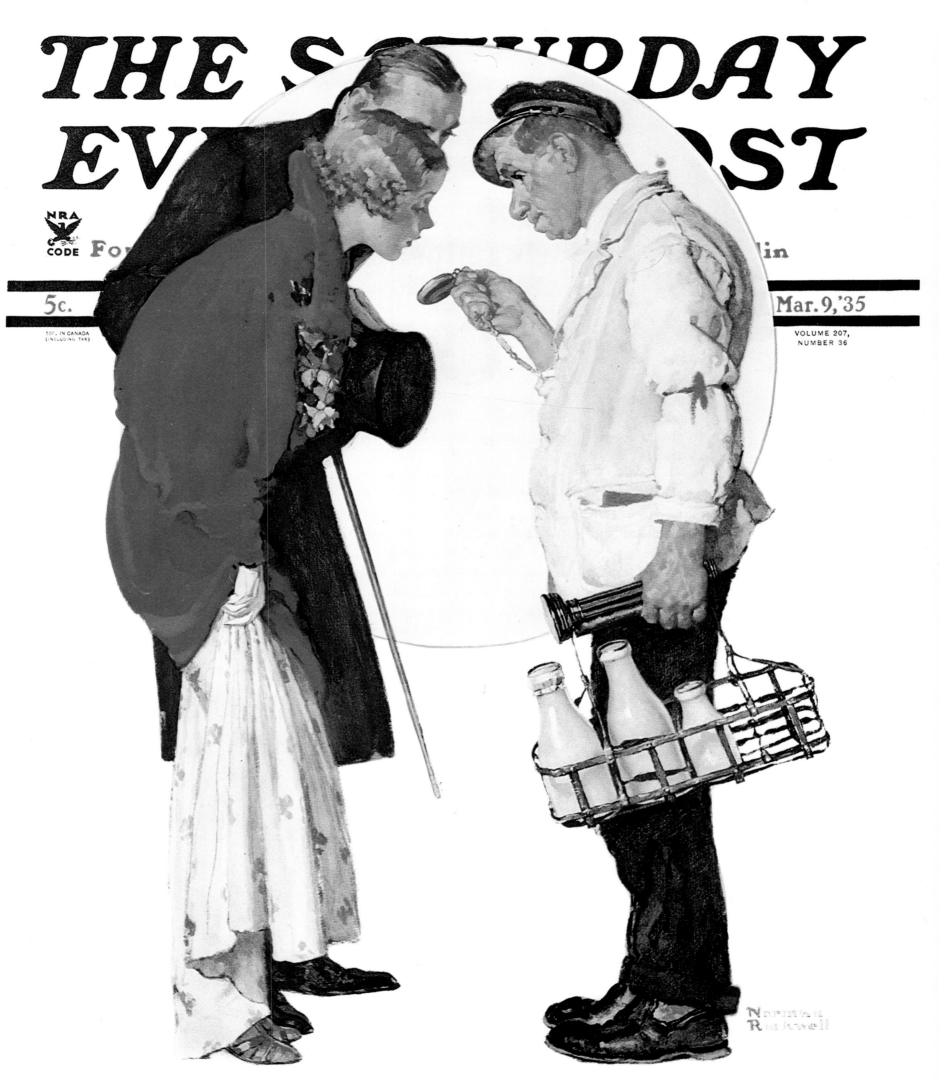

"Spring Morning"

Oh what a beautiful day. On the way to school what young man couldn't be diverted by two fluffy rabbits who happened to cross his path.

In this picture we see Mr. Rockwell is as much at ease with rabbits as he is with cats and dogs.

Some people criticized Rockwell, saying that his pictures of children growing up in America did not reflect the entire picture. He painted children playing, fishing, swimming, and hiking, but did not reveal the difficult, often bleak experiences of growing up in the city. But as usual he portrayed not what he always saw but what he wanted to see.

Several years later he was commissioned by a large drug company to do a series of paintings to advertise a drug for depression. After completing the original pencil sketches, he informed the company that he could not complete the project because the pictures were too sad and it was not his type of art. This, once again, showed that Rockwell was unable to portray sadness or strife and both his personality and his paintings revealed his contentment and optimism.

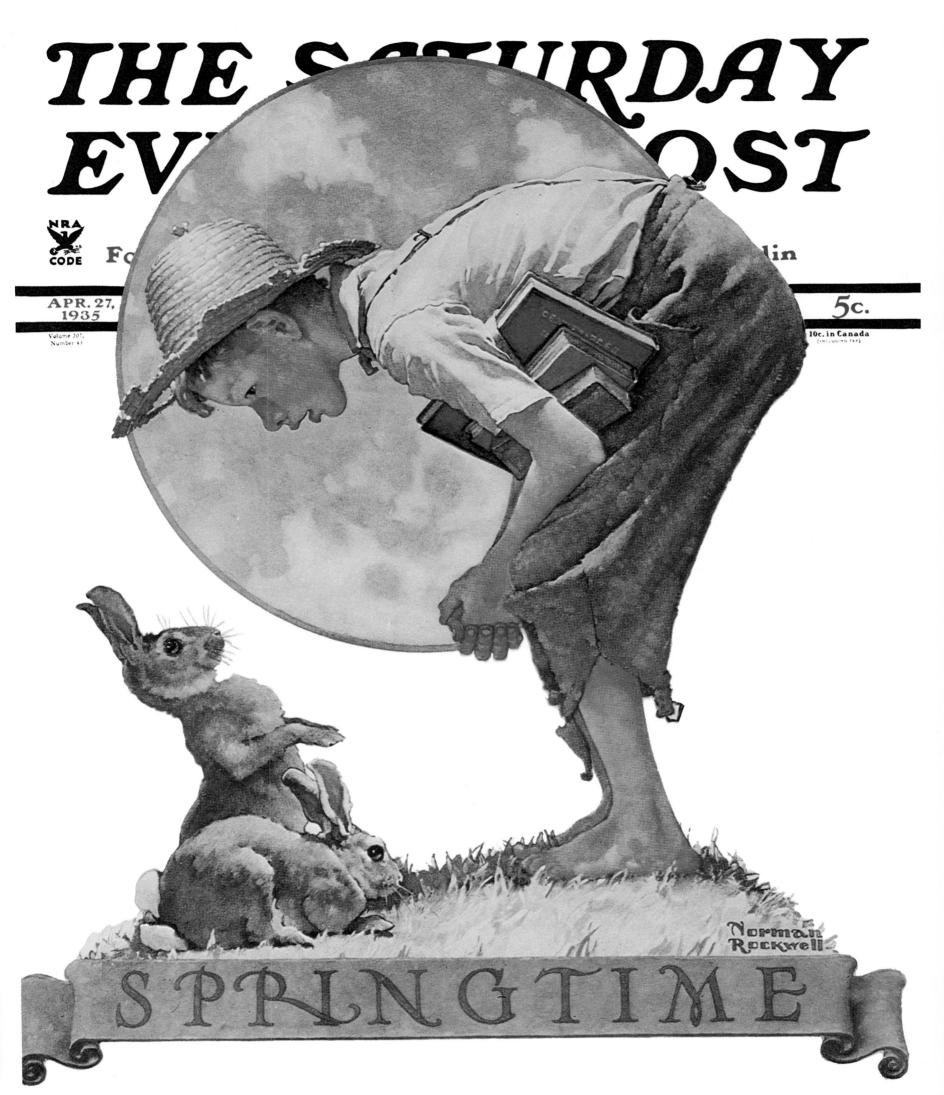

"Speed Demons"

It has often been said that America has a love affair with the automobile. More than any other invention it changed the lifestyle of every American, and Norman Rockwell was no different.

On this cover we see a young couple in the rumble seat of a sports car that is barreling down the highway at an incredible speed to the delight of an exuberant young lady and her dog. Rockwell portrays the action in this picture so well that you might expect the car to zoom right off the page.

The dog's flying ears, the girl's scarf, the boyfriend's tie and attempt to hold his hat on all add to the motion of the moment.

On the July 31, 1920, and the July 19, 1924, *Post* covers Rockwell displayed speeding cars and both style and speed have changed drastically over the years.

Once again in this issue it is interesting to note the writers who were doing work for the famous magazine, proving once again that the *Post* was extremely gifted with literary as well as artistic talent.

THE SATURDAY EVENING POST

Illustrated Weekly
A.° D.¹ 1728 by Benj. Franklin

10c.
in Canada
(INCLUDING
TAX)

5c.

JULY 13, 1935

Volume 208 Number 2

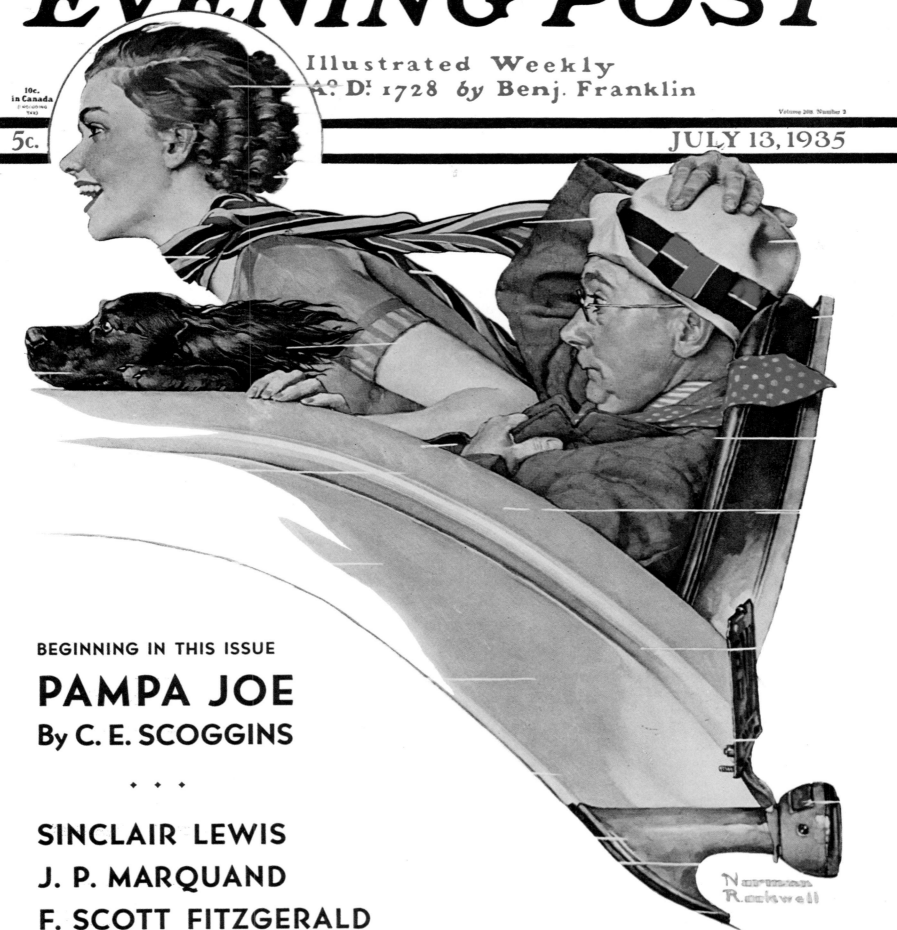

BEGINNING IN THIS ISSUE

PAMPA JOE
By C. E. SCOGGINS

. . .

SINCLAIR LEWIS

J. P. MARQUAND

F. SCOTT FITZGERALD

"First Day of School"

Rockwell liked to dress people up in fancy and unusual costumes and paint their pictures, but he gradually got away from doing it because people just didn't like those covers as well as everyday occurrences with modern-day dress. On this cover we see a mother bringing her pride and joy to school for the first time and presenting him to the teacher. Both women are dressed in costumes of the 1870's, but the mother looks friendly and pretty and the teacher dull and a bit mean. Behind her back is a thrashing stick to be used to keep junior in line if necessary, and by the looks of the bandage on his head and his expression she will have her hands full.

Rockwell said that it seemed that every schoolteacher in the country wrote to him complaining about how ugly he made the teacher. He felt teachers were a touchy lot, especially when they complained again after the March 17, 1956, cover in which a teacher again appeared far from glamorous.

One of the hallmarks of *The Saturday Evening Post* until 1939 was the circular focal point somewhere near the center of the picture. In this picture the circle was the map of the Western Hemisphere.

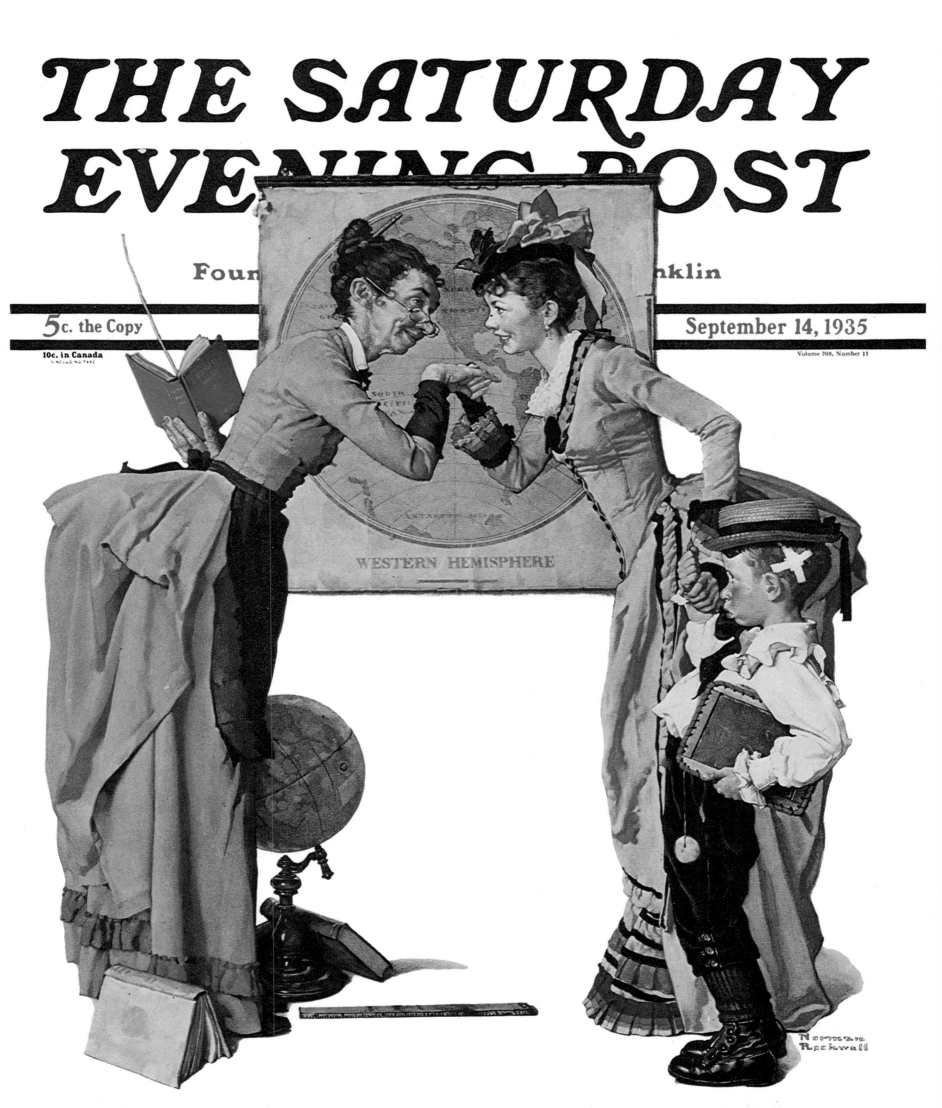

"An Autumn Stroll"

Norman Rockwell has been called a narrative illustrator. His paintings are not just pretty pictures, but each one tells a full story with the viewer able to grasp the basic theme with little effort.

Narrative painting began in 19th-century England and several pictures from that era are as important as history books in depicting the dress, decor, habits, and activities of the people. Rockwell followed in their tradition and even if the reproduction of his painting on a magazine cover was not a true example of the original, it told his story to millions of people and said what he wanted to say.

In this picture we can almost feel the chill in the air as a handsome young man and his faithful dog take a hike through the falling leaves of November. With his leather jacket, knapsack, walking stick, and pipe he is enjoying the crisp air and autumn smells, maybe for the last time before winter snows begin.

1935 was a highlight year in Norman Rockwell's life. He was called upon to illustrate two books, *Tom Sawyer* and *Huckleberry Finn*. Norman decided that going to Hannibal, Missouri, where the stories were based, would give him a better insight into the work. His theory proved right and the books were a great success. The project seemed to be a turning point and his career began to rocket to unforeseen heights.

THE SATURDAY EVENING POST

Fo

November 16, 1935

Volume 208, Number 10

5c. the Copy

10c. in Canada
(INCLUDING TAX)

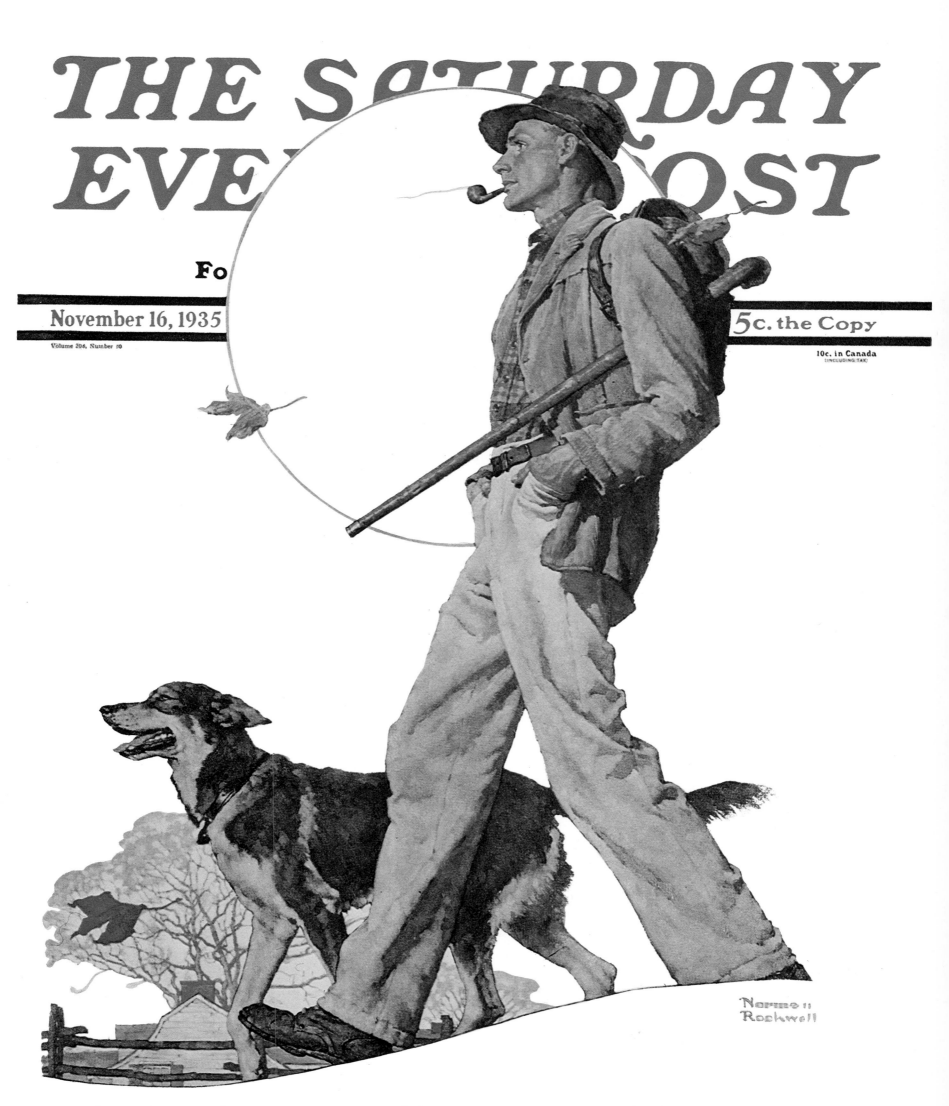

EVALYN WALSH McLEAN · JOHN TAINTOR FOOTE

"Santa Reading His Mail"

Although Rockwell preferred to work on real-life episodes, from little vignettes that occurred to him during his life or from experiences of others, sometimes he had to delve into the depths of his imagination for material.

And this time his creative mind took him to the North Pole, where we see a saintly Santa Claus enjoying one of the millions of letters that are written to him each December.

All through the night the candle burns as old Saint Nick opens mail bag after mail bag to read the requests of boys and girls from all over the world.

And after each letter is read, the requests are recorded in a log which is checked against an expense list (*Post* cover December 4, 1920), and then checked again against a list of good boys and girls (December 6, 1924, December 4, 1926, and December 16, 1939), and finally after all his toys are completed (December 2, 1922), he begins his long journey on Christmas Eve.

THE SATURDAY EVENING POST

5 cts.

Fo... ...lin

DEC. 21, 1935

Volume 208, Number 25

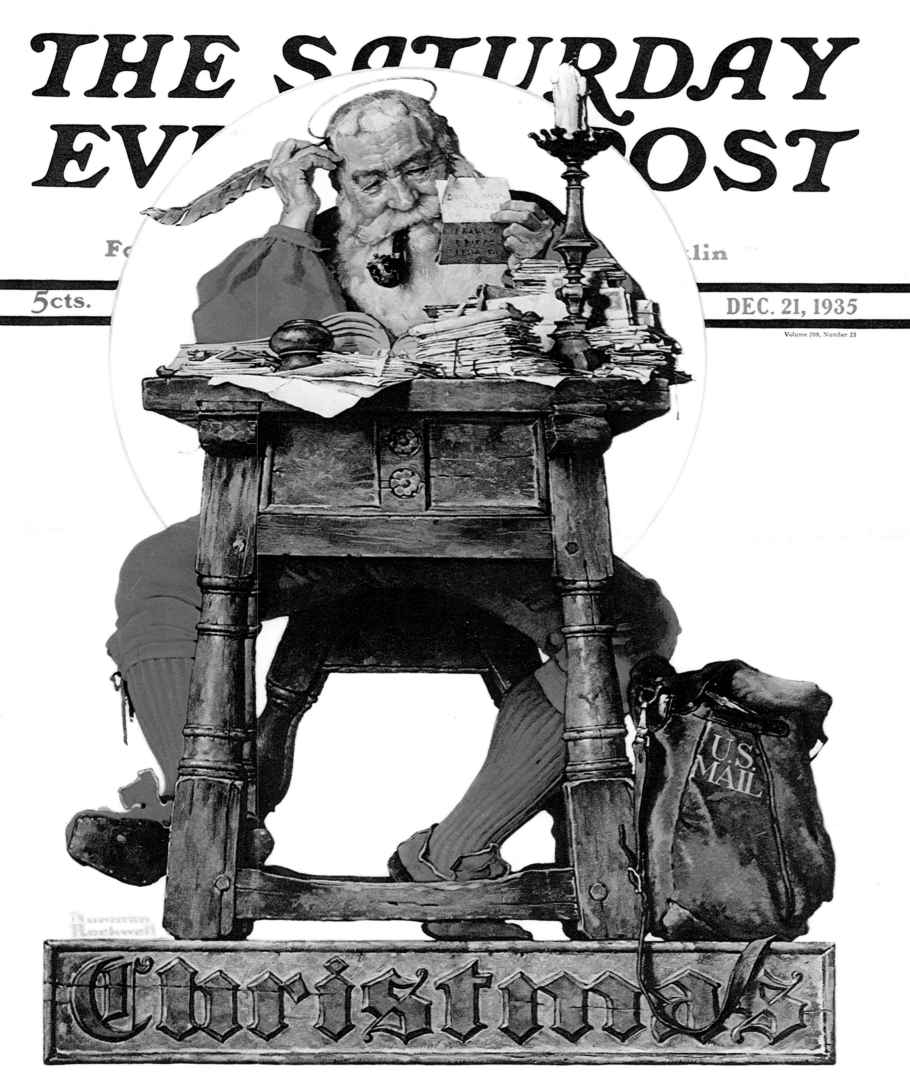

Christmas

WILLIAM HAZLETT UPSON · FRANK H. SIMONDS

"Big Moment"

In his youth Norman Rockwell had a well-to-do elderly uncle by the name of Gil Waughlum who was something of a scientist and inventor. Rockwell remembered him as a stout old gent, with round pink cheeks and a bald head, who was extremely jovial and a bit eccentric.

His biggest problem was that he got his holidays mixed up. On Christmas day he would visit with a gift of Fourth of July firecrackers, on Easter he would bring Christmas gifts, and on Thanksgiving chocolate rabbits. Occasionally he even got his houses mixed up and once hid presents all through one of the neighbors' homes.

When this cover of a small boy digging into a beaming grandfather's coat pocket was painted, Mr. Rockwell really had old Uncle Gil in mind.

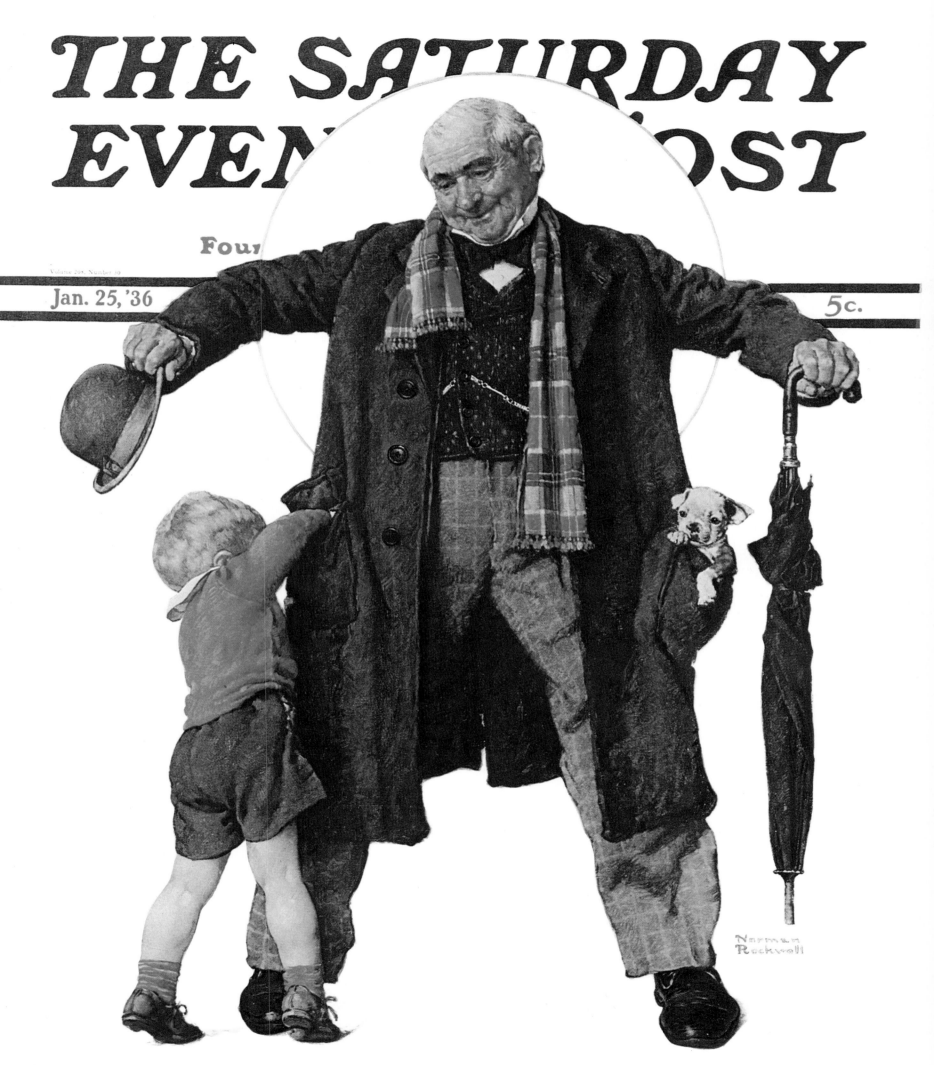

"The Movie Star"

Times were rapidly changing and the ticker tape world of 1929 and 1930 was being replaced by the celluloid world of the movie film. Hollywood was the most important town in the country and its inhabitants were the kings and queens of the land. Hollywood set the pace for dress, decor, etiquette, and demeanor. People idolized their favorite stars and millions of words were written daily in the newspapers and magazines, and the public loved every one.

In this cover a beautiful movie queen who resembles Jean Harlow has just arrived in town from Hollywood and is being interviewed by the local press. She has received her welcome bouquet and now acts aloof as the reporters bombard her with questions.

Dave Campion, with the cigar, as well as other neighbors posed as the media in this picture and a classic old box camera is also a point of attraction.

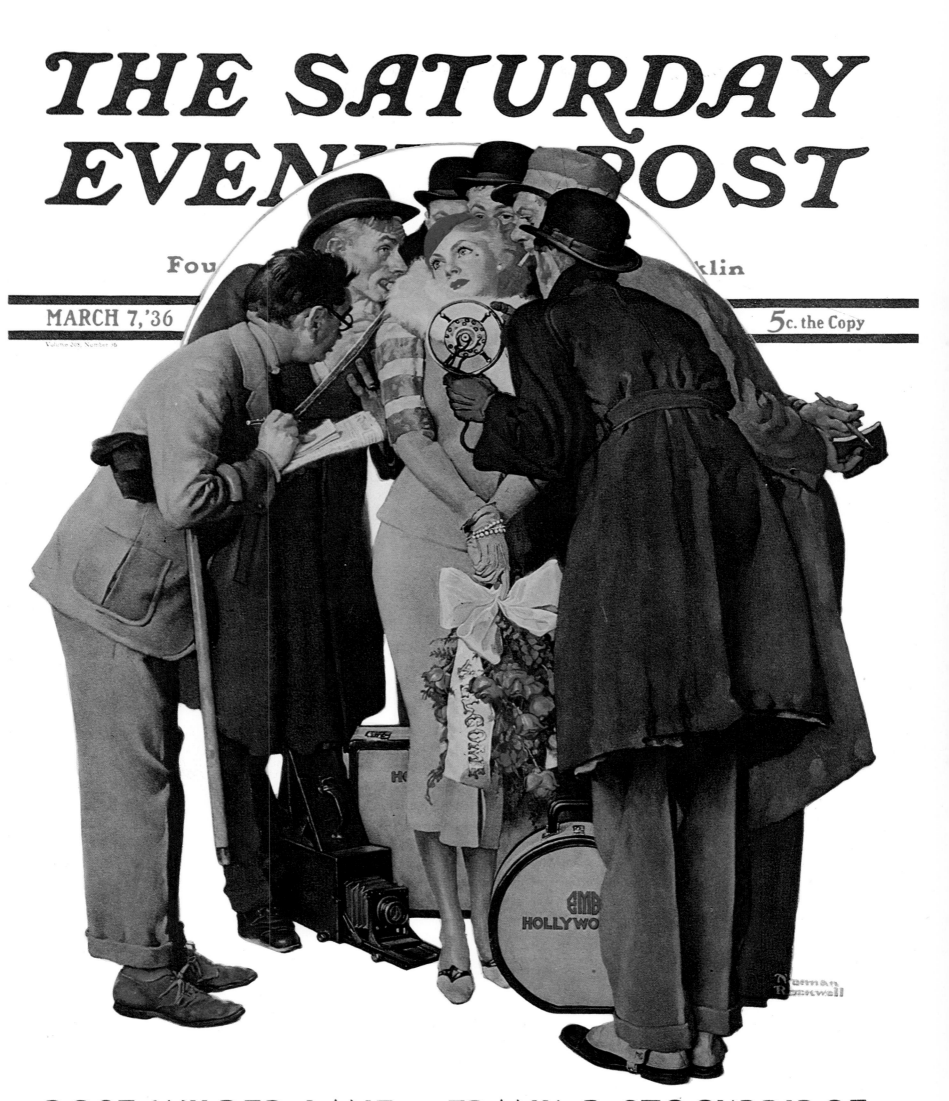

THE SATURDAY EVENING POST

Fou klin

MARCH 7, '36

5c. the Copy

ROSE WILDER LANE · FRANK P. STOCKBRIDGE

"The Scarecrow"

With his ship of fortune on a steady course Rockwell was given a new challenge. He was asked to paint a mural in the Yankee Doodle Room of the Nassau Inn in Princeton, New Jersey. He accepted the assignment and sketched out a Revolutionary War picture to illustrate the theme of the tune "Yankee Doodle." He worked on the painting for nine months and when it was completed the 13-foot-long, very humorous, and extremely accurate mural was considered one of the finest bar room decorations in the world. The mural still stands in the Nassau Inn and is a highlight of the entire area.

While working in the beautiful Princeton area and its agriculturally famous fields and woods, he came up with the idea for the spring 1936 cover—a bright and smiling young lady while walking through a field on a warm spring morning stops to greet a portly scarecrow and place a flower in his lapel.

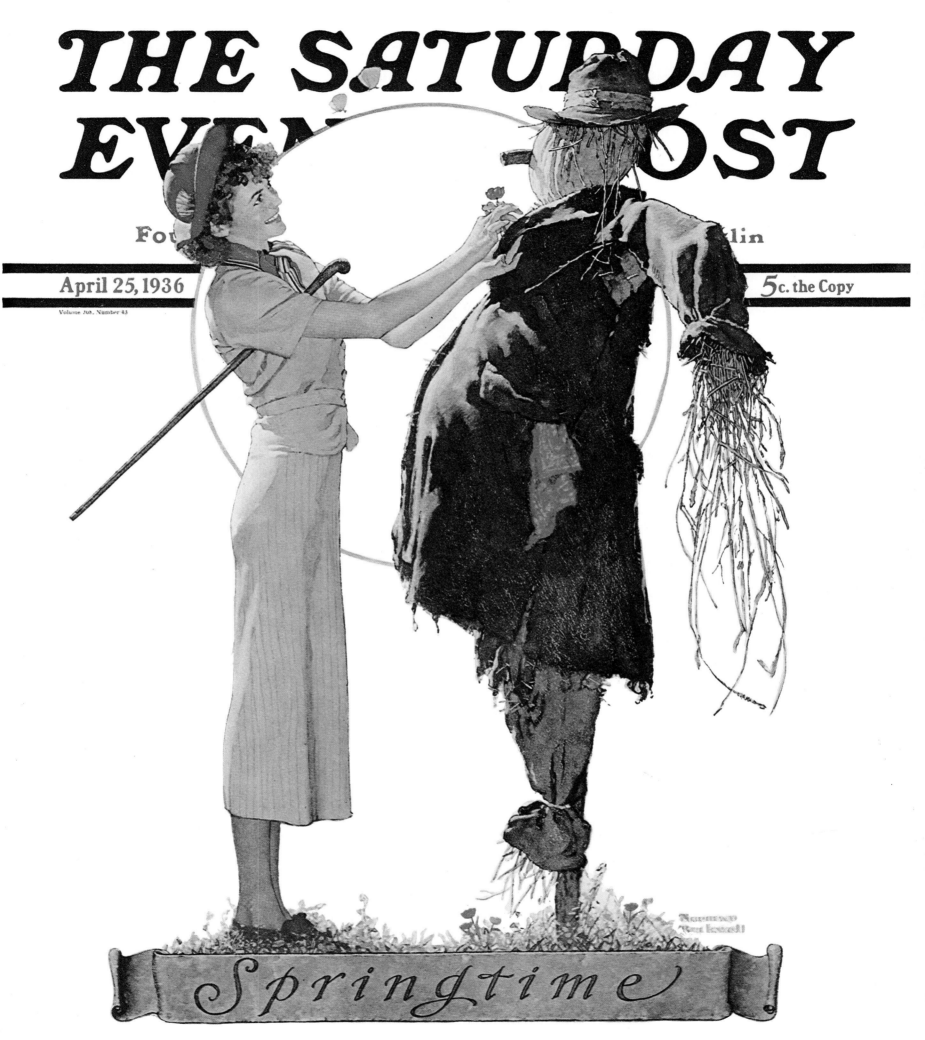

THE SATURDAY EVENING POST

Fou... ...lin

April 25, 1936

Volume 208, Number 43

5c. the Copy

Springtime

VINCENT SHEEAN · J. P. McEVOY · EDDIE CANTOR

"Taking His Medicine"

This cover was inspired by one of the illustrations that Rockwell did in the *Tom Sawyer* series. Aunt Polly always seemed to know the proper medication for curing almost any ailment and despite Tom's displeasure she is determined to get the concoction down his throat.

Norman loved the people and the town of Hannibal, Missouri, and wherever he wandered he constantly sketched in order to get accurate backgrounds.

And costumes were of equal importance, so he decided to trade his fancy eastern garb for the tattered and torn hats, shoes, pants, and shirts of the townspeople. At first they thought he was crazy, but later he was so besieged with clothing that he had to make a quick exit from Hannibal.

"Young Love"

In this picture Rockwell again turned to the innocence of young love—a dreamy young couple in their teens sitting on a knoll and discussing future plans.

After he had lived in New Rochelle for several months, he had built up a list of available models and wasn't forced to chase stray kids and dogs around the streets. He had a notebook filled with names and addresses, but even with that he once commented that the task of choosing a model for a picture was about as exciting as judging heifers at a county fair.

But this couple appear to be perfect for their parts with their young, bright faces and pure, innocent expressions.

"The Barbershop Quartet"

If someone could turn up the volume on this picture, we are sure that the strains of "Sweet Adeline" would reverberate through the room. This colorful picture was the pride and joy of barbershops across the country, and even if singing wasn't an integral part of their establishment, certainly the comb, brush, razor, apron, and a copy of the *Police Gazette* was.

This picture once again showed Rockwell's uncanny ability to capture facial expressions, as anyone who has enjoyed the wonderful sounds of a barbershop quartet can easily pick out the tenor on the left and the bass on the right, and the perfect harmony rising from the middle.

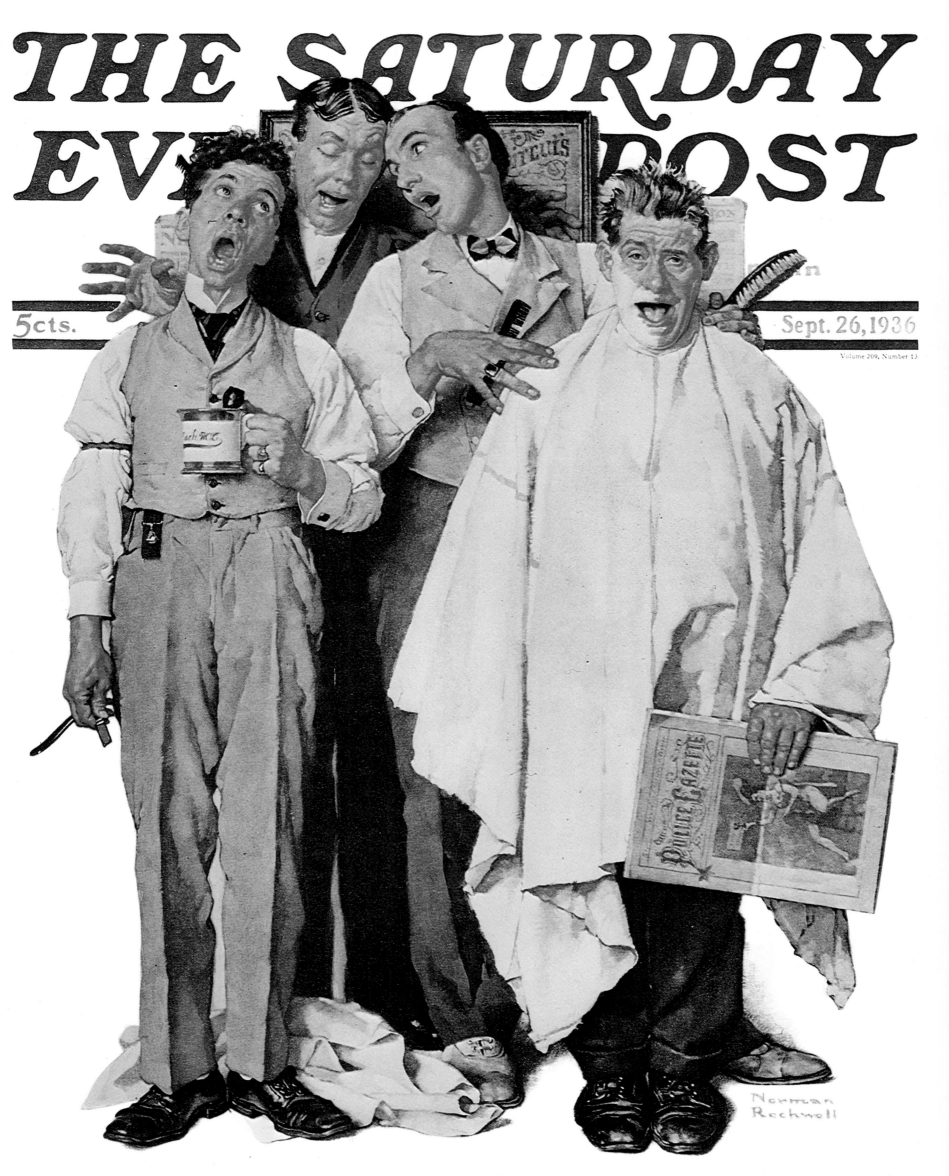

"The Nursemaid"

On the July 9, 1921, *Post* cover Rockwell painted a screaming little girl sitting on her brother's lap while waiting to get her picture taken. Although kids were a mainstay in his art through the years, infants were difficult to work with and he avoided them for fifteen years until this hysterical baby made the cover in 1936.

Here we see a perplexed nurse pondering the difficult dilemma of how to quiet her young charge after her milk bottle, lollipop, teddy bear, doll, and picture book have failed.

Following the publication of this cover, Rockwell wrote that he wondered how many people in the country hated him. On this October 24 cover his model was a very good-looking woman with a nice figure who turned out rather matronly in the painting.

THE SATURDAY EVENING POST

An Illus
Founded A°. D

OCTOBER 24, 1936

Volume 209, Number 17

5c. the Copy

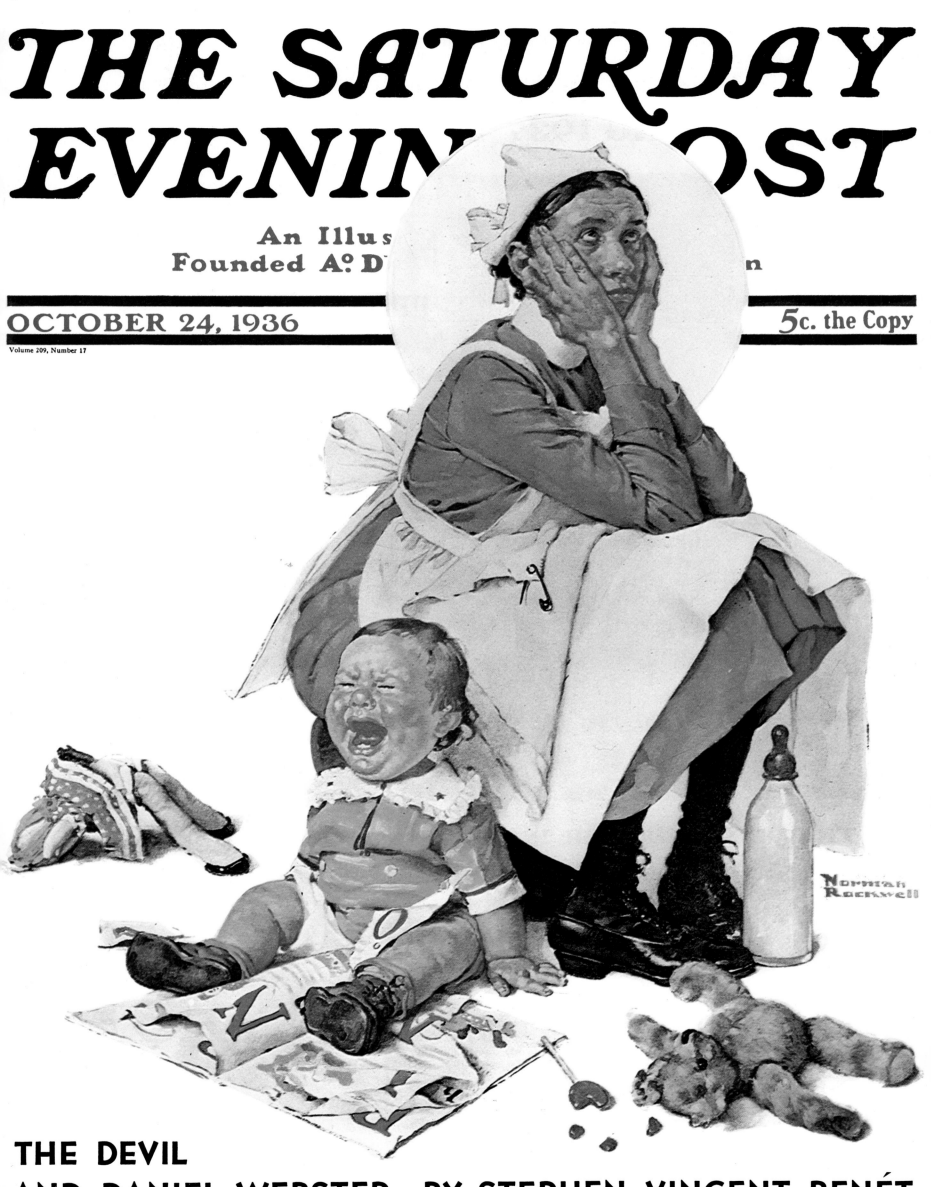

THE DEVIL
AND DANIEL WEBSTER—BY STEPHEN VINCENT BENÉT

"Eavesdropping"

With two simple park benches as props Mr. Rockwell takes us into the park, where a young couple in love are exchanging tender thoughts and disturbing the concentration of the elderly man trying to read his book. Of course he could take his little dog and move to another bench, but by the tiny smile on his lips we can see that truth is indeed more fascinating than fiction.

Rockwell was now turning out covers with more frequency and excellent content. He had more commissions than he could handle with other magazines and book editors and advertising agencies after him.

He was very happy and his family was growing. A third son, Peter, was born and ideas were plentiful.

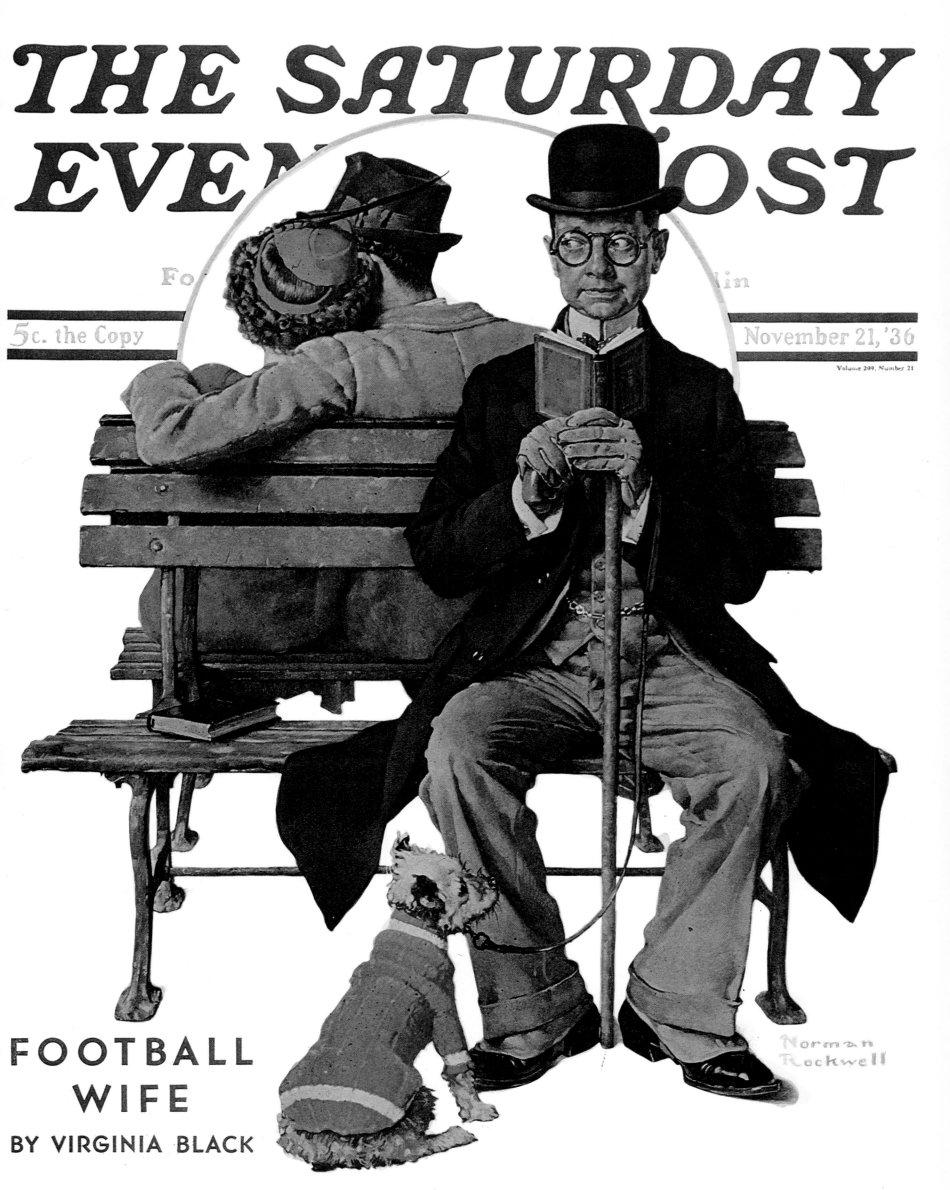

THE SATURDAY EVENING POST

5c. the Copy

November 21, '36

Volume 209, Number 21

FOOTBALL
WIFE
BY VIRGINIA BLACK

LIFER—BY CHARLES FRANCIS COE

"Under the Mistletoe"

The year 1936 was one of pleasant surprises and sad disappointments for Rockwell. Financial and artistic success abounded, his marriage was a happy one, and three beautiful sons occupied his free moments, but his work was shaken when George Horace Lorimer announced his forced retirement from the *Post* after 37 years. Lorimer was like a father to Rockwell and helped to guide both his career and his life. The new editor was Wesley Stout, who remained with the *Post* for five years and did not relate well with Rockwell. Mr. Lorimer died one year later and the news shook Norman severely.

But once again he was chosen to do the Christmas cover in 1936 and again he decided to go back in time and portray a musketeer stealing a kiss from a pretty lady under the mistletoe in a friendly tavern.

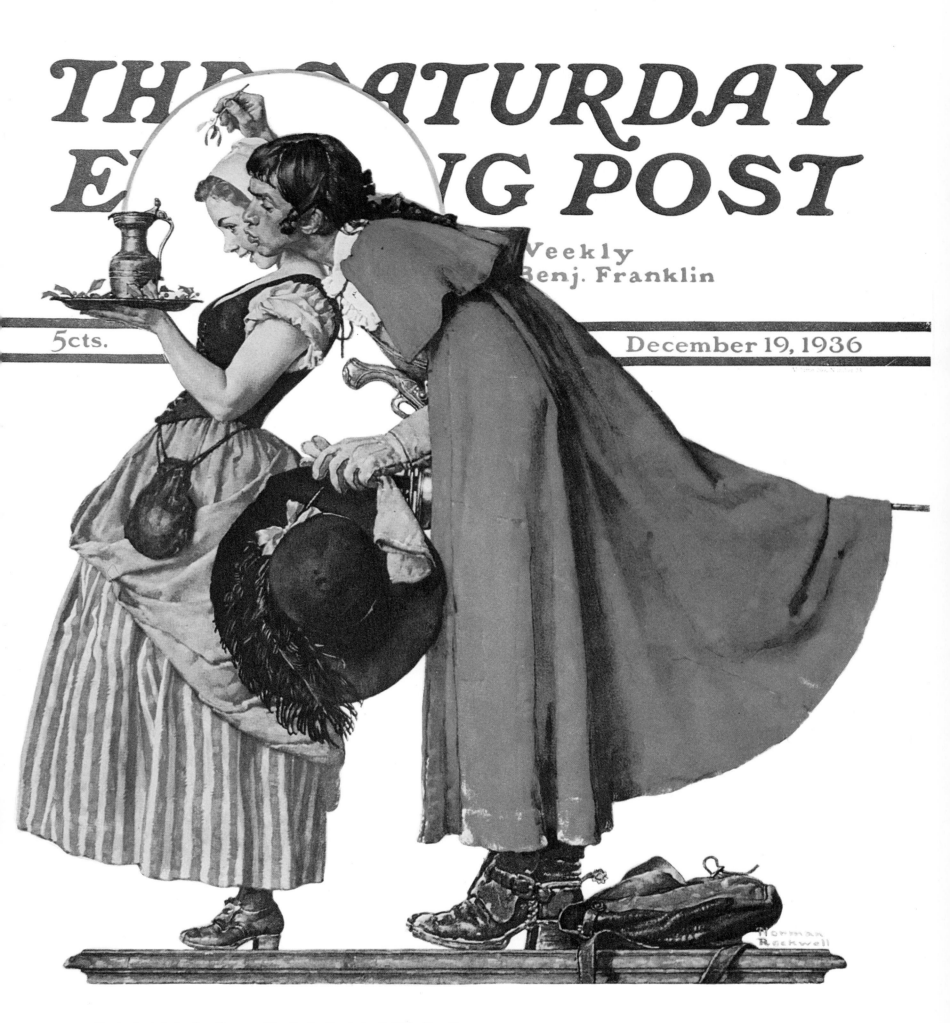

THE SATURDAY EVENING POST

Weekly
Benj. Franklin

5 cts. December 19, 1936

SWING BUSINESS • HENRY ANTON STEIG
TISH GOES TO JAIL • MARY ROBERTS RINEHART

"Missing the Dance"

A picture of discontent, but what young lady has not been grounded on the night of a big event because of a cold.

On this cover Rockwell's brush tells the story of a beautiful young lady with an obvious fever and nasal congestion, as attested to by the thermometer in the glass and the handkerchief. The bottle of medicine and nebulizer sit on her night stand, which apparently did not contain a potion magic enough to save the day.

With invitations strewn across the covers she glumly peruses the dance information and her red eyes and nose add to the sadness of the scene.

And somewhere is a handsome young man who is equally unhappy because his date has the flu.

THE SATURDAY EVENING POST

Fou

Jan. 23, 1937

Volume 209, Number 30

5 cts.

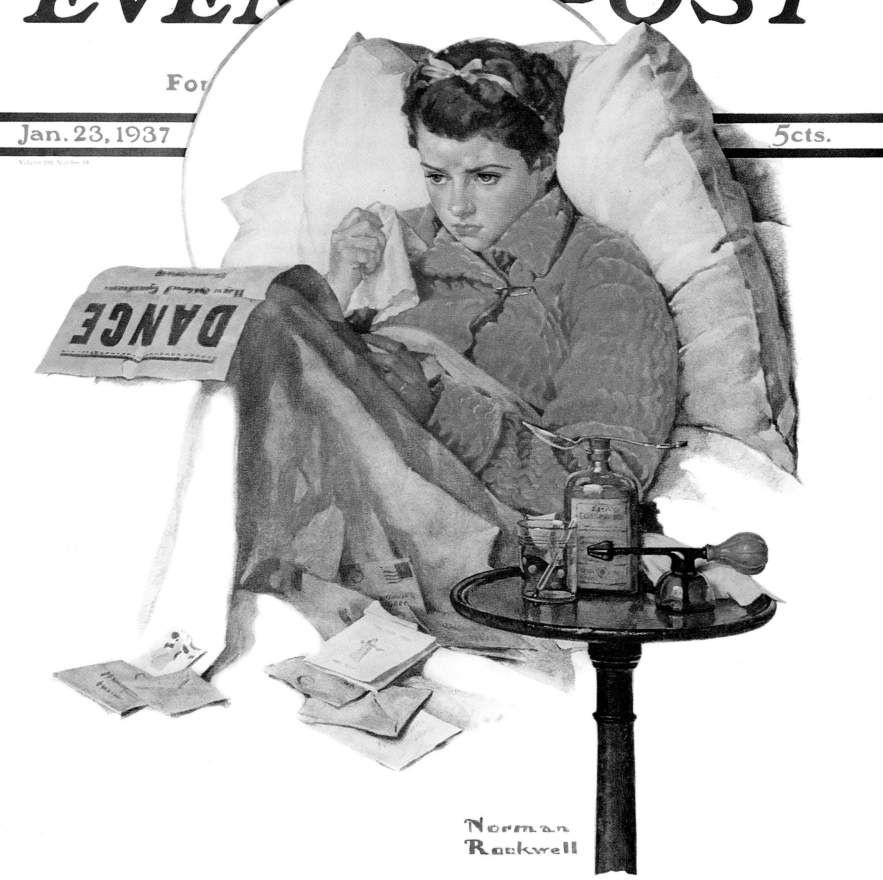

DANCE

Norman
Rockwell

BEGINNING **PADEREWSKI'S LIFE STORY**

"Ticket Agent"

When Rockwell had a magazine cover that required a special setting, he would go to the area and get the feel of the place. For *Tom Sawyer* he went to Hannibal, Missouri, for Louisa May Alcott's biography, he went to the Alcott house in Concord, Massachusetts, and for this picture he went to the local train station.

Here we see a tired and dejected ticket salesman who day after day sits behind bars like a prisoner while all around him are travel posters telling of exciting vacation spots around the world.

To add to the frustration of the scene is a little sign that says "Are you bored? Travel." And yet the farthest he travels is to his home after each monotonous day of tortuous timetables, tedious ticket sales, and tormenting travelers.

Dave Campion was chosen again for this picture because of his wonderfully expressive face, which could portray gloom as easily as excited happiness.

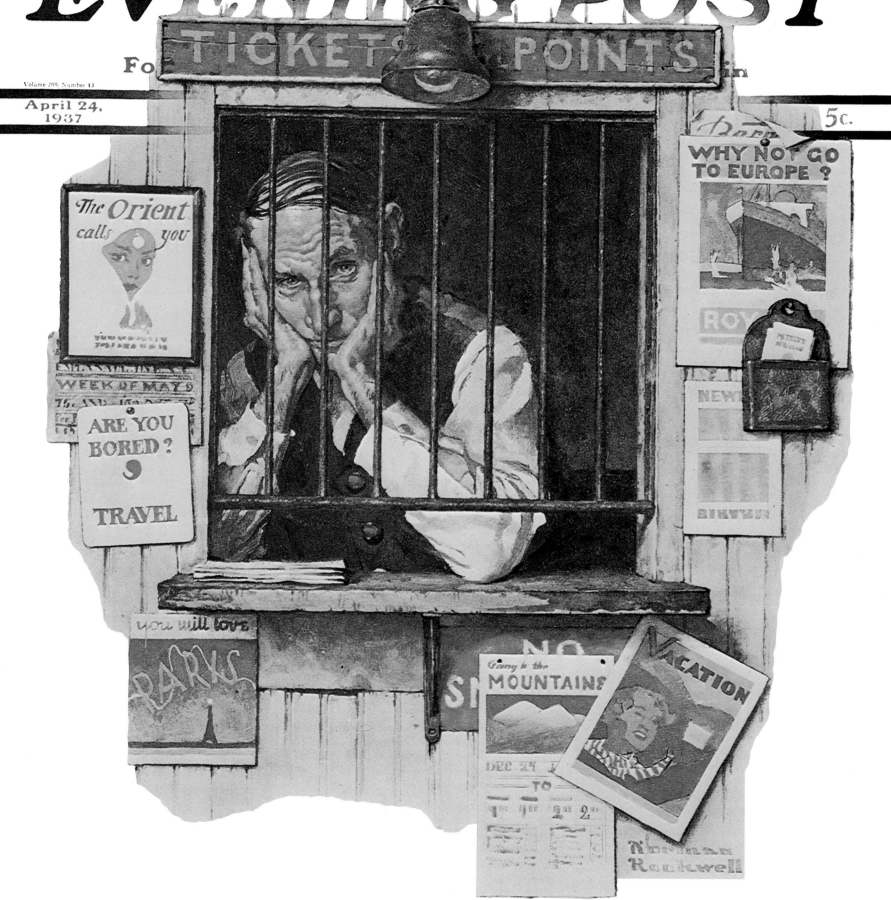

THE SATURDAY EVENING POST

Volume 209. Number 43

April 24, 1937

5c.

THE $47,000,000,000 BLIGHT—By SENATOR VANDENBERG

"The Gaiety Dance Team"

Dolores and Eddie are talented performers who have been on the road for as long as they can remember. Their old steamer trunk has seen openings in every town from New Rochelle to New York City and they thrive on applause and good reviews.

Then suddenly—flop. Vaudeville was beginning to die and motion pictures had top billing. *Variety,* the newspaper in Eddie's pocket, had nothing to offer and so they sit dejected and alone, with empty pocket and purse, pondering their future.

By 1937 only a few theaters such as Radio City Music Hall in New York City offered stage shows with their movies, and only a few dancers such as Fred Astaire and Ginger Rogers were lucky enough to get jobs in the movies.

Once again the genius of Norman Rockwell emerges as the faces of the performers tell the entire story.

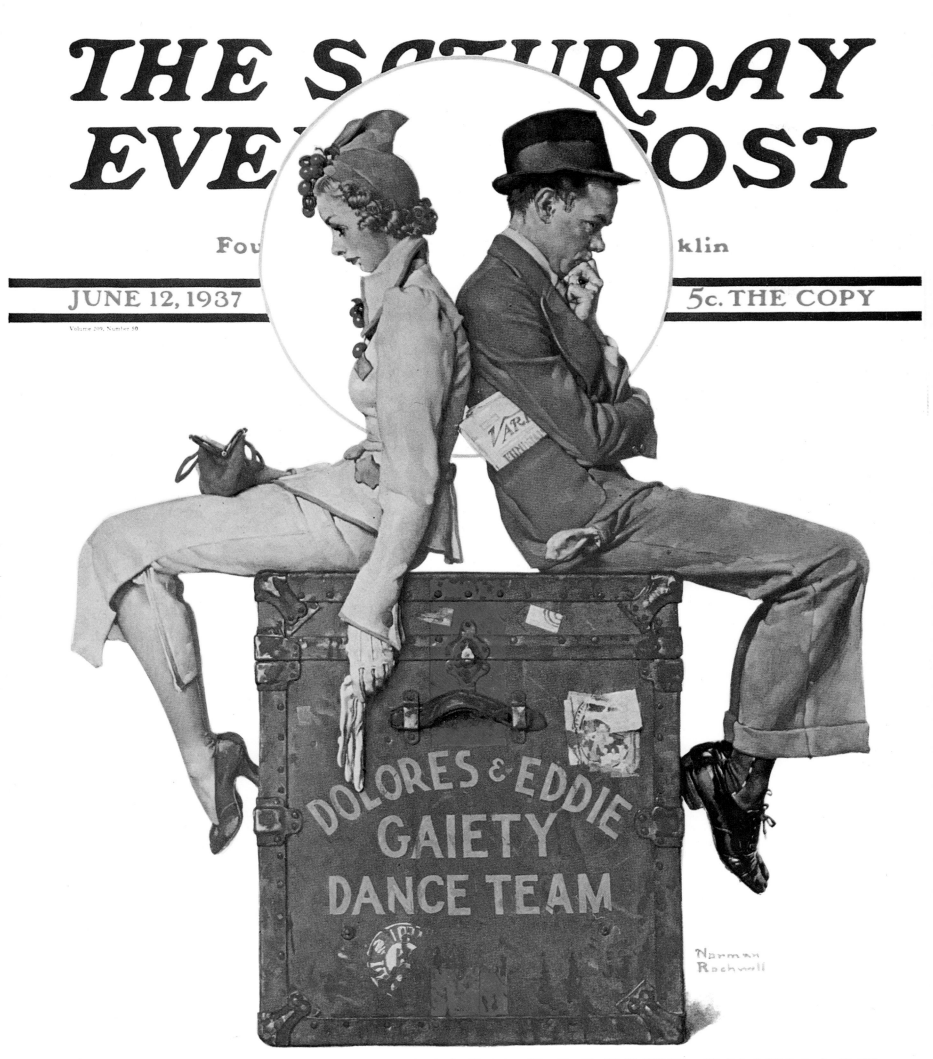

"Off to the Auction"

In 1926 the Rockefeller family began the restoration of Williamsburg, Virginia, to give Americans a taste of colonial times. Following this, many other restorations began to take shape—Mystic Seaport in Connecticut and Sturbridge Village in Massachusetts among them. Museums became extremely popular and when people began to pay admission to see relics that had been stored in their attics after having been passed down for generations, a new surge of buying and selling antiques began.

On this cover an enterprising woman is as proud as a peacock as she struts from the auction house with an armful of treasures from someone's attic.

Included in her find is a brass candlestick, a Grecian bust, a patch quilt, an artist's portfolio, an old clock, an oil portrait, a bedwarmer, a large cast-iron ladle, a portable stove, and a porcelain and brass vase. Each of her treasures has an auction tag on it and were probably purchased at a bargain price.

Once again Norman Rockwell's collection of props came in handy, or maybe some of this material was buried in his own attic.

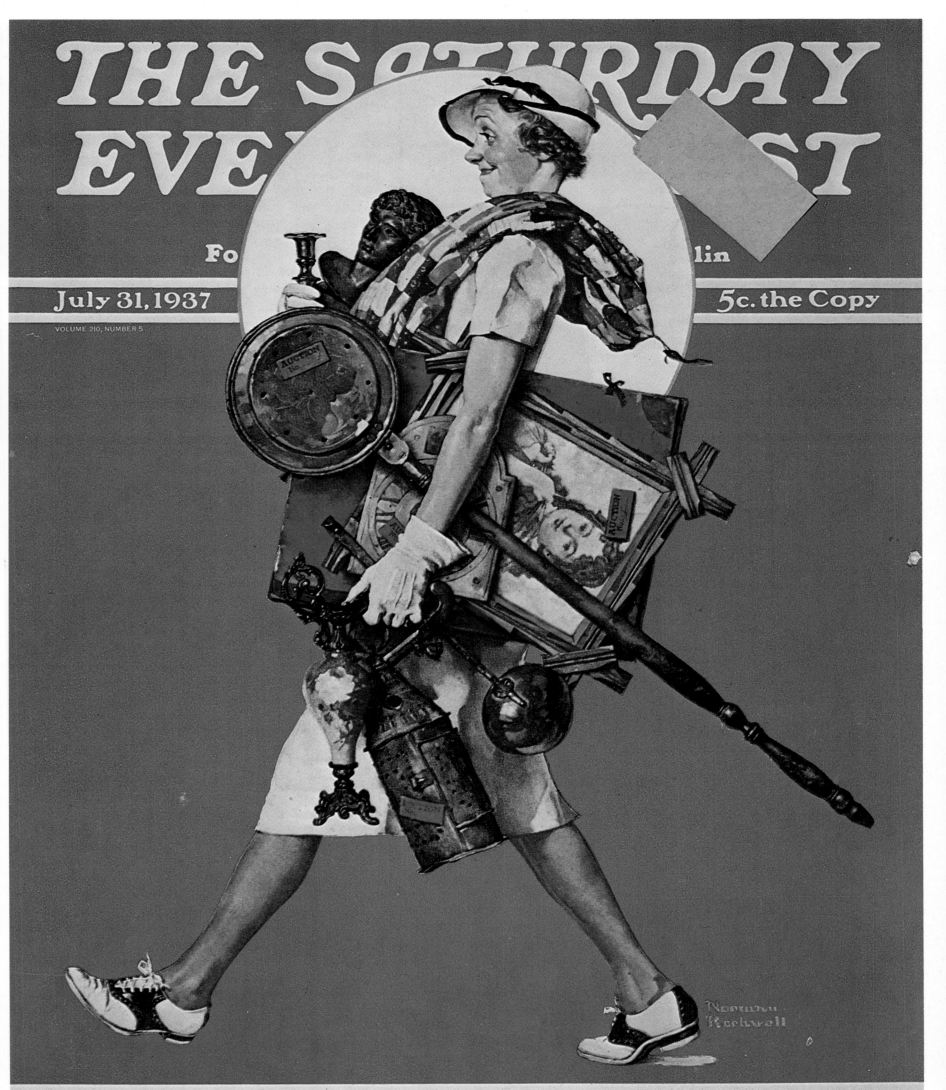

"Traffic Problems"

In his younger years Rockwell made a vow never to use photography in his work. But times were rapidly changing, as were styles and tastes in art. From the Midwest came an invasion of talented new illustrators, among them Al Parker, John Falter, and Steven Dohanos, who were challenging the established artists. These young fellows got impossible perspective because of their use of photography. They told Rockwell, "You don't drive a horse and buggy anymore. Why not use photographs?"

When Rockwell tried photography for the first time, he felt like a traitor to his profession. But he soon found that not only were his covers more interesting but the detail was greater and the models were less expensive and more available.

On this cover, as viewed from slightly above the action, we see a surprised and upset street painter who is watching his meticulous white line being carried away on the paws of two frisky passers-by. Obviously, the playful pets paid no heed to the red flags which were used to deter traffic.

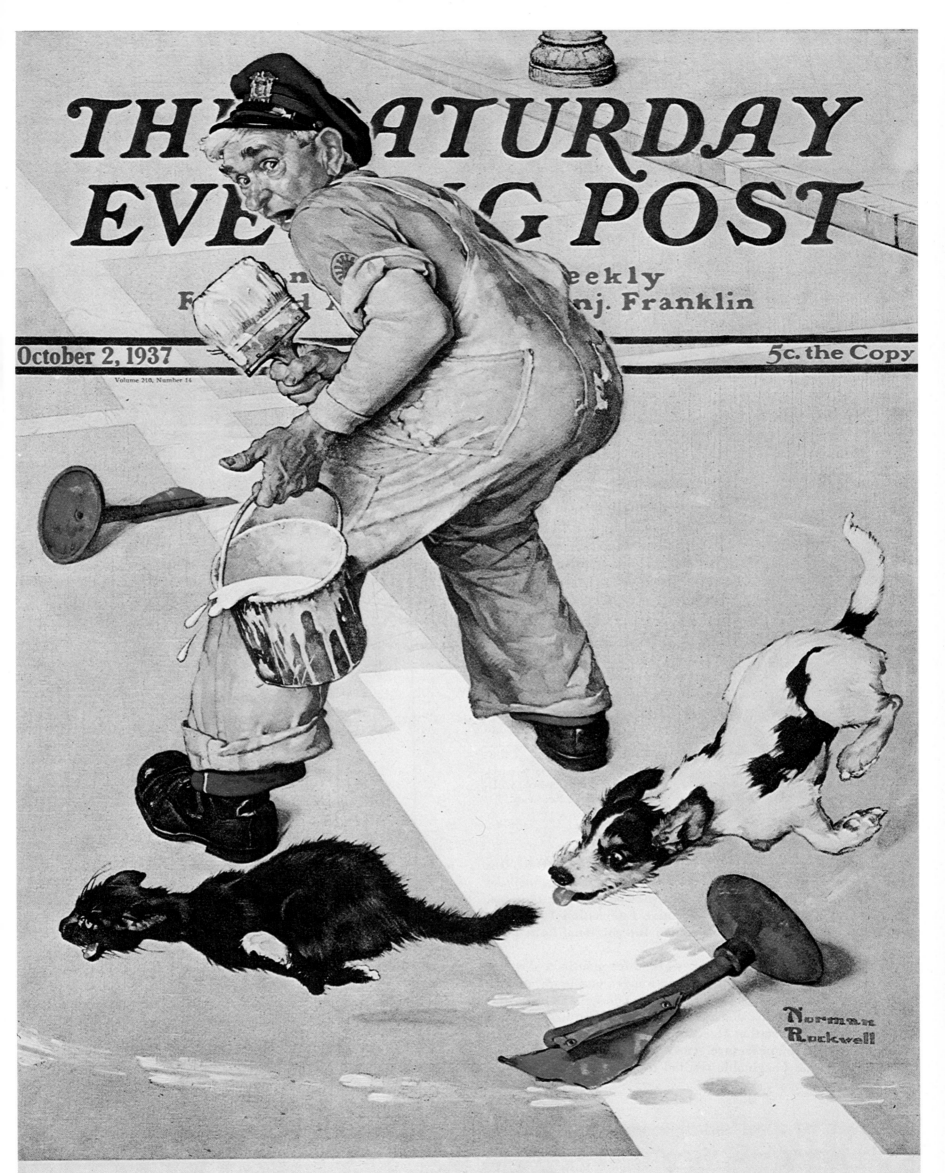

"Christmas Snow"

What a momentous cover! A classic Norman Rockwell picture coming out right on Christmas Day and the announcement that *The Saturday Evening Post* had reached another milestone: three million magazines circulated weekly.

Grandpa couldn't wait to get to his grandchildren with his recently purchased doll, drum, hobby horse, and other assorted packages, including a holly wreath, but unfortunately the newly fallen snow had covered an icy pavement and Gramps went head over heels into a snowdrift.

When Norman Rockwell moved to New Rochelle, New York, one of the reasons was to be near another famous *Post* artist, J. C. Leyendecker. Through the years he used several of Leyendecker's techniques and this cover is an example. Though only his head, hands, and legs show, we know that all of the old fellow is under there somewhere.

Rockwell chose Pop Fredericks again to pose for this cover because his round cheery face added the perfect touch of spice to the picture.

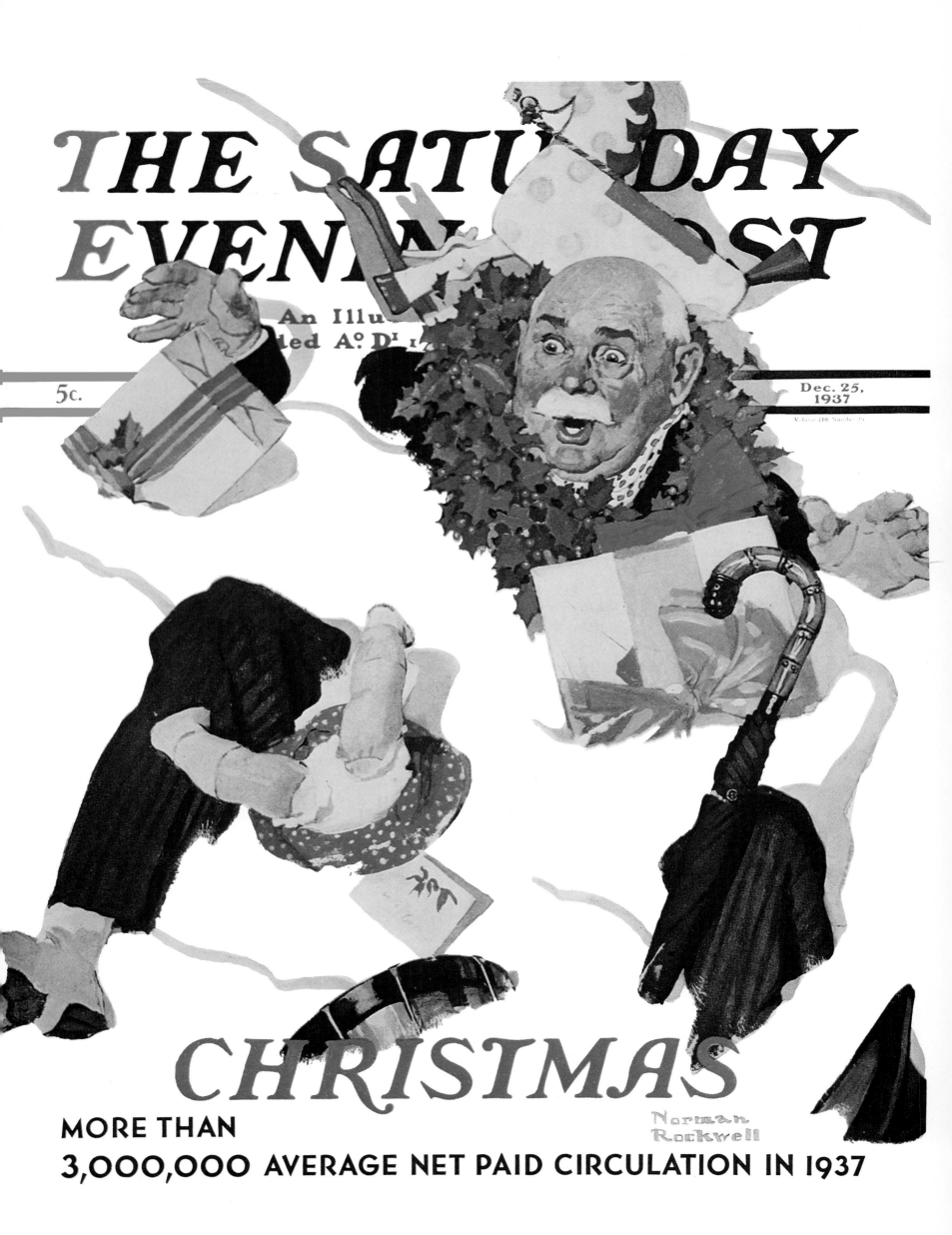

"Schoolgirl Crush"

The dormitory rules state that everyone must be in bed by ten o'clock and male companions are not allowed in the dormitory at any time. But there is nothing in the rules forbidding one long last look at a favorite movie star before the lights go out.

Here we see two dreamy students sitting in their pajamas on their dormitory bed, gazing at a photograph of Robert Taylor, the idol of millions of American women. Several other famous leading men are strewn across the bed and you can almost hear the sighs as the girls study the picture, and in the next few moments they might even steal a kiss.

About this time movie magazines were becoming very popular and girls everywhere spent their free hours trading photographs of movie stars and discussing their favorite pictures.

This is one of several Rockwell paintings that include portraits of famous people within the story of the painting. Abraham Lincoln appeared on February 19, 1927, and three movie actresses were on the cover for September 22, 1934. Franklin Roosevelt and Thomas Dewey appeared on November 4, 1944, Harry Truman and Tom Dewey again on the October 30, 1948, cover, and Jane Russell appeared in the famous "Girl at the Mirror" picture of March 6, 1954.

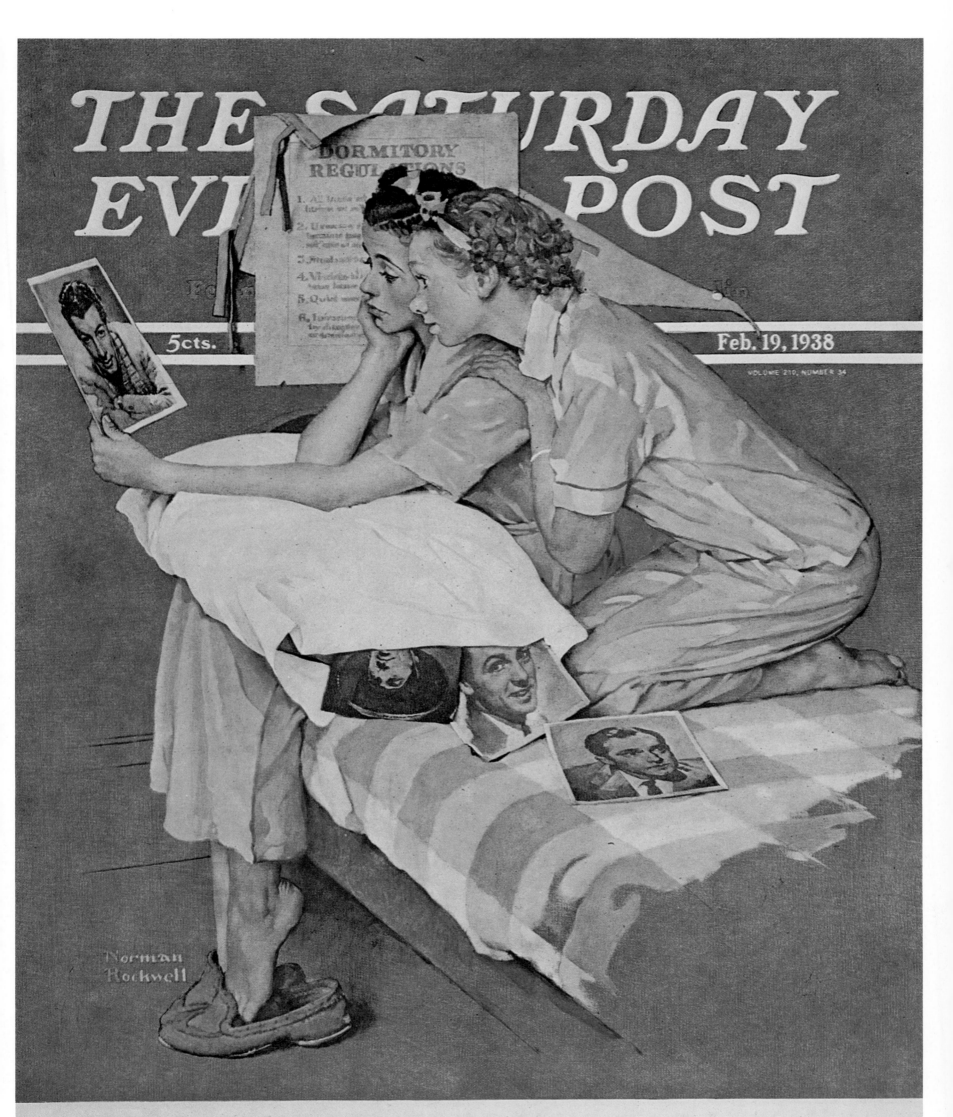

"See America First"

As time passed, Norman Rockwell began to feel justified in using photography in his art work. Besides the various angles and interesting detail that he could achieve, facial expressions with endless variations were available. Even with the best model a smile or a frown could be held for only so long before it would begin to fade and sag. But with a photo it was captured and could be adjusted if needed.

And what a wonderful facial expression was captured in this April 23, 1938, cover. An original American inhabitant who has lived his entire life within the borders of our land has just received a brochure in his mailbox. If he hasn't seen America first, who has?

In this year 1938, *Judge* magazine gave its High Hat Award to Norman Rockwell "for becoming a tradition in art while still a young man." He was to receive countless rewards as the years went on—the most prestigious one being the Presidential Medal given by President Gerald Ford in 1976.

THE SATURDAY EVENING POST

An Illustrated Weekly
Founded A°D° 1728 by Benj. Franklin

APRIL 23, 1938

Volume 210, Number 43

5c. the Copy

BEGINNING

LITTLE DOC—THE STORY OF DR. DAFOE

"Maiden Voyage"

Skyways Airlines has a very special passenger today. Grandmom is taking her first flight. A friendly stewardess has given her a map and a red pencil so that she can chart her course from the northwestern part of the United States clear across the country. And although the back of her seat is in a reclining position, Granny is anything but relaxed, and she sits erect to gaze at the wild blue yonder.

With her suitcase on her lap and her coat on the armrest our traveler is even afraid to take off her hat as she sits somewhat anxiously with her hands clenched and somewhat smiling as she anticipates her excited family waiting at the airport.

By this time Rockwell was a seasoned traveler and flying was not a new experience to him, but he always shared the anxiety and excitement of the lady on this *Post* cover.

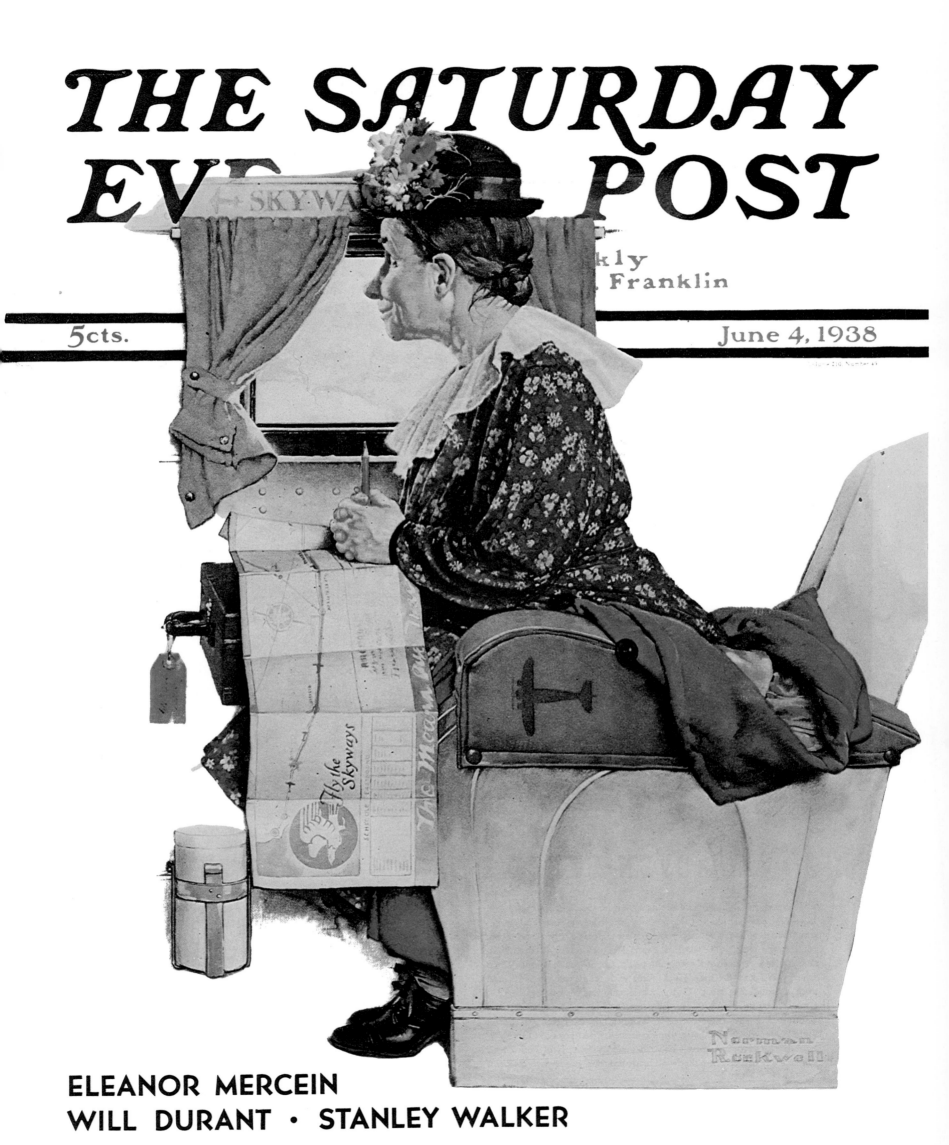

"Drawing a Blank"

In the summer of 1938 Rockwell got restless again. The studio seemed musty, Mr. Lorimer was gone, his old models Van Brunt, Harry Seal, Wilson, and Van Vechten had either died or disappeared, and as seen in this picture new ideas were difficult. His well was running dry and it was time for a change.

He and Mary decided to travel to England. So they packed up Jerry, Tom, and Peter and sailed for Europe. The trip was enjoyable but did not cure his restlessness or solve his problems. Something else was needed.

On this cover he vented his frustrations as he sat in front of a blank canvas staring at the ever-present *Post* logo and stealing glances at the pocket watch ticking seconds toward the cover deadline. He has plowed through his files and old sketches waiting for a bulb to light above him, but his head continues to remain as blank as the canvas and even a good luck horseshoe doesn't seem to be the answer.

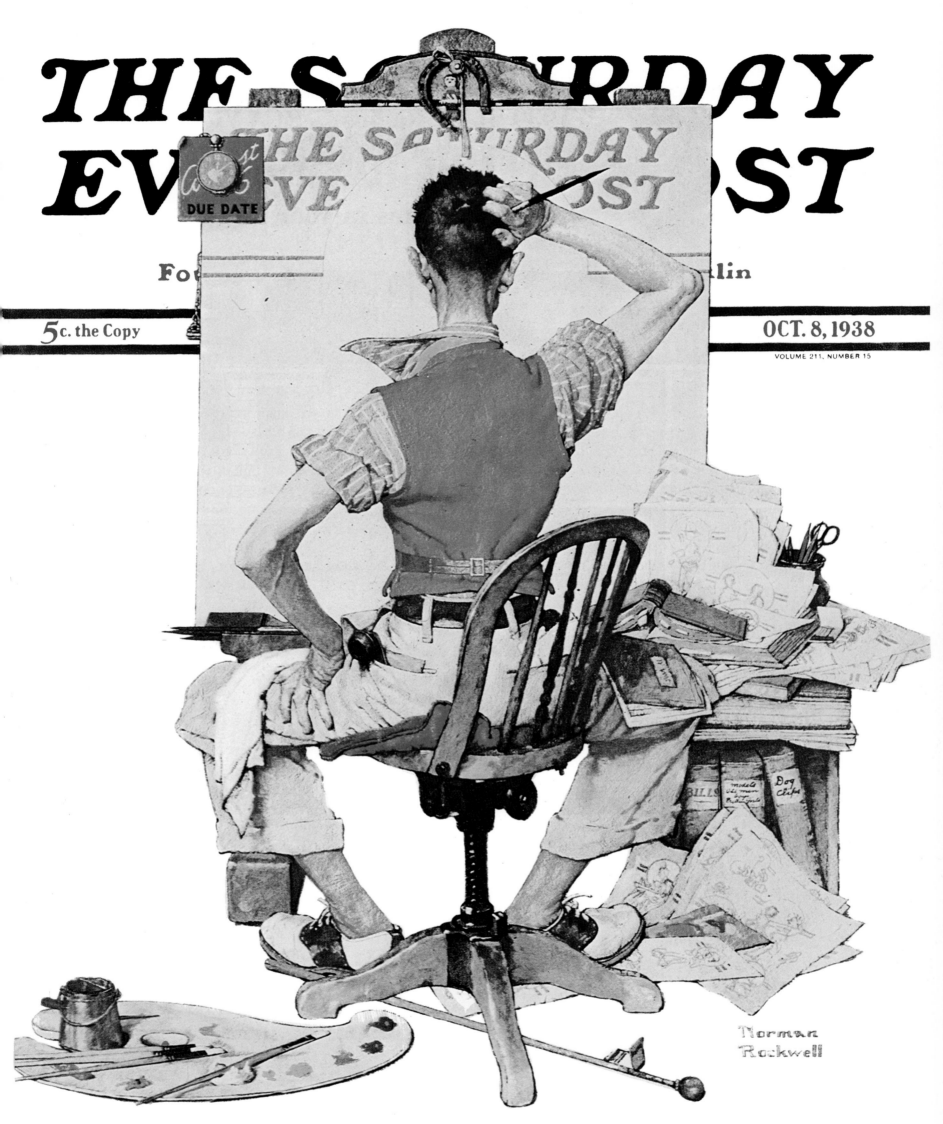

"The Football Hero"

Although Rockwell never actively participated in the sporting life, either because he was too frail or too busy, he was extremely sports-minded, and his paintings reflected his love and admiration of athletic endeavor. From his third *Post* cover of August 15, 1916, which took us to a family baseball game, he has painted pictures about golf (September 20, 1919), ice skating (February 7, 1920), swimming (June 4, 1921), football (November 21, 1925), fishing (August 3, 1929, and July 19, 1930), croquet (September 5, 1931), hunting (November 16, 1935), and our saintly football player. Following this cover he touched on baseball, football, basketball, skiing, and marble shooting in future covers, but by far baseball appears to be his favorite sport.

Today several original Rockwell paintings hang in the Baseball Hall of Fame in Cooperstown, New York.

Rockwell admired athletes from the time he was very young. He said that "boys who are athletes have an identity—a recognized place among other boys. I didn't have that—all I could do was draw!"

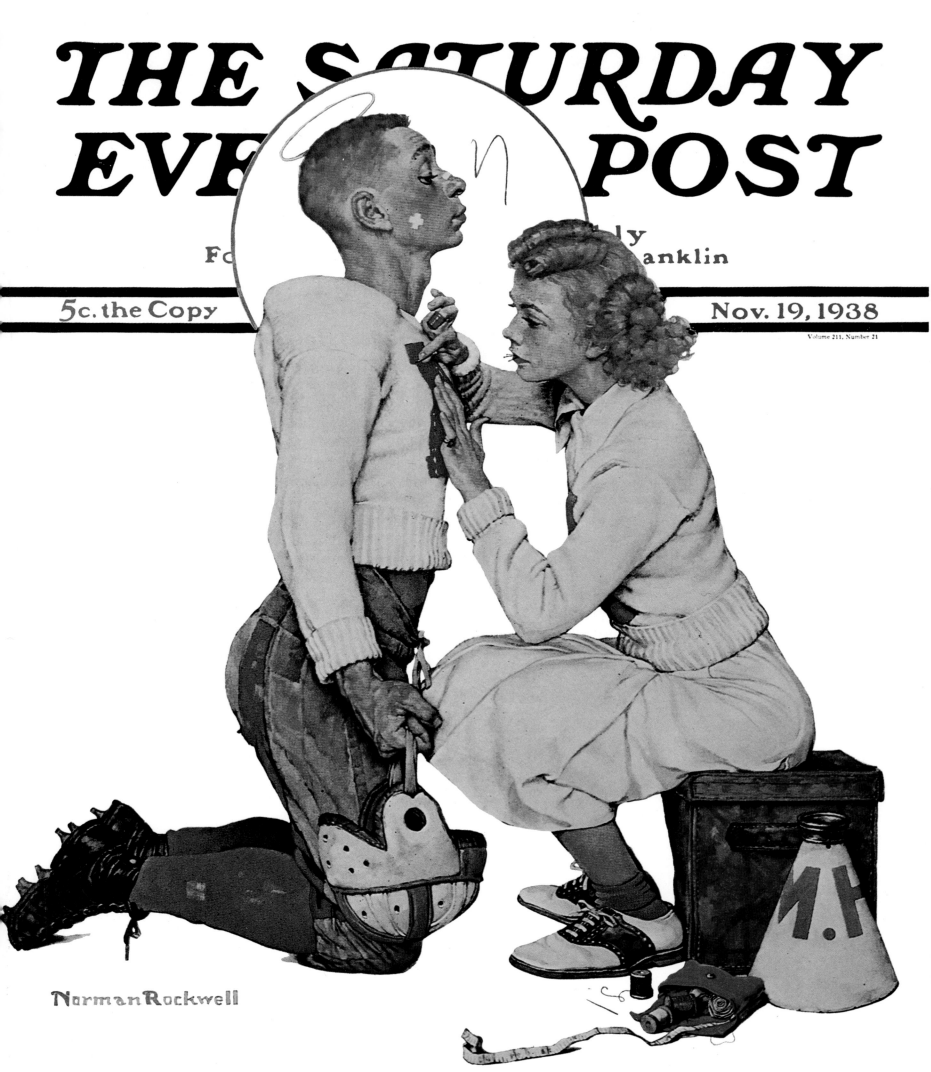

THE SATURDAY EVENING POST

5c. the Copy

Nov. 19, 1938

Volume 211, Number 21

Norman Rockwell

BEGINNING **EASY TO KILL**—By AGATHA CHRISTIE

"The Muggleton Stage Coach"

Week after week, month after month, and year after year Norman Rockwell and his talented associates at the *Post* came up with new ideas or unique variations of old ideas. The public took them for granted, but for the artist each new creation was a monumental challenge.

Christmas covers were an even greater challenge to Norman Rockwell, because he had the honor of doing so many of them.

There was a time when Christmas without a Rockwell cover on the *Post* was like Christmas without a tree.

This plump 18th-century Englishman with his traveling clothes in his satchel and his umbrella and walking stick over his arm is waiting for the coach to bring home the victuals for the Christmas feast. It is obvious that Rockwell did much research into the apparel of the day from the high-button vest to the low-button boots.

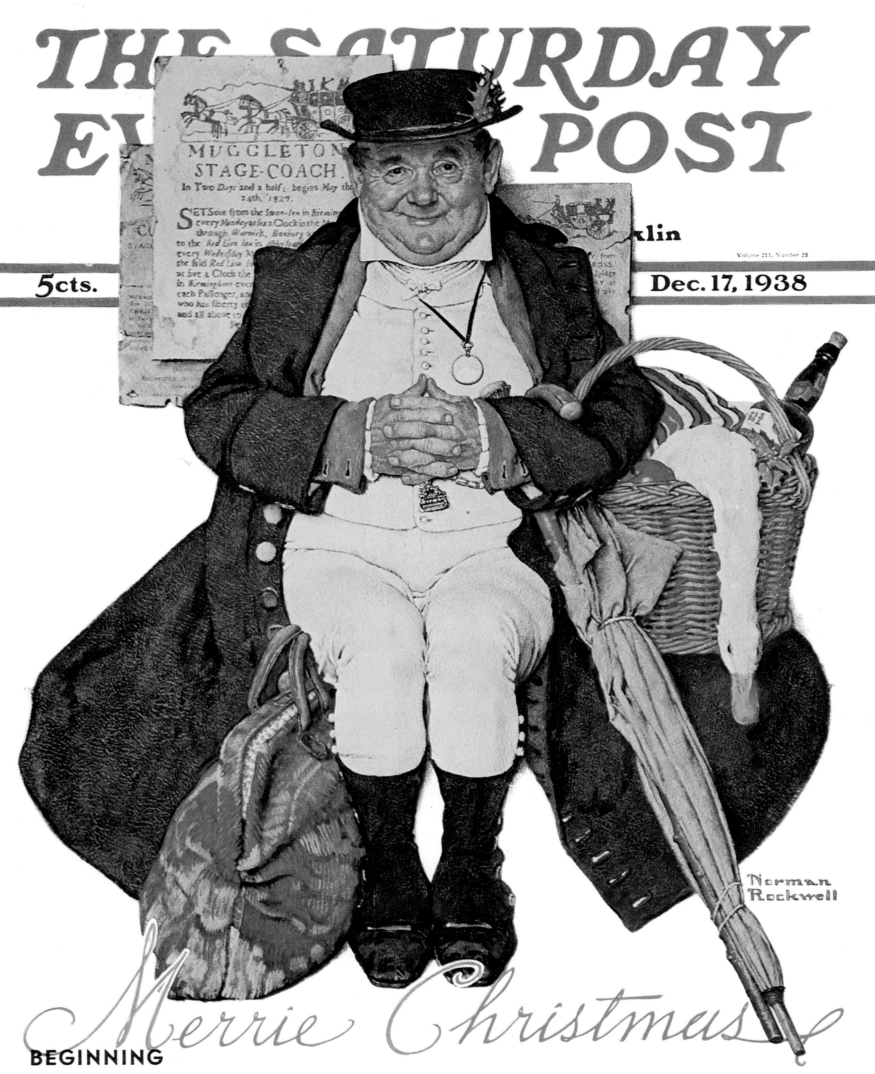

"The Court Jester"

Most of the early covers that Rockwell painted for *The Saturday Evening Post,* particularly the humorous ones, depicted a single simple situation that involved one emotion. Later he felt that if two emotions were elicited simultaneously, such as a smile with a bit of a frown or a giggle with a tear, the picture had even greater value. He pointed out that Charles Dickens and William Shakespeare used this principle often by playing comedy against tragedy. "And," he added, "they were two pretty good men."

This is why he thought that pictures of children were so popular. Not only were they funny and cute, but also nostalgic and bittersweet.

In this colorful February 1939 cover the emotions are far from subtle as a sorrowful, pouting court jester gazes at his mirror image, who is happy and laughing in the miniature.

But only the genius of Rockwell can turn things around in that the jester is so comical in his expression that his sadness makes us all laugh, reminiscent of the famous little sad clown Emmett Kelly.

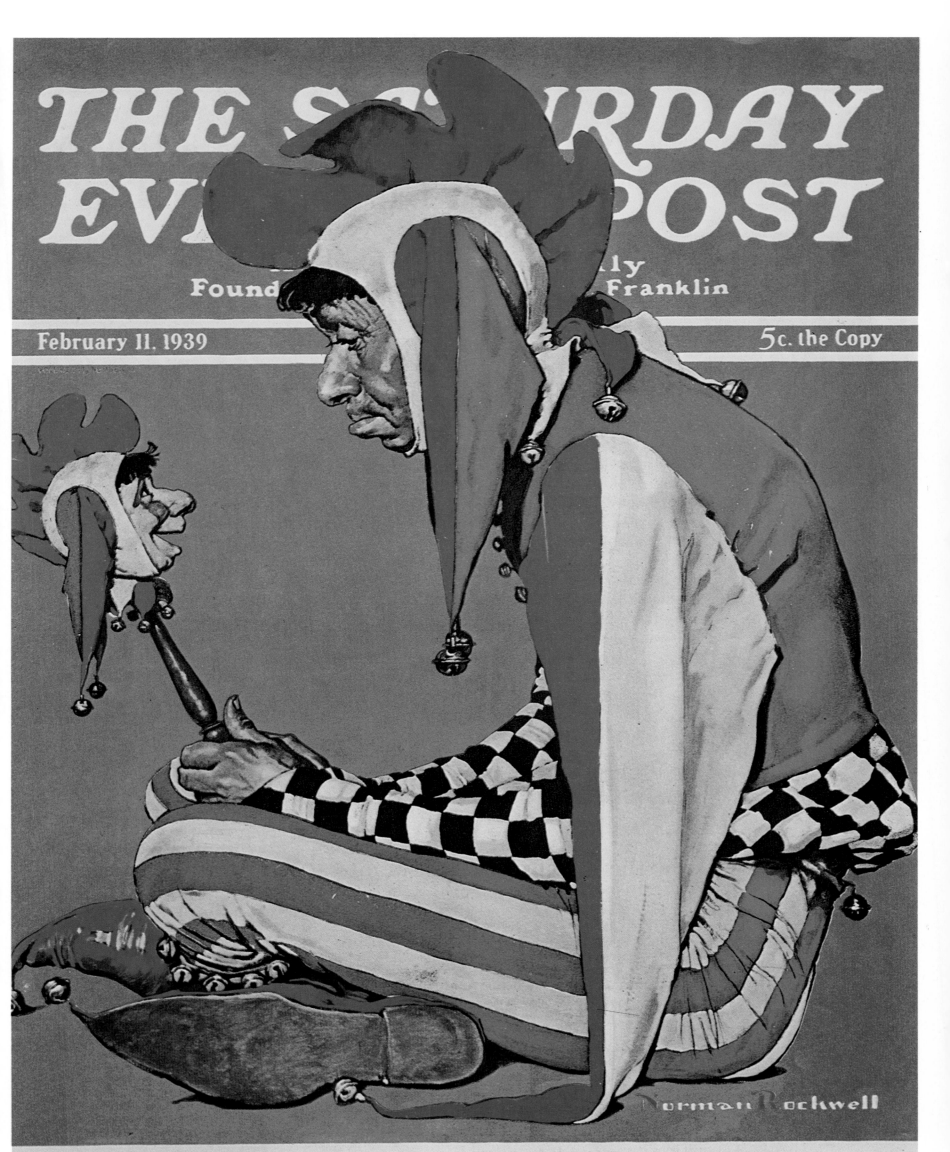

"The Pharmacist"

Norman Rockwell has often been called a workaholic, a man obsessed with being a professional in his chosen endeavor and stopping at nothing in his quest for perfection. In doing so he admired other professionals whether they be doctors, teachers, athletes, or sign pole painters. It has been said that he touched almost every occupation in his work and he made people proud when they identified with one of his pictures and found themselves on the cover of a *Saturday Evening Post*.

On this cover he has depicted a beloved neighborhood druggist, a man who was always there for medical advice when the doctor was away or for minor remedies when the ailment wasn't serious. From morning until night the apothecary light was on as various ointments, liniments, tonics, syrups, and pills were being formulated.

And here we see a young boy with a bad head cold curiously watching a mysterious concoction being created and wondering what it will taste like.

With his trusted pharmacopoeia on his table and his mortar and pestle marking the page, the tired old scientist shows us that his hand is still as steady as his mind as he carefully prepares the elixir.

James K. Van Brunt was the intent druggist for the picture and his diploma on the wall is displayed proudly, showing that he is indeed a professional.

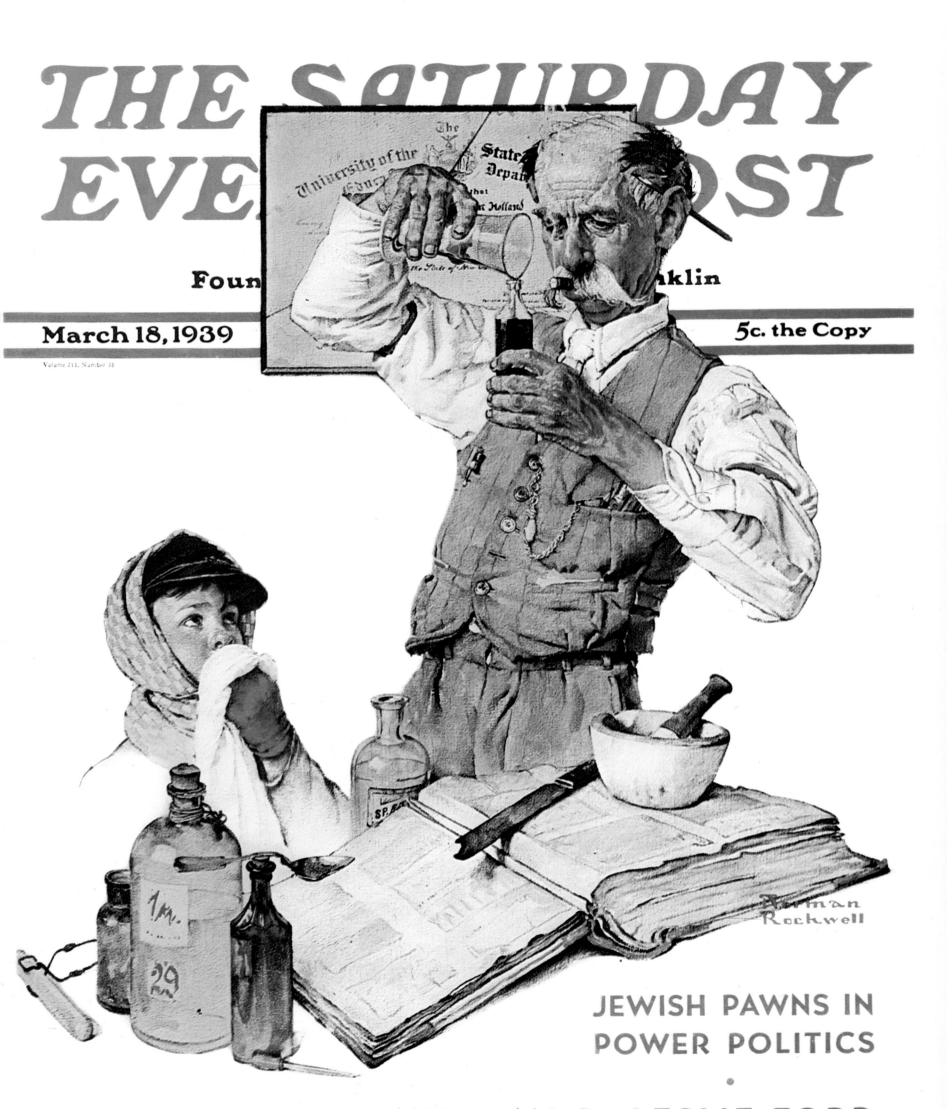

"Sport"

In the fall of 1938 Mary and Norman began to think of relocating in a more rural area. They headed north, following Route 7 into Vermont. When they reached the small town of Arlington, Vermont, Norman began to look around and talk to some of the townsfolk. He quickly realized that the people seemed to look like the people in his pictures. The more he listened and looked, the more fascinated he became. They decided that a summer vacation spot would stimulate his mind and he purchased an old farmhouse on sixty acres of meadow with an apple orchard and a famous trout stream known as the "Batten Kill."

The following spring he invited Mead Schaeffer, the famous *Post* illustrator, and Fred Hildebrand, a friend and model, to drive up with him for some fishing. Never much of a fisherman, Rockwell did manage to bait Schaeffer into moving up to Arlington with him and the two became closer than ever.

In this humorous cover Rockwell left out his deepest feelings about fishing as we see a dyed-in-the-wool angler sitting in the pouring rain with the water running off his hat and coat into his pail of worms and his already listing boat.

He is either waiting for the rain to stop or just one fish to bite, but instead he might catch a whale of a cold.

This was the first cover on which Rockwell deviated from his usual signature and signed his name in script.

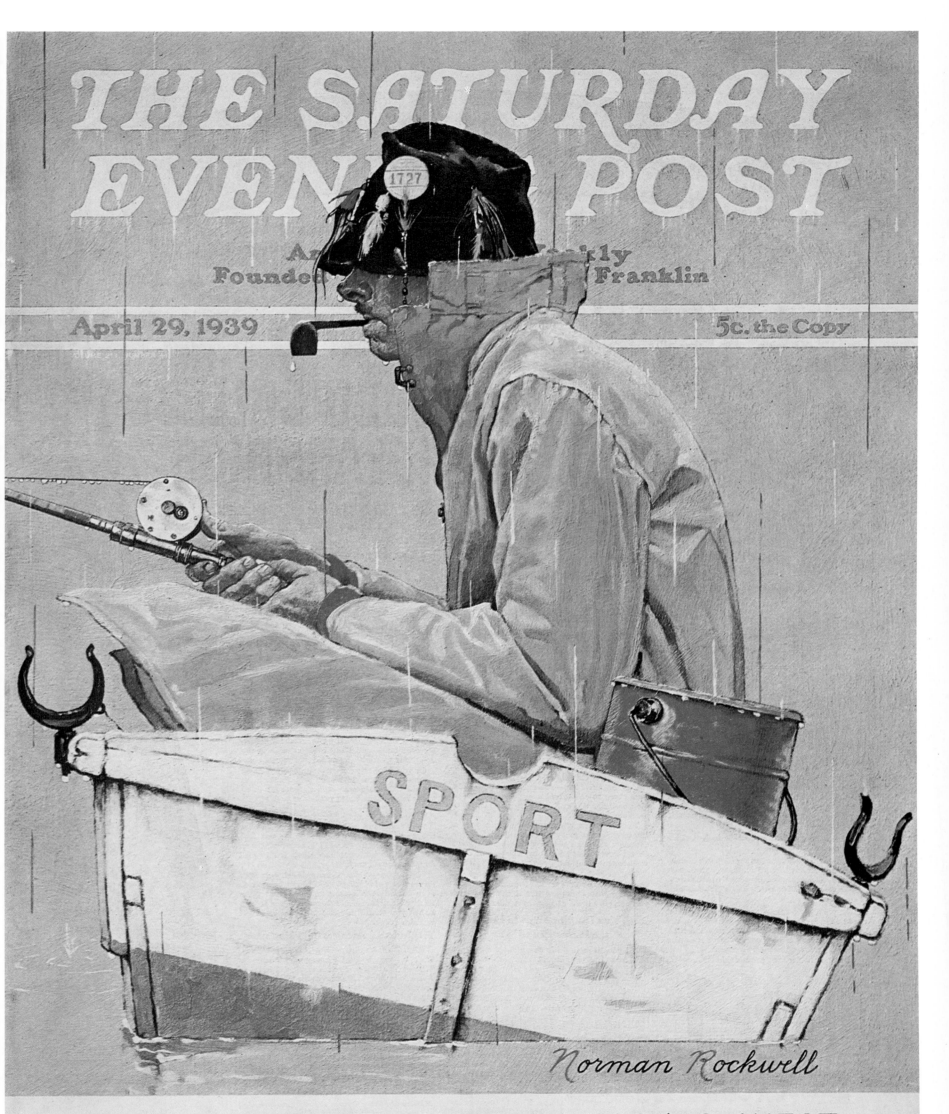

"The 100th Year of Baseball"

In 1839 Abner Doubleday laid out a diamond-shaped field with four bases sixty feet apart in Cooperstown, New York, and created a game called baseball. The game became immensely popular and was soon called the American pastime. One hundred years later the National Baseball Museum and Hall of Fame opened in Cooperstown and it has become an American landmark.

The Saturday Evening Post joined the celebration commemorating the great event and chose their premier artist to honor it with a cover.

Using costumes depicting an earlier time when the umpire ruled from behind the pitcher, Rockwell created this fanciful masterpiece, which is one of several on display in the Baseball Museum.

He again signed his name in script, using a fancier calligraphy.

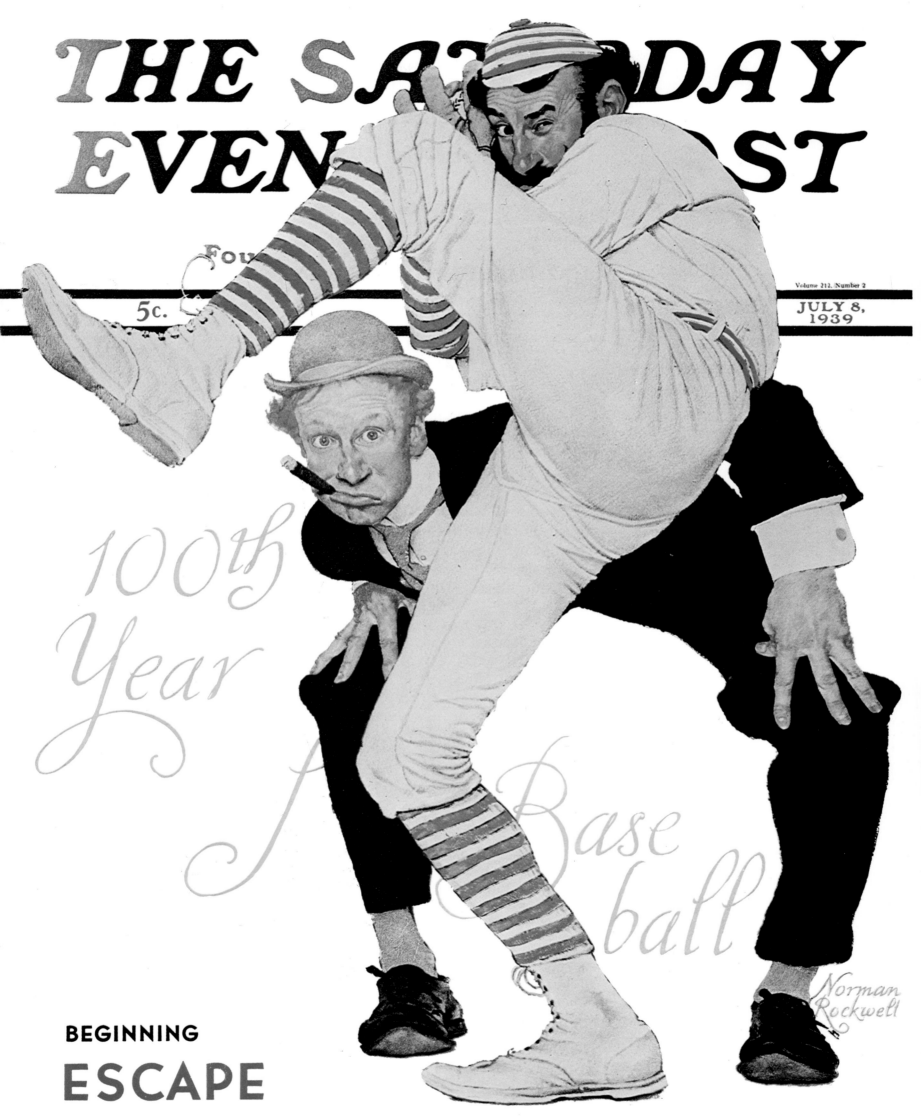

"Summer Stock"

The Rockwells adored their first vacation summer in Vermont. New scenery, new models, new experiences, and plenty of room to work were like an awakening for the artist. The boys loved romping through the meadows and fishing and swimming in the Batten Kill.

Mary and Norman found time to socialize with new friends, become interested in local activities, and go to barn dances and summer stock shows.

This lovely actress is putting on the final last-minute touches before she emerges as the heroine in an Elizabethan play. Her dressing room is the back stage of a barn, her dressing table a battered wooden crate, and her wardrobe assistants a couple of local barnyard residents.

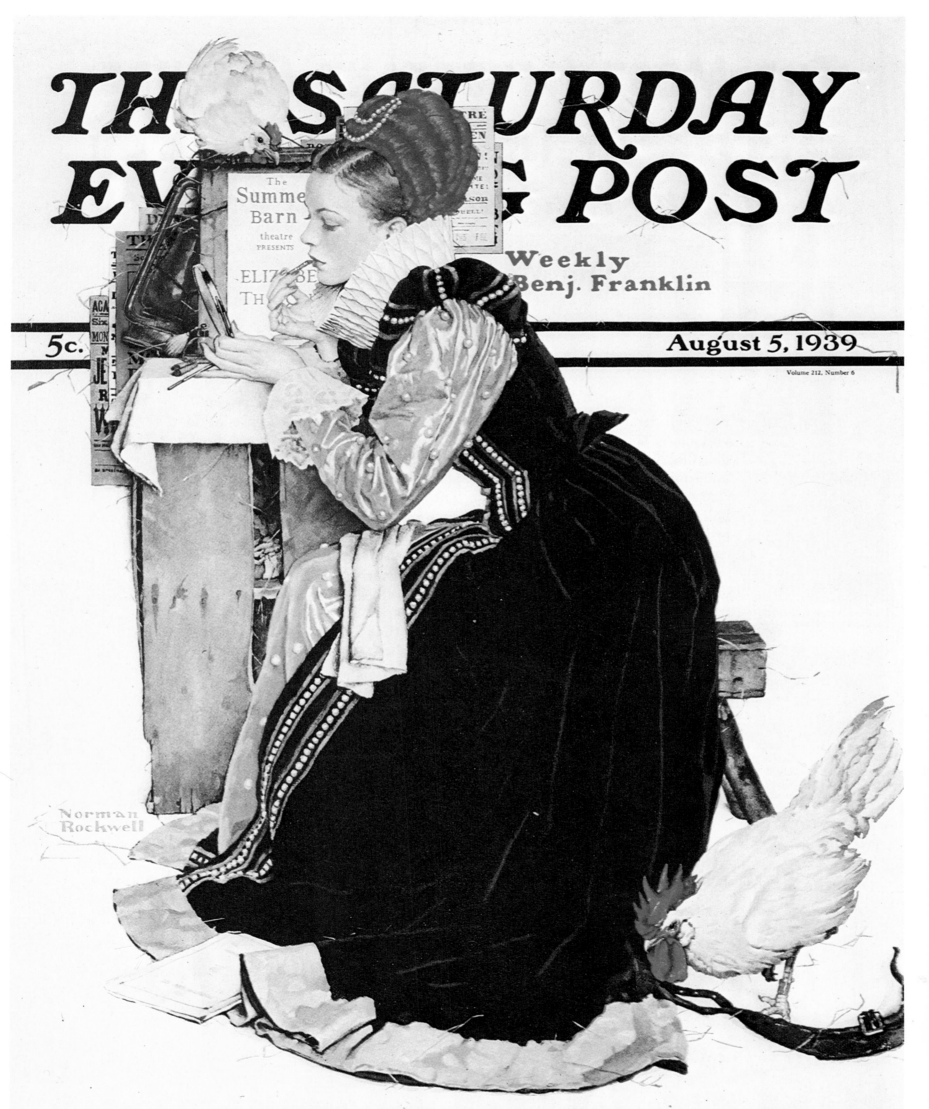

"The Marbles Champ"

Arlington, Vermont, was utopia for Rockwell. He said it was what he used to dream about when he was a kid playing on the vacant lots of Amsterdam Avenue in New York City. Each morning he took long walks through the apple orchard, watched the rabbits and squirrels and an occasional deer, and picked flowers and blueberries.

And he loved to watch the kids. They were forever swimming, playing ball, climbing trees, and frequently pitching hay. Seeing children at play brought many ideas to mind for pictures and this *Saturday Evening Post* cover of September 2 was the first he painted after moving to Arlington.

On this cover, a sharpshooting young lady with a full bag of marbles and then some is knuckles down as she is about to clean out her disgruntled friends.

The girls of America loved this cover and the boys were probably saying that they let her win.

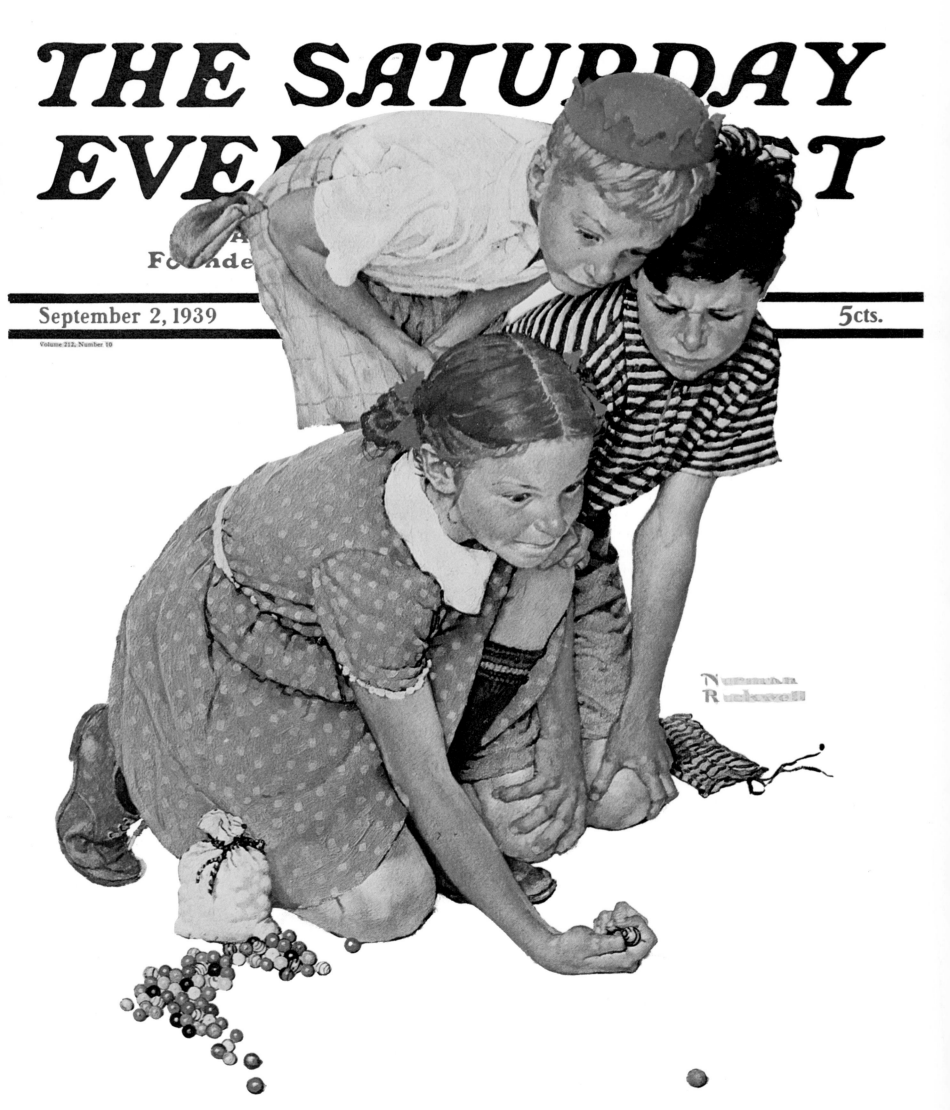

THE SATURDAY EVENING POST

Foonde

September 2, 1939

5cts.

Volume 212, Number 10

Norman Rockwell

COMMUNIST WRECKERS IN AMERICAN LABOR

"Music Hath Charms"

An early acquaintance of Rockwell's in Arlington was a local under-sheriff named Harvey McKee. He described him in his autobiography as "a small, soft-spoken man with white unruly hair and a black drooping, handlebar mustache. But his size and manner belied his spirit. Some of the tales he told of jailing drunks and rowdies were hair raising." After Rockwell studied him for a while and listened to his stories, he got an idea for a *Post* cover.

Here we see Harvey, the sheriff, sitting outside a jail cell, tearfully listening to a prisoner playing a harmonica. With his faithful dog at his feet and his trusty rifle in his arms, Harvey's thoughts are somewhere "home on the range."

A few days after Harvey McKee agreed to pose for this picture, he showed up at the Rockwell studio with a broken collarbone and a badly swollen left hand. He told Norman that he was beaten up by two ruffians while attempting to rescue a girl in a deserted shack.

Rockwell asked Harvey if he wanted to postpone the sitting, but he didn't and Rockwell painted the solemn lawman swollen hand and all.

The ruffians were arrested by a posse shortly after the incident.

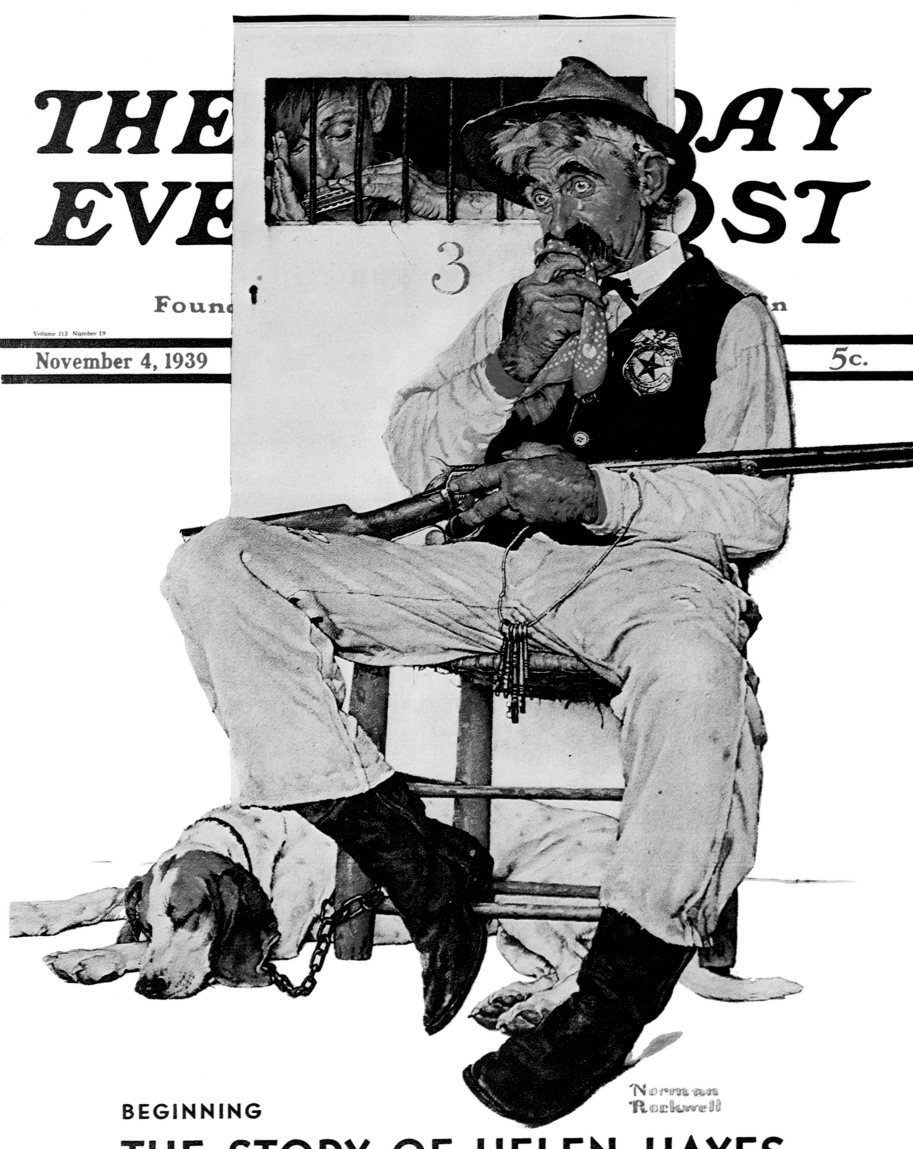

THE SA...DAY EV...OST

Founded...

Volume 212. Number 19

November 4, 1939

5c.

3

Norman Rockwell

BEGINNING
THE STORY OF HELEN HAYES

"Extra Good Boys and Girls"

The first winter in Vermont was unique for the Rockwells. The heavy snows and bitter cold of the Green Mountains were quite different from the wet, dingy days in the city. And Christmas seemed like Christmas should be. There was always snow and the countryside was beautiful. The neighbors were warm and friendly and there was happiness and contentment in the Rockwell home.

Now, with Jerry—eight, Tom—six, and Peter—three, the holiday was taking on more meaning and excitement. Santa Claus was coming and extra good boys and girls were going to get whatever they wanted.

Here we see the jolly man sitting in front of a great map of the world carefully placing little red flags along a red ribbon, which are his major stops along the way.

Although the town of Arlington, Vermont, is blocked by the plump fellow, we are sure that it is one of his most important destinations.

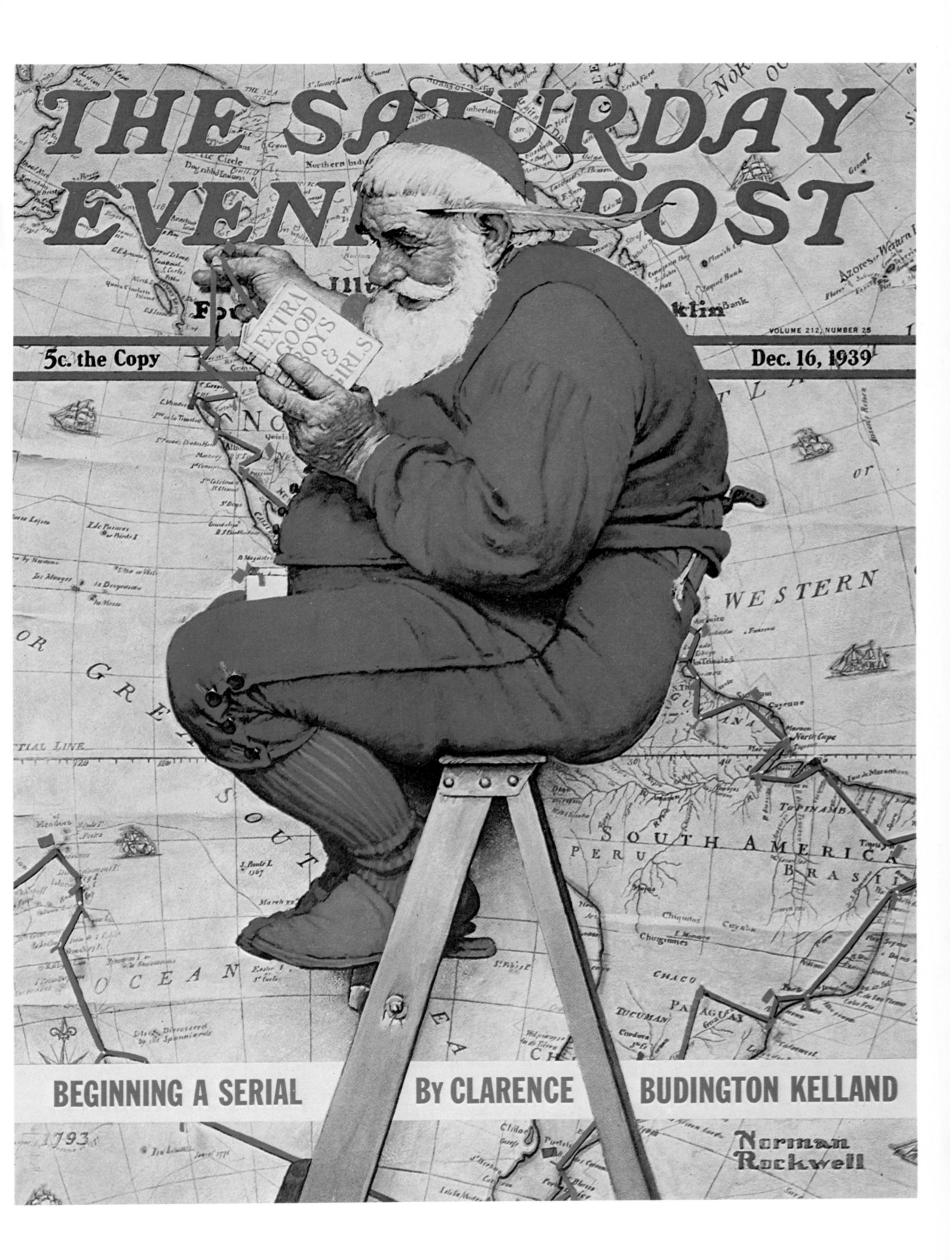

"The Decorator"

Although Arlington, Vermont, was a tiny mountain village with a population of about five hundred people, the Rockwells didn't live in rural discomfort. Following the first cold winter, the farmhouse was expanded and redecorated in cozy New England style. They had a maid and a gardener-handyman. Norman, who was too busy concentrating on his art, let Mary make the decisions about painting and fixing up the house and she busily involved herself in these happy chores as well as taking care of her four boys.

On this March 30, 1940, cover we look in on a familiar scene as a young housewife decides to freshen up the scenery with some new bright colors. But when she gets to the favorite chair of the master of the house, some negative glances are coming around the bend. But although he may grunt a bit and puff a little more smoke than usual, she will win in the end, and he will live happily in contemporary decor forever after.

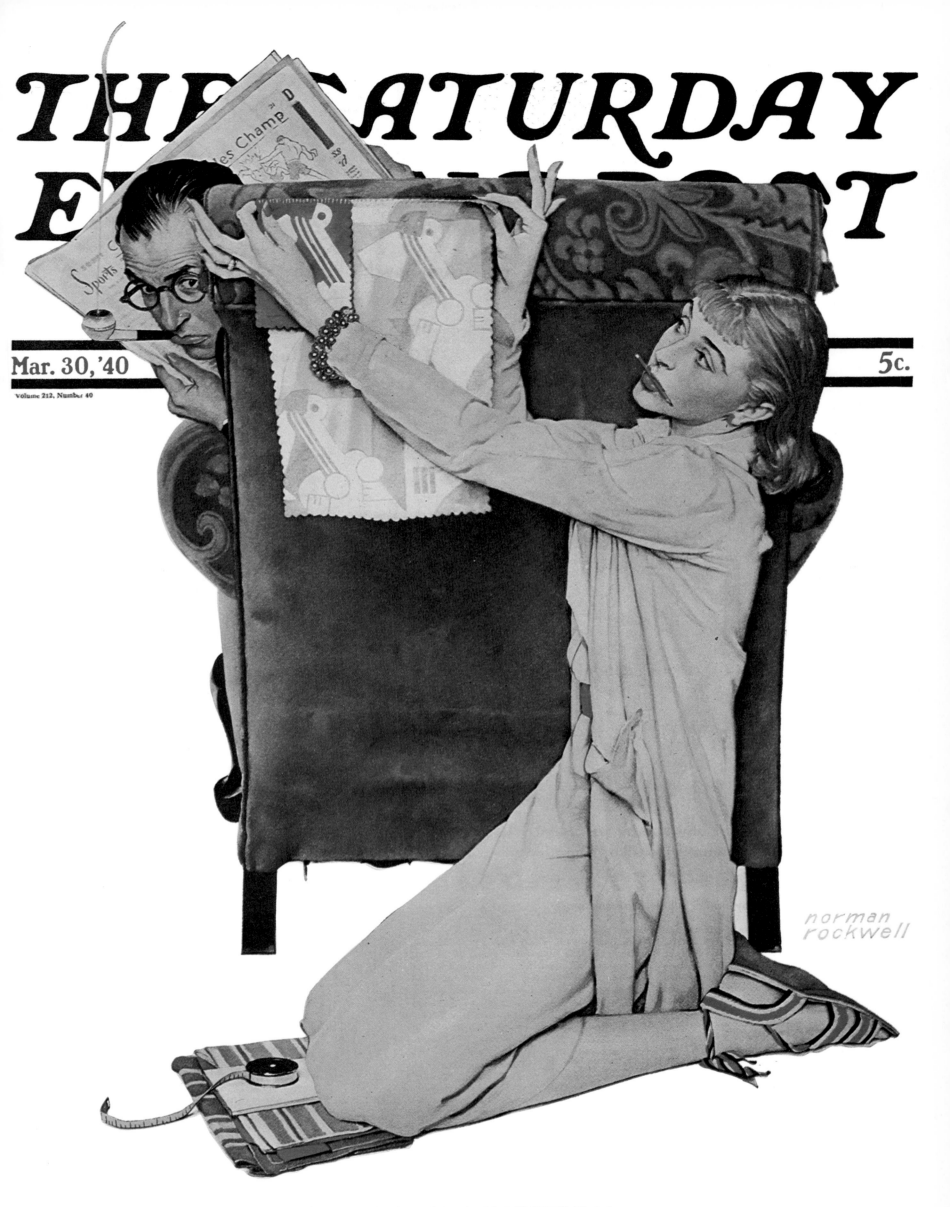

"The Census Taker"

In 1790 the United States Congress decreed that a new agency known as The Bureau of the Census be formed as an agency of the U. S. Government and every ten years in the years that end with zero shall conduct a count of the inhabitants of the land.

And at the beginning of each decade the men with their large black books would appear from the great metropolitan areas to the tiny towns like Arlington. Peter Rockwell once wrote that Arlington was so small that everyone knew everyone. It was the sort of place that you could go into a general store, pick up your merchandise, ring up the cash register, and take your own change without ever seeing the proprietor.

This humorous cover of an overworked mother still in her housecoat and curlers with her brood peeping out from all over is a typical Rockwell occupational spoof. She is having great difficulty recalling the birthdates of her offspring.

The scene takes place in California as we see by the census book and many people from the West Coast wrote to Norman Rockwell asking what the funny-looking stick at the feet of the census taker was and why he was wearing rubbers in a place where the sun always shines.

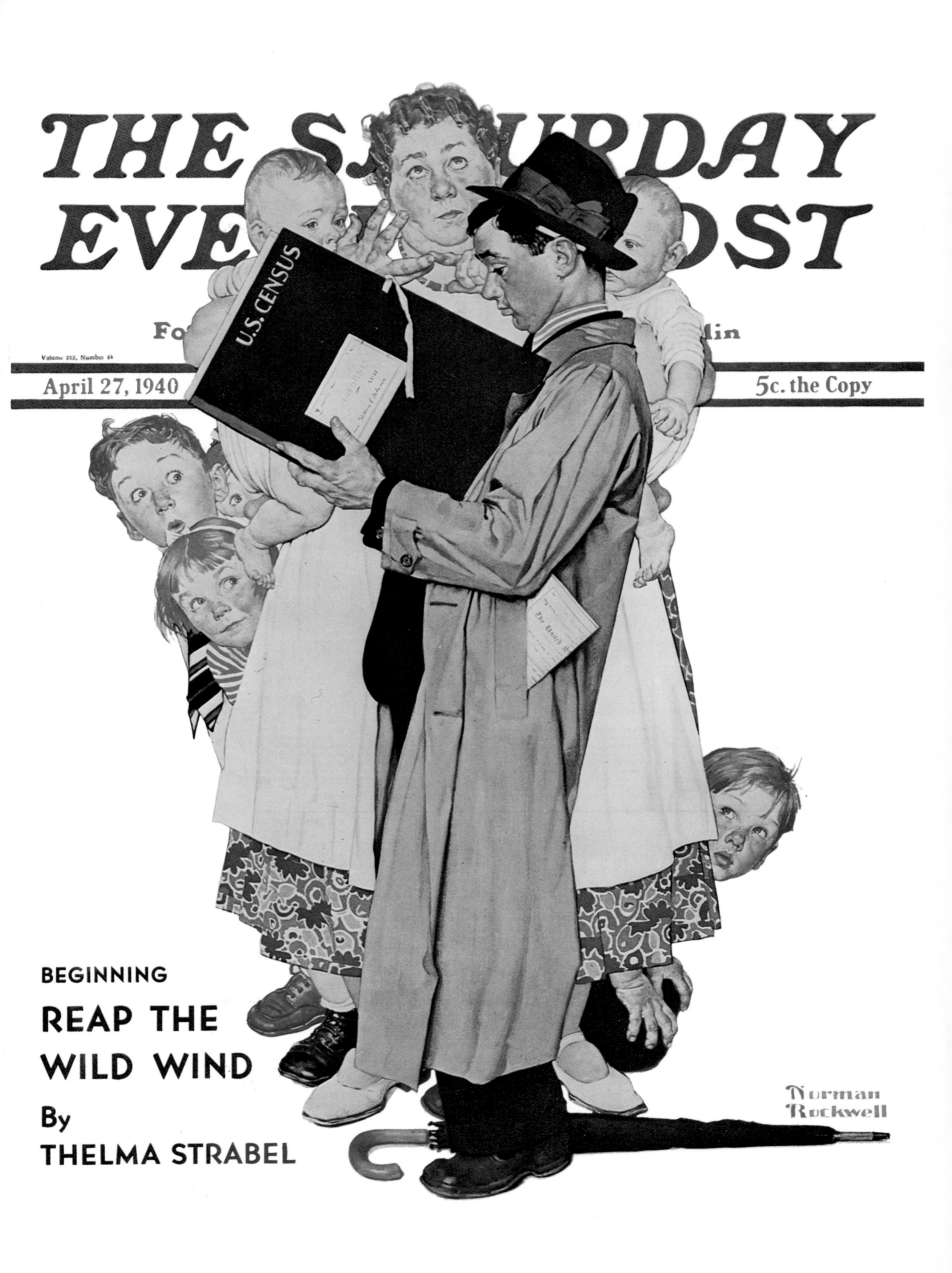

"Shave and a Haircut"

Most people enjoy being pampered every once in a while, even an important businessman who must look his best before a big meeting or a business trip or a social event. This cigar-smoking tycoon has a delighted smile on his face as his cheeks are massaged, his hands are manicured, and his shoes are polished to a mirror finish.

Norman Rockwell never had time for such luxuries, but he obviously thought about them, especially when an important or famous person came to visit. Linda Darnell was a frequent visitor in Arlington. She was a serious art student and Norman loved teaching her. Another good friend that would stop in on his trips east was Walt Disney. How much in common these two men have had—art, humor, patriotism, fame, and fortune.

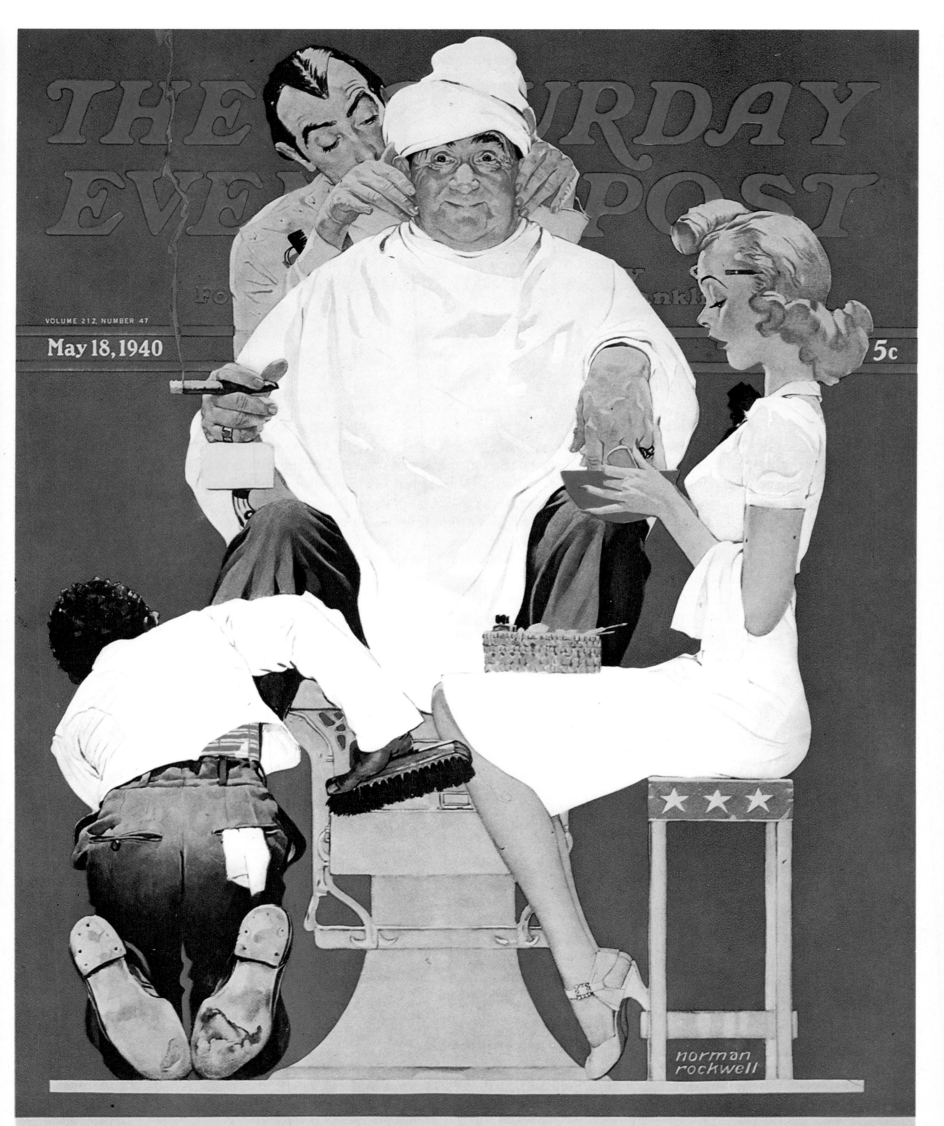

"Ice Cream Sundae"

Norman never used professional models after he moved to Vermont. He had a catalog memory of everybody's face and when he needed someone to pose he would call a local teacher, the doctor, a neighbor, or Mary or the boys. He was forever looking for models. Once a woman became upset when he followed her daughter and Norman had to ask the state police to explain to the woman who he was.

During the second summer in Vermont, he had a hundred or more people that he wanted to paint. Everyone seemed eager and willing. His imagination took on new life. "Ideas were jumping out of my brain like trout out of the Batten Kill at sunset."

In this picture we can almost feel the heat of a hot July afternoon as this bewildered young man searches for his companion in a sea of umbrellas as the scorching sun melts the dripping ice cream.

In the early 1940's, the Rockwells would take their vacations on the beaches of Provincetown at the tip of Cape Cod.

THE SATURDAY EVENING ST

An Illustrated
Founded A? D? 1728 by ...lin

VOLUME 213. NUMBER 2

July 13, 1940

5c. the Copy

Norman Rockwell

YOUNG AMES RETURNS By WALTER D. EDMONDS

"Home from Camp"

At the end of every summer, thousands of children all over the country pack up their camping equipment, leave their idyllic memories behind, and start the long trek homeward to the waiting arms of anxious parents.

Camping friends remain friends forever and those things which a young boy or girl can't bring home with them will remain dear to their hearts.

But this young lady has tried to bring everything but the cabin home with her. In addition to her trunk, knapsack, blankets, and sporting equipment, she has also managed to transport various forms of flora and fauna to go with her sad heart and scraped knee.

Rockwell wasn't a total stranger to camping. On one occasion he journeyed to Canada to hunt moose so he wouldn't be out of the conversation with his several hunting friends in Arlington.

He and a guide spent five nights and six days in the Canadian forest sleeping in small damp cabins. He walked until he was exhausted, and it never stopped raining. During the entire episode they never saw a moose, and when they returned to the lodge they learned that the son of the owner had shot a moose from the front porch of the building that afternoon.

Back in Arlington, Norman thought to himself, as he sat in front of his warm fireplace, "They can talk about hunting and fishing forever—I'm through," and he was and was never frustrated with their stories again.

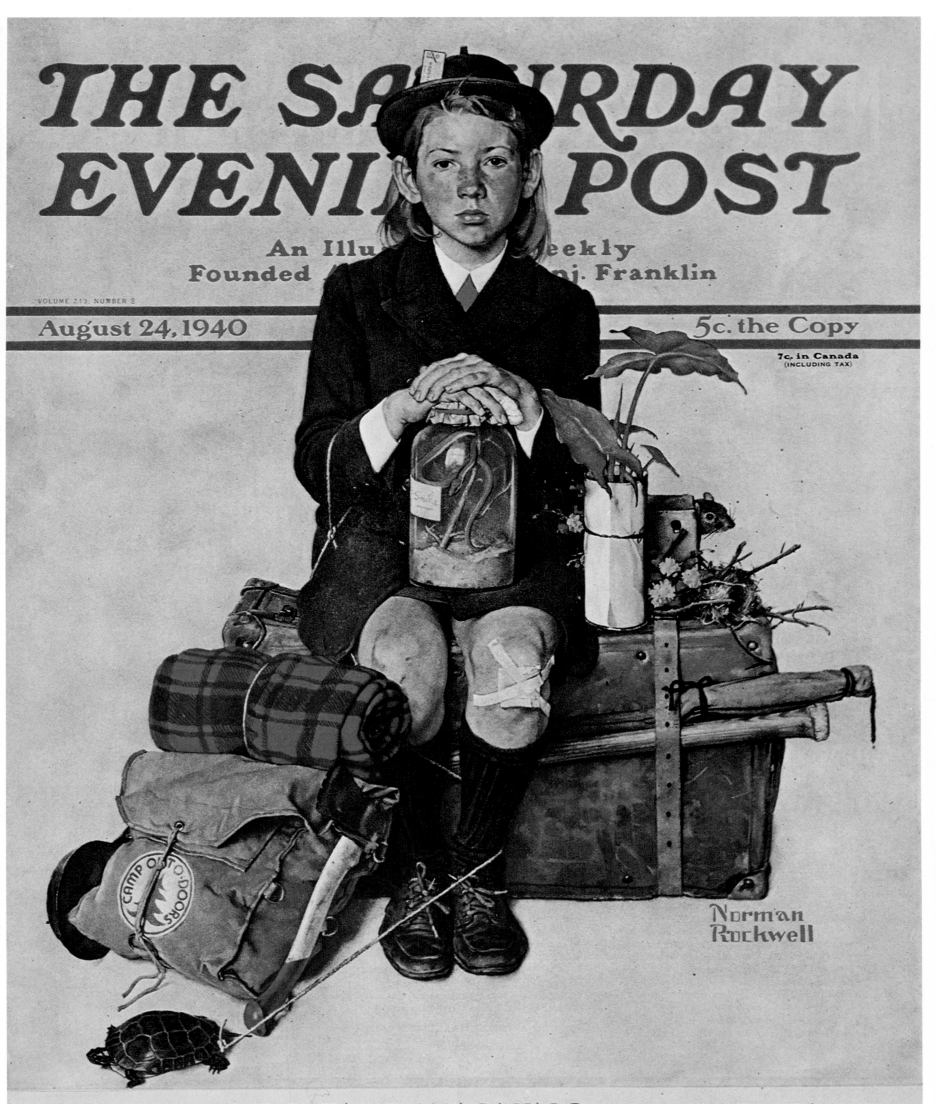

THE SATURDAY EVENING POST

An Illustrated Weekly
Founded A.D. 1728 by Benj. Franklin

VOLUME 213, NUMBER 8

August 24, 1940

5c. the Copy

7c. in Canada
(INCLUDING TAX)

Norman Rockwell

BEGINNING SAILOR TAKE WARNING By RICHARD SALE

"Miami Bound"

Thanksgiving is vacation time for many colleges and some adventuresome students pack up their barest necessities and either head for home or a dreamed-about vacation spot. But usually high on desire and very low on funds, they find that hitchhiking is the only way of traveling.

This whimsical fellow has taken off his white duck shoes and is relaxing with his ukelele to the tune of "Moon over Miami" as his suitcase announces his destination to passing motorists.

Rockwell, who always had wanderlust as a young man, can identify with this picture. As he was painting it his mind was certainly traveling over the highways and byways of America.

THE SATURDAY EVENING POST

An Illustrated Weekly
Founded A.° D.! 1728 by Benj. Fra...

November 30, 1940 5c.

Volume 213, Number 22

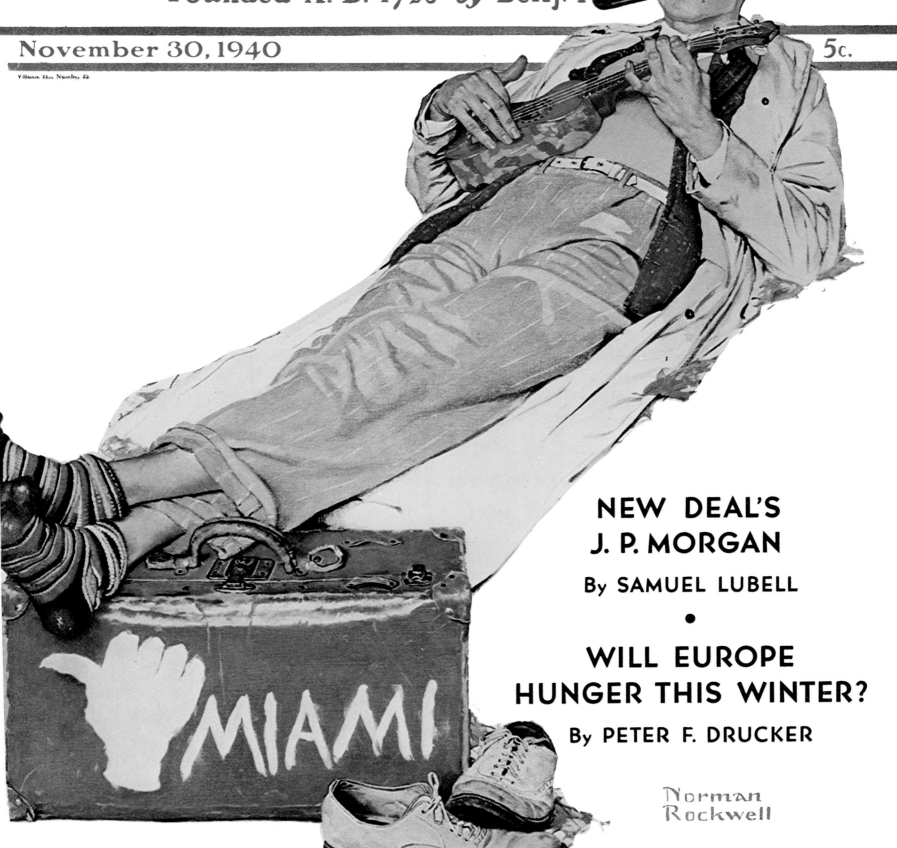

NEW DEAL'S
J. P. MORGAN

By SAMUEL LUBELL

•

WILL EUROPE
HUNGER THIS WINTER?

By PETER F. DRUCKER

Norman
Rockwell

MIAMI

"Department Store Santa"

A few hours ago an excited little fellow was sitting on the lap of Santa Claus in Drysdale's Department Store and telling him how well behaved he has been and what he would like for Christmas.

Now, since he was a very dependable lad, Mom has entrusted him to help her carry a few packages on their trip home, and as he enters the subway car he spies a strangely familiar face. Can it really be?

Santa, who appears exhausted after a very trying day, is too tired to read the newspaper and is content to relax and think about a nice dinner and a good night's sleep.

He appears to be sitting on a wisp of mistletoe, which may be accidental or may be another bit of Rockwell humor, as is the difference between the happy, energetic Santa on the Drysdale sign and the weary fellow we are watching.

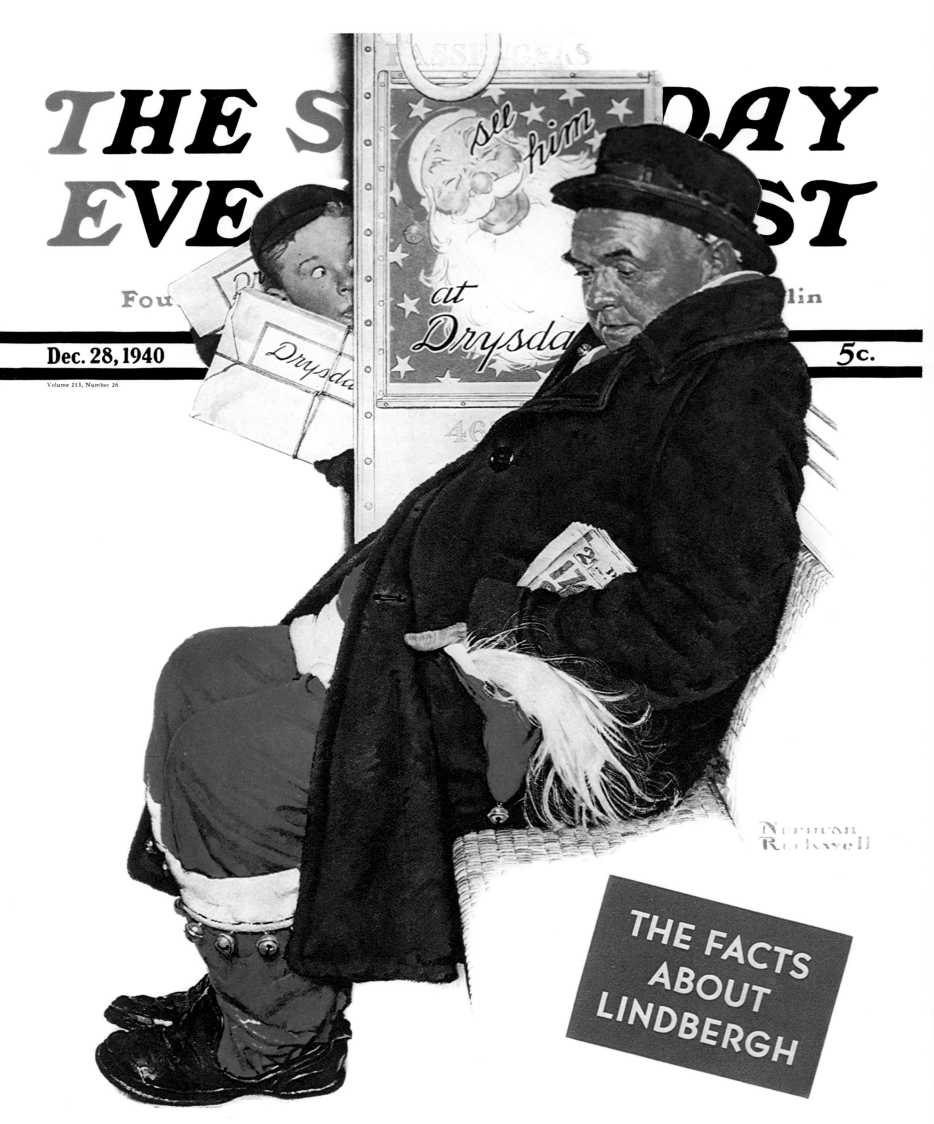

THE S... DAY
EVE...ST

Fou...lin

Dec. 28, 1940

5c.

Volume 213, Number 26

THE FACTS
ABOUT
LINDBERGH

BEGINNING **WHEREVER THE GRASS GROWS** By ALLAN R. BOSWORTH

"The Glamour Girl"

To paraphrase an old saying, "You can take a boy out of the city but you can't take the city out of the boy." Here Rockwell has done back-to-back covers on a subway train.

The year is 1941 and everyone was reading *The Saturday Evening Post*. It had become one of the most popular publications in the world, and its weekly distribution had reached 3,300,000 and was climbing.

On this clever cover, a high school girl wearing her boyfriend's fraternity pin and her school sweater is on her way home after classes and reading the latest copy of the *Post*.

Although we can't see her face, we are sure she is a true American beauty as is the beautiful lady on the *Post* cover.

Rockwell gives great detail to her dirty sandals and her pile of books and even to the graffiti on the book's edge. The magazine cover could very well be of a famous movie star like Dorothy Lamour, who was playing in many pictures during that period.

THE SATURDAY EVENING POST

Four ... Weekly ... Franklin

More than 3,300,000 Net Paid

March 1, 1941

Volume 213, Number 35

5c. the Copy

7c. IN CANADA

BEGINNING
SING FOR A PENNY
A FOUR PART NOVEL
By CLIFFORD DOWDEY

ALCOHOLICS ANONYMOUS
By JACK ALEXANDER

Norman Rockwell

"Convention"

Conventions are an integral part of many businesses in our country and once a year participants come to a chosen spot from all over to sell their wares, air their views, and have a good time. Even artists must go to conventions occasionally, because on this cover Norman Rockwell has accurately and in great detail depicted a weary hotel hatcheck girl who is weighted down with the hats, coats, scarves, and umbrellas of the frolicking conventioneers.

Although Rockwell loved the country, he told his sons many stories about his life in the big city and the family took frequent trips to New York. He would love to show them Broadway and the Bowery and would love to talk to strange people. Peter Rockwell remembers going to Rockefeller Center at seven o'clock in the morning just so the boys could run up the down escalators.

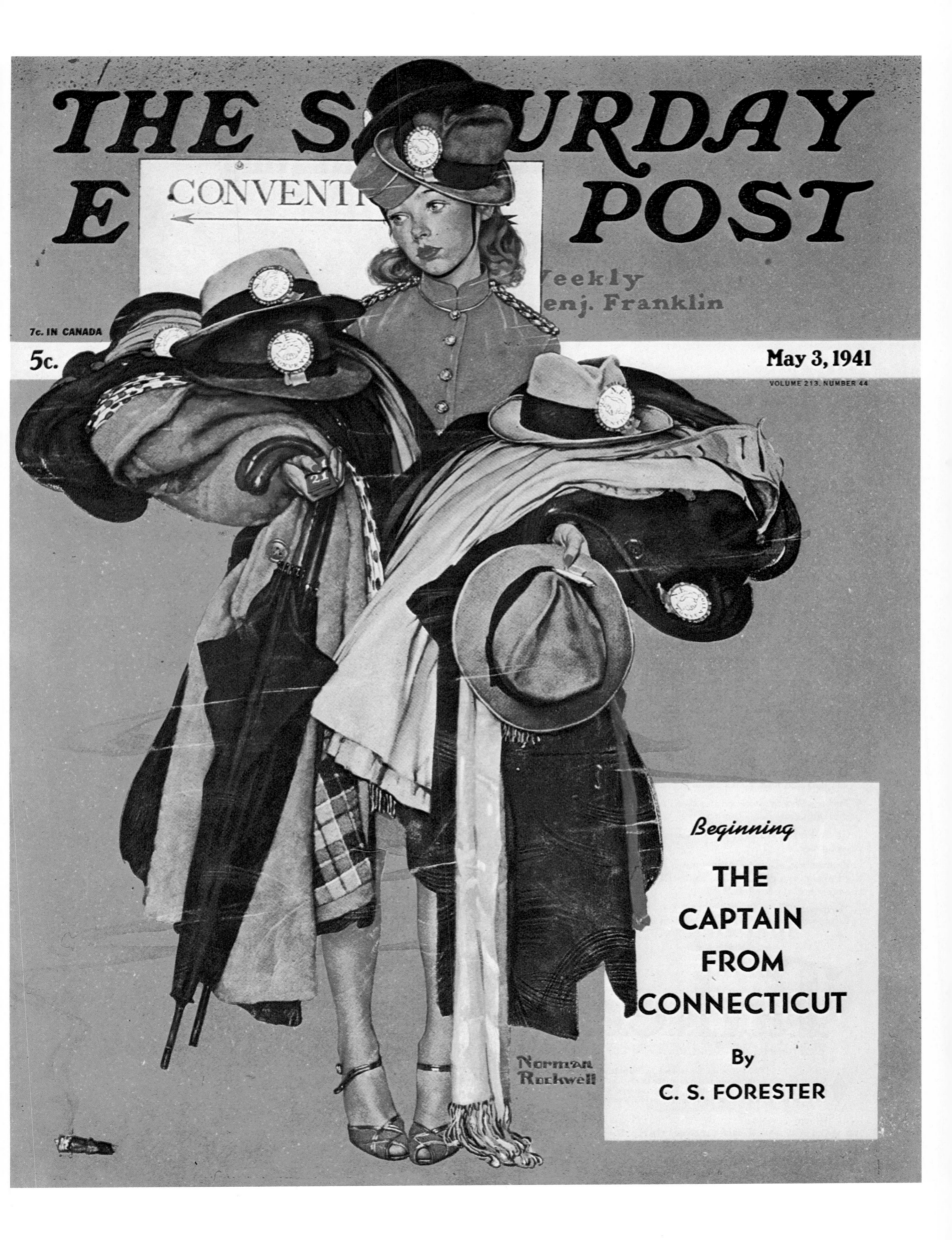

"The Flirts"

It has been said that "all work and no play makes Jack a dull boy" and Norman Rockwell lived by these words. Although he worked extremely hard and pushed himself sometimes to the point of exhaustion, he enjoyed what he did immensely and felt that every occupation should have a share of rewards and fun.

Whether it was a doctor examining a doll (March 9, 1929), a barber taking time off to sing (September 26, 1936), or a teacher getting candy from a caller (October 27, 1917), every job has its bright moments.

On this July 26, 1941, cover, a large truck stops at a traffic light (as seen in the rear-view mirror) and lo and behold a shiny convertible with a beautiful girl pulls up beside it. It's love at first sight for the truck drivers, but the beautiful blonde won't even cast them a glance as they recite "she loves me—she loves me not" while pulling off the petals of a flower.

This was the first *Post* cover that Rockwell didn't sign his name to, but his distinctive style and the initials on the car give away the creator.

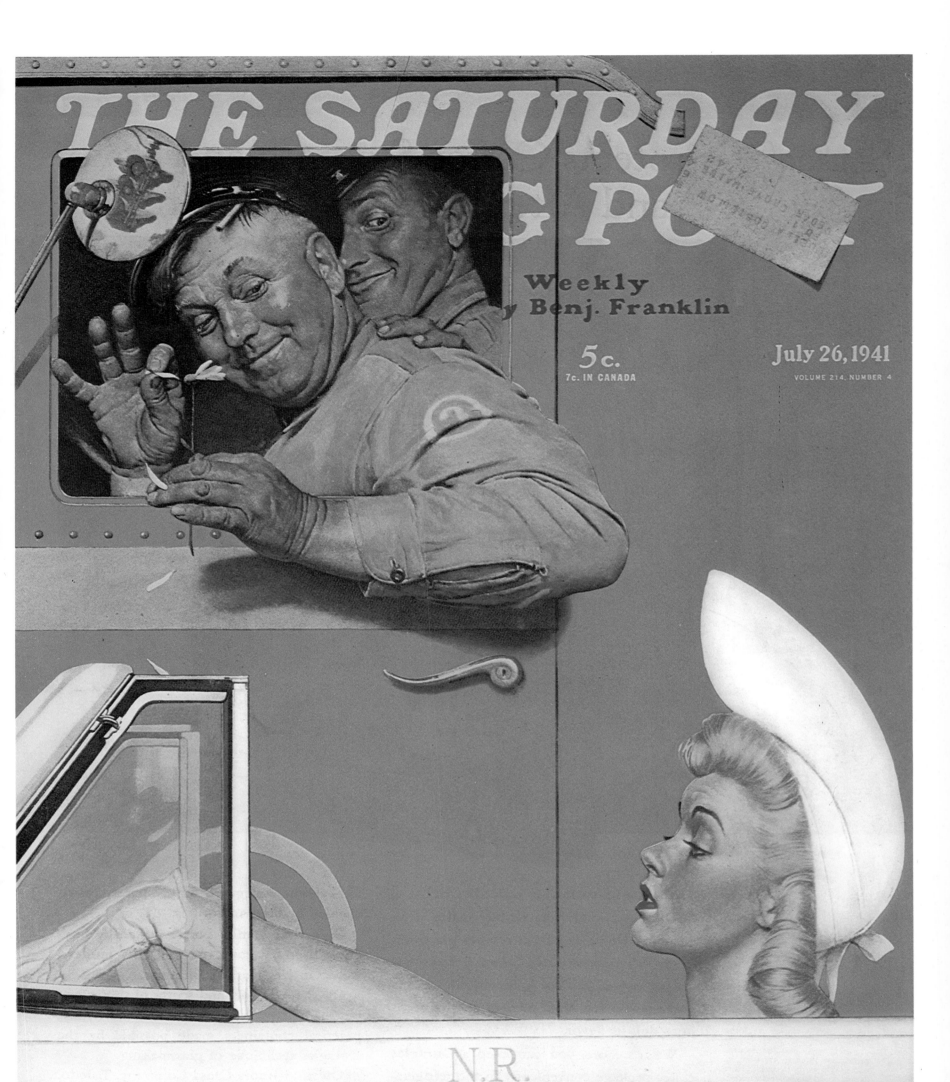

"A Package from Home"

During 1940, the war in Europe was escalating and Americans were getting very concerned. Even the little town of Arlington, Vermont, was beginning to feel the effects as more and more of its young men were joining the armed forces. During the grange dances, the local boys would show up proudly displaying their handsome uniforms. Rockwell became extremely interested in the local soldiers and the war in general and attacked the subject as if he was going to fight the enemy single-handed. This picture is the first of his most important series. One night at a square dance in Arlington, he spotted a young man named Robert Buck. Although he was supposedly too short for military duty, he was perfect for a Rockwell model and was soon to become one of the most famous soldiers of World War II. Rockwell remembered an old children's book called "Wee Willie Winkie" and because Bob Buck looked like a Wee Willie he became Willie Gillis on *Post* pictures and was the star of eleven *Saturday Evening Post* covers.

On this cover, the first of the series, Willie has received a package from home with a big red sign saying "food" on it. Willie became the most popular fellow in the outfit.

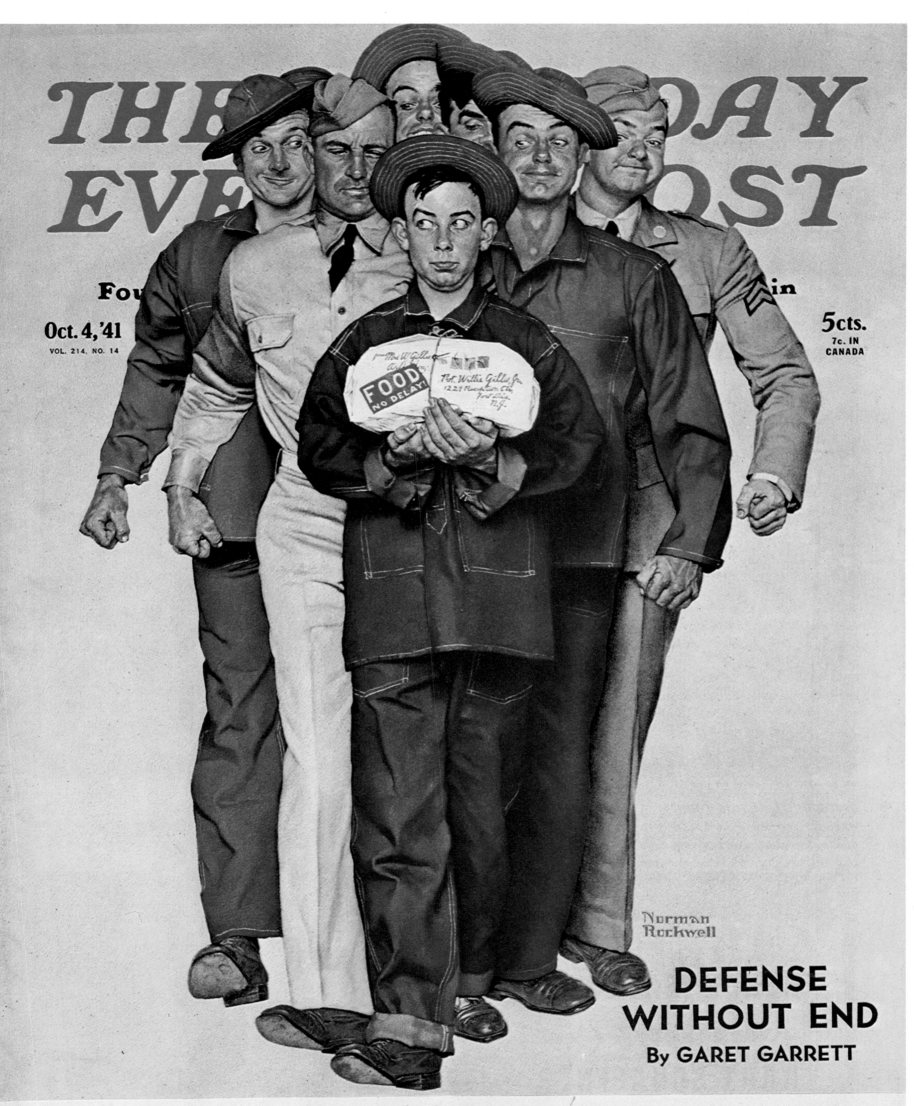

"Home Sweet Home"

Seven weeks after the first Willie Gillis cover was published, the second one appeared on the *Post*. In this picture we see Willie at home on furlough and fast asleep under a colorful patchwork quilt.

His army uniform is haphazardly hanging on the foot of the bed and his shoes and socks are thrown on the floor. This could never happen in Fort Dix, New Jersey, where he is stationed, nor could he get coffee in bed or sleep until eleven o'clock.

What a wonderful feeling it was for every GI to return to his own clean, warm bed and enjoy the comforts of "Home Sweet Home."

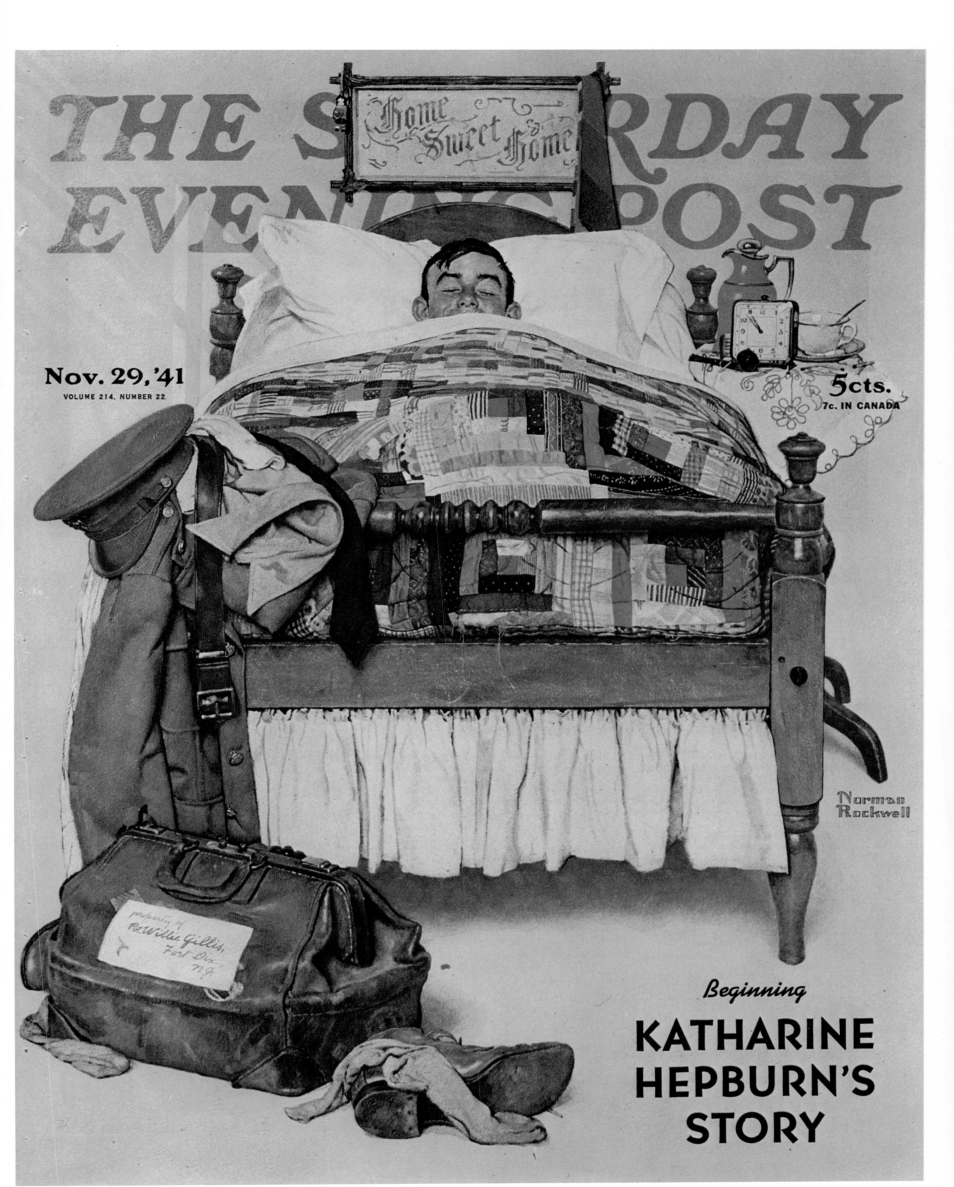

"The Christmas Newsstand"

Norman Rockwell had a total idea in mind when he painted this Christmas 1941 *Post* cover. He pictured a corner newsstand of the enclosed variety that are seen on the streets of big cities. Since it was December, he wanted snow on the roof, frost on the windows, and smoke coming out of the smokestack. He wanted the stand decorated for Christmas, and inside he imagined the cozy warmth of a little stove protecting an elderly proprietor from the wintry wind and cold.

Before Mr. Rockwell started the picture, he met with Mr. Ned J. Burns, a historical researcher and model maker for The Museum of the City of New York. Mr. Burns made a miniature model of the newsstand so that Mr. Rockwell could experiment with lighting effects—a blue light for the outside to achieve the cold effect and a warmer yellow light for the interior. The snow was sugar and Rockwell had a difficult time keeping the autumn flies away while he painted.

The model was an adaptation of a newsstand at 48th Street and Sixth Avenue in New York City where many Manhattanites bought their copy of *The Saturday Evening Post.*

An afterthought, which was an important sign of the day, was a "Buy Defense Bonds" sign and a red cross.

"Willie at the U.S.O."

This was Willie Gillis's third appearance on a *Post* cover (the originals of his first two covers were already hanging in the Fort Dix New Service Club Library—a loan from artist Rockwell). The picture was a transcontinental achievement. After he had completed the rough sketches for this cover, Mr. Rockwell felt that he needed a rest and a change of scene, so he decided to exchange Vermont's snowy hills for a little California sunshine. In that, he reckoned without the *Post* and its bullhide whip. He went west, but he took his sketch and his painting equipment with him. Willie came back by express and artist Rockwell enjoyed his vacation.

The girls? Well, read left to right and you have Helen Mueller, New York model, Willie, and Kay Aldridge, ex-model, California's 1942-vintage "Wine Queen" and starlet whom the Navy picked as one of the six most beautiful girls in Hollywood. Miss Aldridge was seen in Warner Brothers' movie *In the Navy Now*.

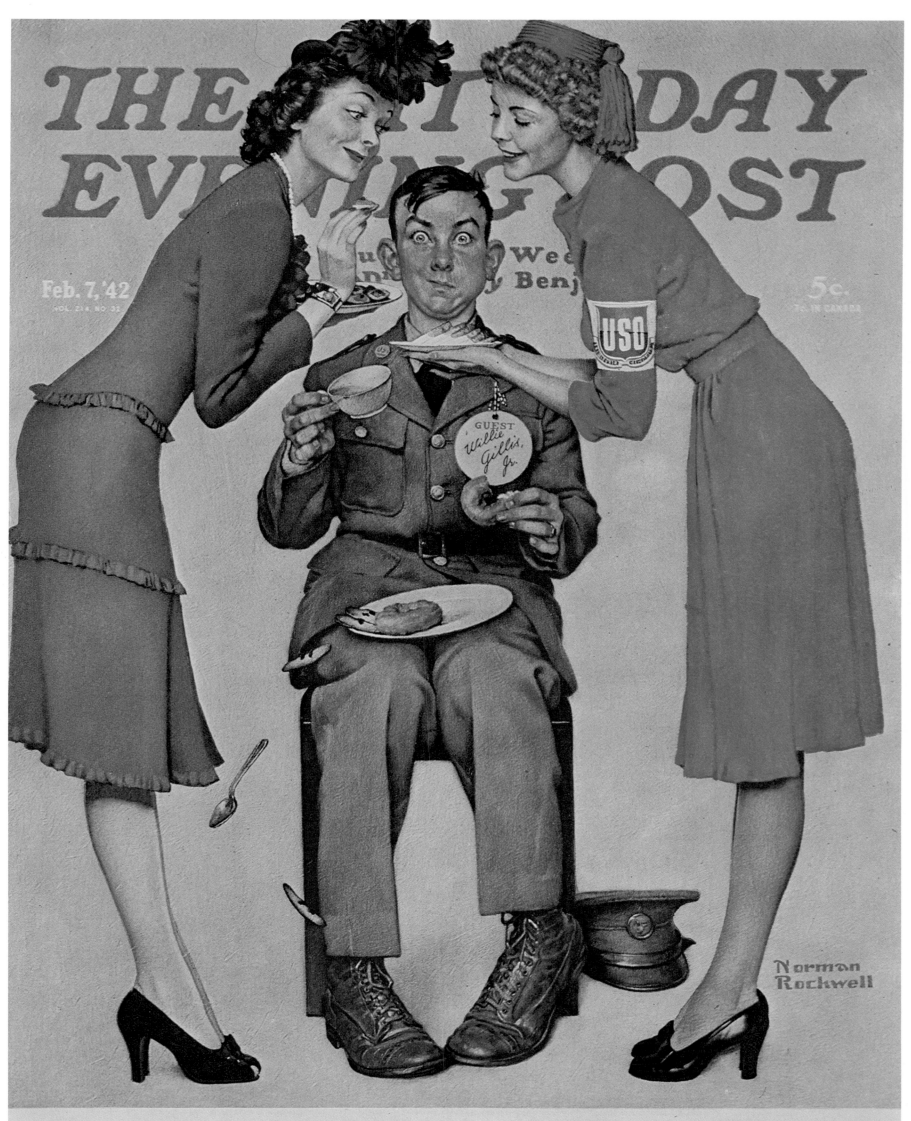

"Devil May Care"

In 1941, the Milwaukee Art Institute gave Norman Rockwell his first one-man showing in a major museum. He was very impressed and excited to be recognized in the hallowed halls of the art palaces where viewers could drink in the genius of Rembrandt, Renoir, Raphael, and Rubens. And now Rockwells were in the company of the works of the great masters.

But that didn't change his style. He still wanted to paint life around him and the love and the fun and the humor that he saw in it.

On this cover of a wonderfully devilish little boy reading his sister's sacred diary, he captured not only the humor of the scene, but also a detailed picture of thousands of young girls' dressing tables.

The mischievous little fellow who is reading the diary is Tommy Rockwell, Norman's middle son, who had to be bribed to pose for this cover. Rockwell said that Tommy was always a devil and was the kind of kid that would have read his sister's diary—if he had had one.

"The Hometown News"

This was the fourth cover in the Willie Gillis series and it marked an important milestone in the history of *The Saturday Evening Post*. Families and servicemen all over the world identified with this painting of young Willie, who takes a moment from the rigors of peeling apples while on K.P. to read about his family in the local newspaper.

At this time the country was in the midst of the greatest war in its history and the people at home needed the heartwarming scenes that Norman Rockwell could bring them and they allowed themselves to smile through the tears of worry and adversity.

And because of spiraling costs caused by the tremendous financial strains of the war, the price of *The Saturday Evening Post* rose from five cents to ten cents with this issue.

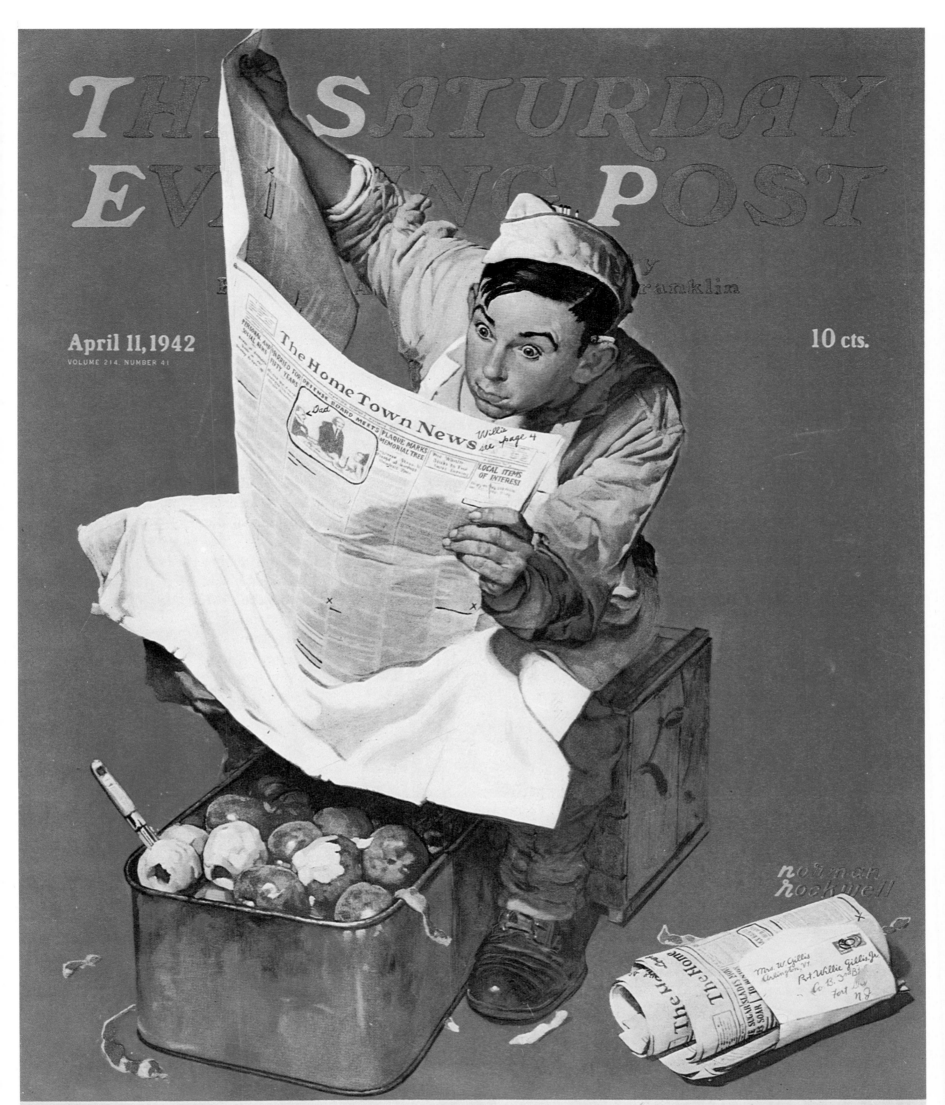

"Blackout"

This cover, with the fifth Willie Gillis picture, hinted that some monumental changes were taking place in the Curtis Building. Ben Hibbs had become the new editor and a new format was noted in the *Post* logo.

Ben and Norman got along exceedingly well. They liked and admired each other, and although Rockwell, who was so used to the domineering ways of George Horace Lorimer, had to get used to the easy manner of Ben Hibbs, together they reached tremendous successes.

When, at the time of their first meeting, Rockwell showed Mr. Hibbs nine sketches and he accepted them all, Norman was flabbergasted and told Mary Rockwell that Ben Hibbs was so easy he would never last at the *Post*. He was, happily, very wrong.

This cover of Willie and a girl friend reading blackout instructions was a classic of facial expression and humor. When the attractive young lady gave Willie her suggestions as to "what to do in a blackout" he was happy to comply with her advice.

THE SATURDAY EVENING

POST

JUNE 27, 1942
VOLUME 214 NUMBER 52
10¢

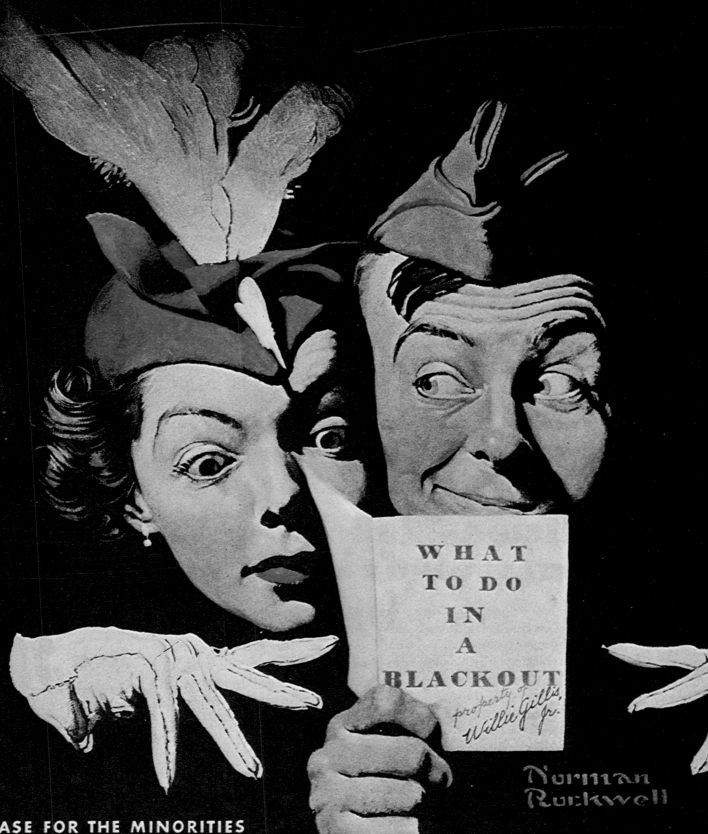

WHAT
TO DO
IN
A
BLACKOUT

property of
Willie Gillis
Jr.

Norman
Rockwell

THE CASE FOR THE MINORITIES
Wendell L. Willkie

OUR TWO MONTHS ON CORREGIDOR Cabot Coville

"Willie at Prayer"

Rockwell was now feverishly working on his Four Freedoms paintings. The idea had come to him from a Franklin Roosevelt speech and both Norman and Ben Hibbs were extremely excited about the concept. His next several cover sketches had been worked out, so most of his effort was going into the Four Freedoms.

One of the pictures, Freedom of Religion, touched off many ideas, one of which wound up being the sixth Willie Gillis cover. Here we see a pensive young soldier solemnly meditating about himself, his country, and the world, and his thoughts and prayers were shared by everyone.

THE SATURDAY EVENING POST

JULY 25, 1942 10¢

READ IN THIS ISSUE

AMERICA'S BLACK MARKET

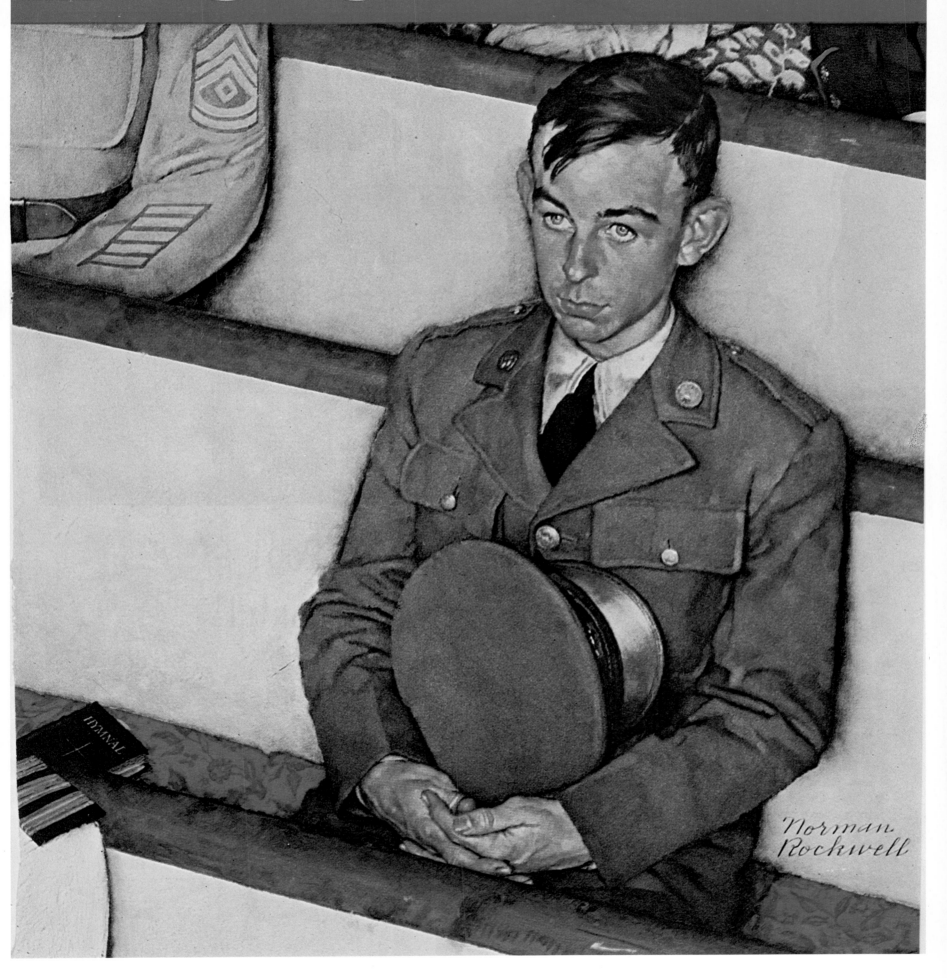

"The Girls Back Home"

The seventh Willie Gillis cover presented a problem for Norman Rockwell. The Willie series had become extremely popular and Willie himself had become a national hero. Hundreds of letters were received by the *Post* and Rockwell with nice comments about the young soldier that reminded people of their sons.

But Robert Buck enlisted in the Naval Air Service and, since he was not available for posing, Rockwell had to improvise.

On this cover we see the interesting results. Two pretty girls, who in reality were the daughters of Mead Schaeffer, a noted *Post* artist and Rockwell neighbor, go to their mail boxes and simultaneously receive photographs of Willie. Rockwell's misfortune for not having Willie around to model for him was a fortunate circumstance for Mr. Gillis at this particular moment.

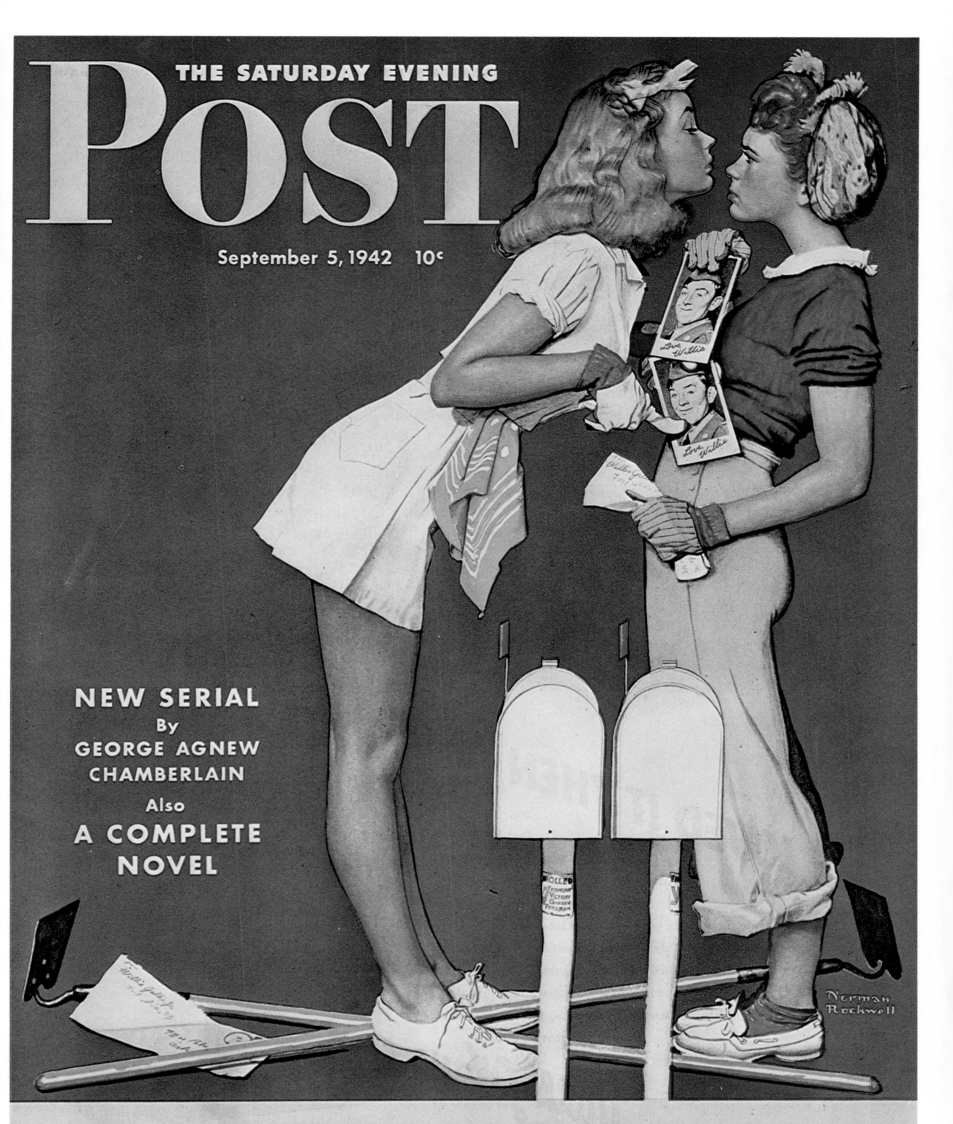

"The Army Cook"

The time is 1:22 a.m. on Thanksgiving morning and an exhausted army cook has just completed preparing a sumptuous holiday feast for 137 hungry soldiers. The place is the headquarters of the 71st Brigade at Fort Ethan Allen, Vermont. And the meal is roast turkey with apple and raisin dressing with all the fixin's that go with it. Over thirty different items have been prepared by the chef and each one carefully checked off with a red crayon. And now he can sit down, take off his boots, have a smoke, and catch a short nap before early morning reveille.

Mothers loved this cover when they saw how well their sons were eating in the service, but they would have preferred them home for the holiday.

This is one of the few Rockwell covers that correspond with an article in the magazine. "Woes of an Army Cook" was written by Earl Wilson, the famous newspaper columnist.

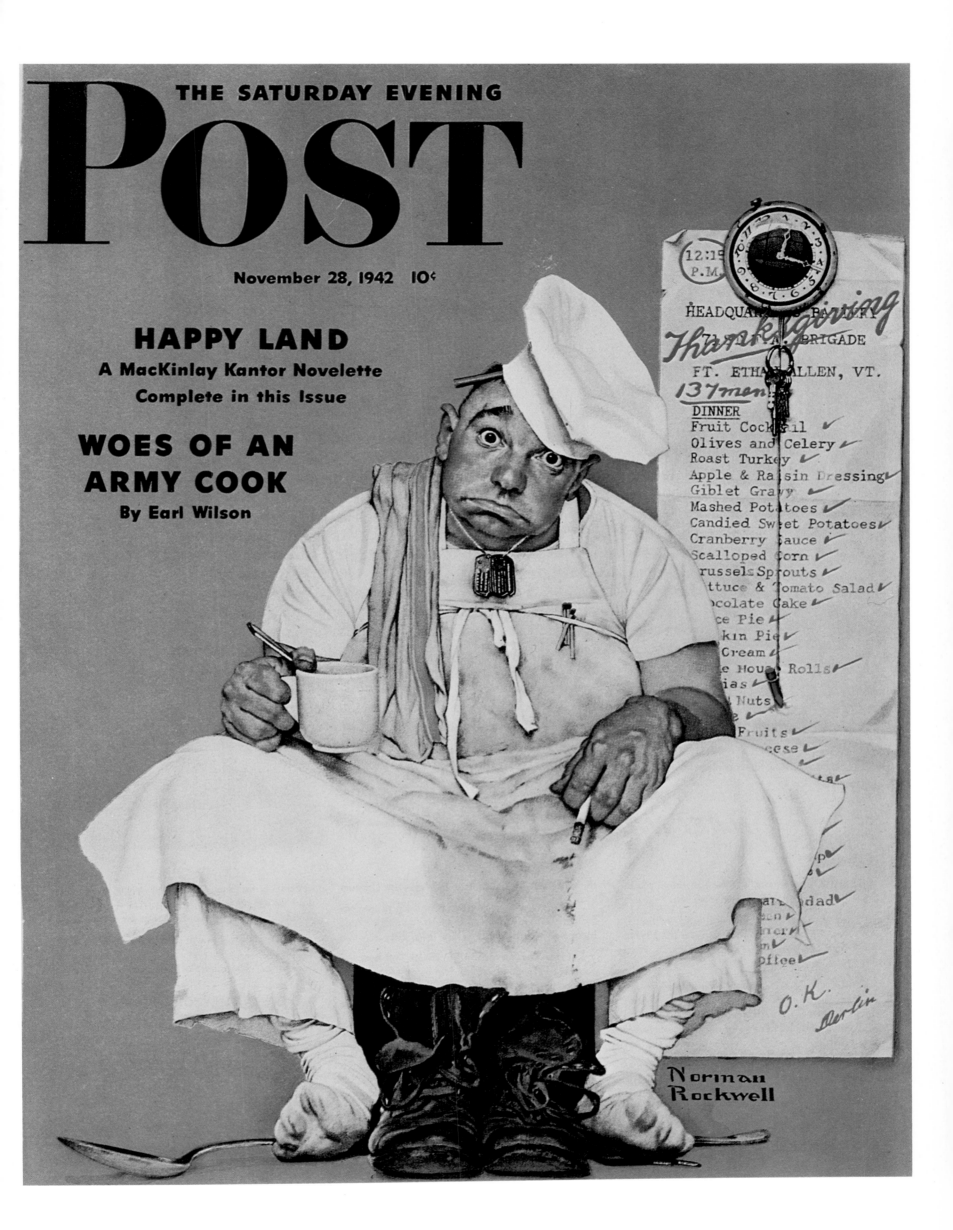

"Wartime Santa"

Despite the tremendous problems in the war-torn world of 1942, Santa Claus appeared right on schedule. Popping through the front page of a newspaper filled with trouble and tragedy was the jolly face of old Saint Nick, and although his load was lighter that year as toys were tough to come by, the spirit was there and people needed him more than ever. From the foxholes to the fireplaces the world paused for a few moments on Christmas Eve, 1942, to briefly celebrate and then get back to the business of fighting a war.

About this time Rockwell was just finishing up the Four Freedoms paintings, and although he could have slowed down a bit in his intensive work schedule, he felt obliged to get this wonderful Santa to the *Post* in time for its Christmas issue.

As soon as the Four Freedoms were completed, they were sent to Philadelphia, where they were published with a great deal of fanfare.

Following their publication, copies were distributed throughout the world as war bond posters and whoever bought a bond got a set of Four Freedoms prints. War bond shows were held around the country. The pictures were viewed by millions and a total of $132,992,539 worth of war bonds were sold.

THE SATURDAY EVENING POST

December 26, 1942 10¢

How Germany Looks
From Switzerland
By CHARLES LANIUS

The Picture Story
of Leon Henderson's
GLAMOUR
SCHOOL

"Merry Christmas"

"April Fool, 1943"

In case you didn't know," the paragraph inside this issue of *The Saturday Evening Post* said, "the picture on the cover was drawn by Norman Rockwell even though he signed his name backwards."

With the pressure of the Four Freedoms over, Rockwell went back to the job of having fun and painted this fabulous April Fool cover, which is the first of three.

On page 99 of the magazine the editors were kind enough to list the 45 errors, which were the trout, the fishhook and the water, all on the stairway; the stairway running behind the fireplace, an architectural impossibility; the mailbox; the faucet; wallpaper upside down; wallpaper with two designs; the scissors candlestick; silhouettes upside down; bacon and egg on the decorative plate; the April Fool clock; the portraits; ducks in the living room; zebra looking out of the frame; mouse looking out of the mantelpiece; a tire for the iron rim of the mantelpiece; medicine bottle and glass floating in the air; fork instead of a spoon on the bottle; the old lady's hip pocket; the newspaper in her pocket; her wedding ring on the wrong hand; buttons on the wrong side of her sweater; crown on her head; Stilson wrench for a nutcracker in her hand; skunk on her lap; she is wearing trousers; she has on ice skates; no checkers on checkerboard; wrong number of squares on checkerboard; too many fingers on old man's hand; erasers on both ends of his pencil; he is wearing a skirt; he has a bird in his pocket; he is wearing roller skates; he has a hoe for a cane; billfold on string tied to his finger, milkweed growing in room; milk bottle on milkweed; deer under chair; dog's paws on deer; mushrooms; woodpecker pecking chair; buckle on man's slipper; artist's signature in reverse.

THE SATURDAY EVENING POST

APRIL 3, 1943 10¢

The never-before-told story of
our marines' struggle for survival

LAST MAN OFF WAKE ISLAND

By LT. COL. W. L. J. BAYLER, USMC

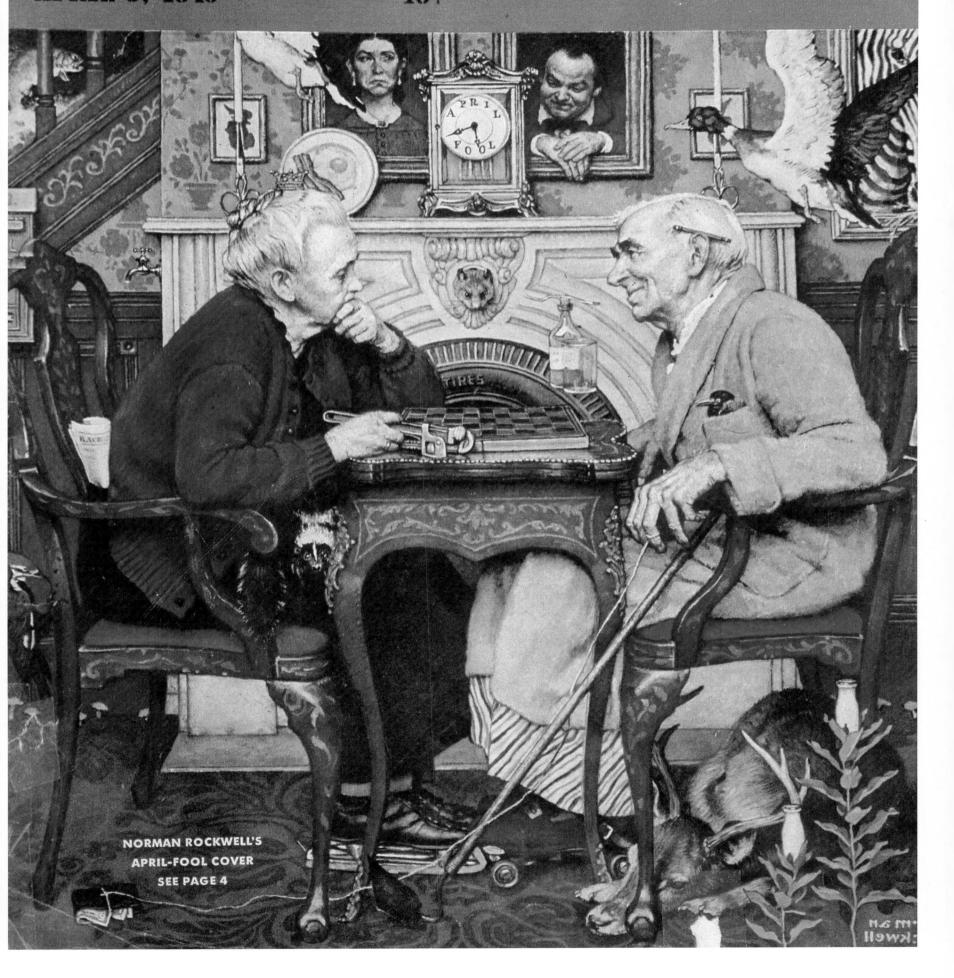

NORMAN ROCKWELL'S
APRIL-FOOL COVER
SEE PAGE 4

"Rosie the Riveter"

As World War II grew more intense, millions of American boys and men were taken away from their jobs and professions to fight for their country. This produced the unusual situation of women having to take over the positions previously occupied by men. Wives, mothers, and sweethearts ventured out to the factories, farms, and offices to keep the wheels of the country turning.

Rockwell honored the working women with this portrait of "Rosie the Riveter." He took the pose from Michelangelo's Prophet Isaiah on the ceiling of the Sistine Chapel and appears to imitate Michelangelo's masculine women.

With the flag of the United States flying behind her, Rosie sits with confidence with her rivet gun on her lap as she eats her lunch.

With patriotic buttons on her overalls and goggles on her cute, dirty face, she intends to win the war at home as her boys are doing it overseas. And with her foot on a copy of Hitler's *Mein Kampf* being crushed under her foot, America will likewise crush its adversaries.

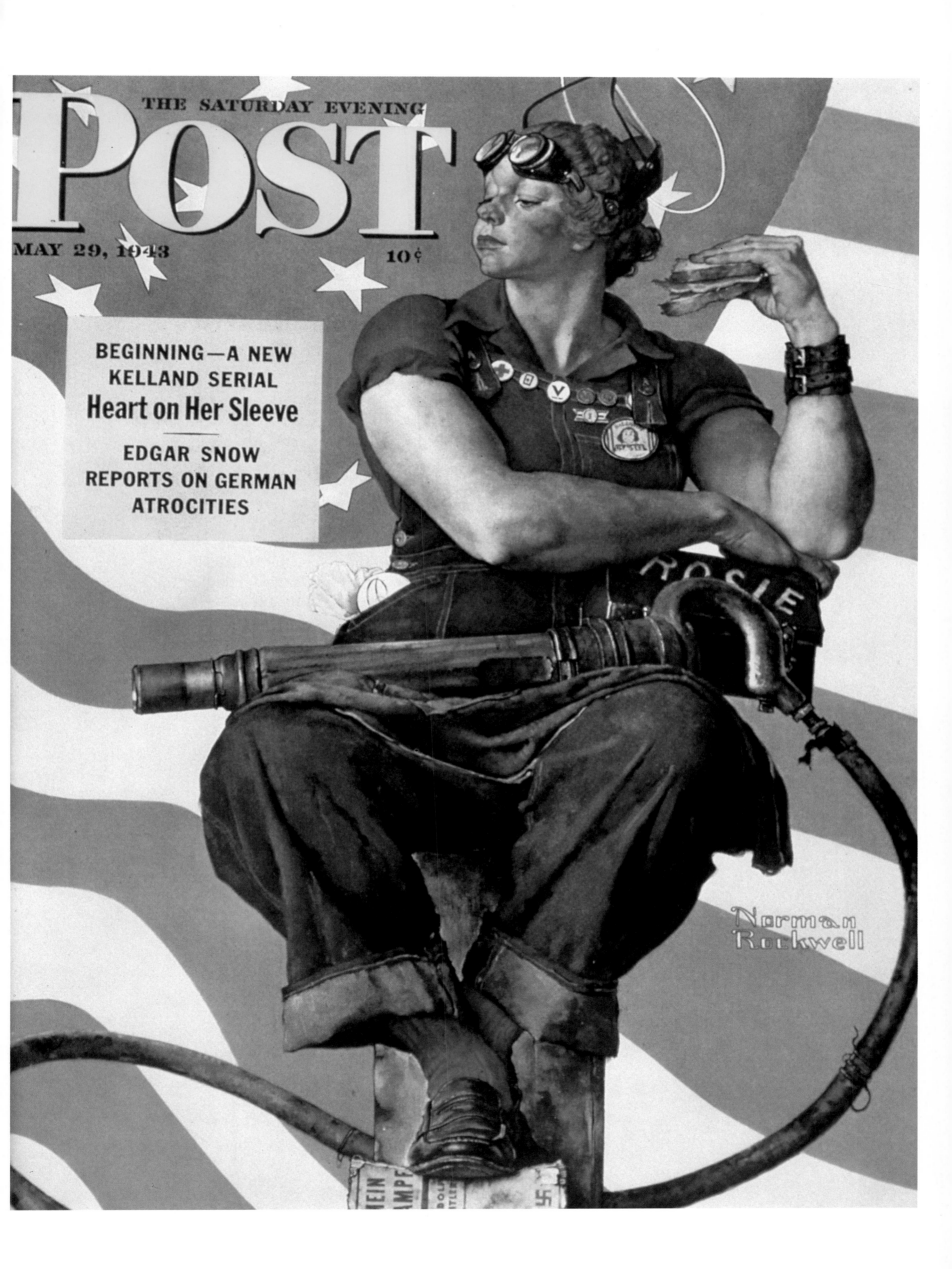

"Willie Travels"

The eighth Willie Gillis cover shows our hero in the Middle East, trying to teach a string trick to an amazed fakir. The detail in the painting is superb, from the GI uniform, helmet, and rifle to the twin cobras. The facial expressions are magnificent and the cigarettes look so real that you can even see them glow.

Rockwell was crushed when after making Willie Gillis the war's favorite soldier Robert Buck went and joined a branch of the Navy. But Rockwell decided to continue the series anyway, because of popular demand, and he painted Willie's adventures until he returned home and went to college on the October 5, 1946, cover.

Years later when Robert Buck, who now lives in Wallingford, Vermont, was interviewed, he stated that he was 16 years old when he first posed for Rockwell and both were surprised at the success of the series.

He wrote that "Norman was a kind gentleman to work with. I had no experience or training for modeling work. Many poses or expressions had to be held for agonizing periods of time. Norman's patience was terrific."

Norman gave Robert Buck the oil painting of the October 5, 1946, cover of Willie at college and it is his prize possession.

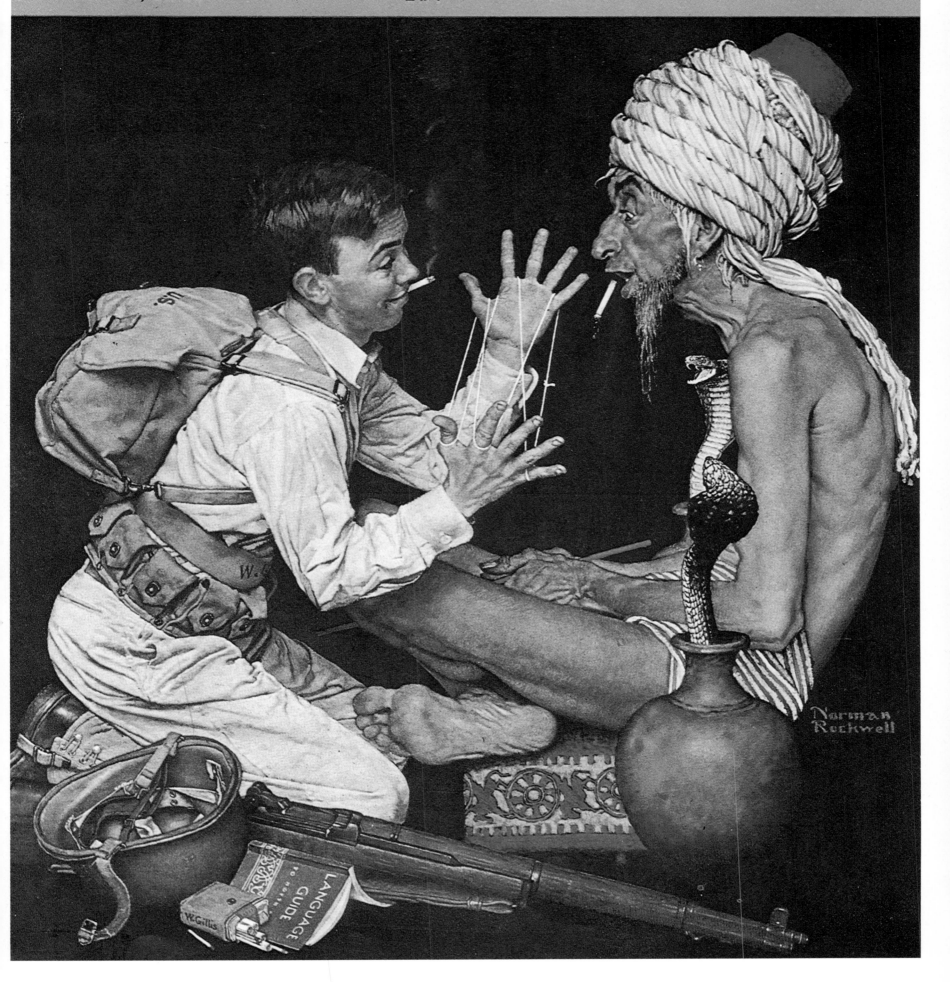

"Manning the Homefront"

This remarkable painting was inspired by the insignia on the cover "Women War Workers." At least thirty-one occupations are represented by this young lady who is energetically off to work. They are boardinghouse manager and housekeeper (keys on ring); chambermaid, cleaner and household worker (dust pan, brush, mop); service superintendent (time clock); switchboard operator and telephone operator (earphone and mouthpiece); grocery store woman and milk-truck driver (milk bottles); electrician for repair and maintenance of household appliances and furnishings (electric wire); plumber and garage mechanic (monkey wrench, small wrenches); seamstress (big scissors); typewriter-repair woman, stenographer, typist, editor and reporter (typewriter); baggage clerk (baggage checks); bus driver (puncher); conductor on railroad, trolley, bus (conductor's cap); filling-station attendant and taxi driver (change holder); oiler on railroad (oil can); section hand (red lantern); bookkeeper (pencil over ear); farm worker (hoe and potato fork); truck farmer (watering can); teacher (schoolbooks and ruler); public health, hospital or industrial nurse (Nurses' Aide cap).

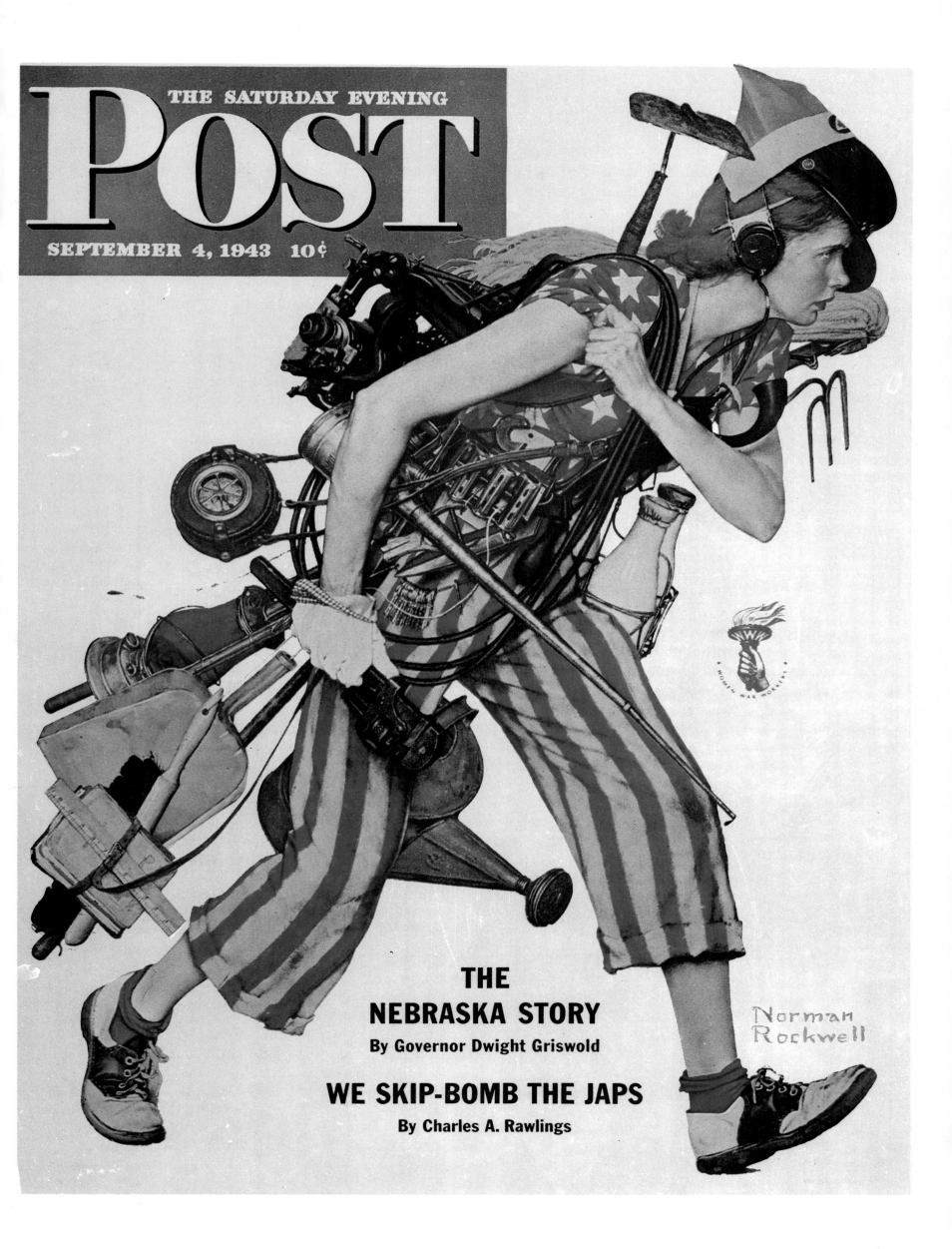

Norman Rockwell, born in 1894 in New York City, is probably the most popular American artist and illustrator of the twentieth century. His paintings, capturing everyday people in everyday situations, are a pictorial history of our nation—and few, if any of us, cannot relate to the stories they tell.

Rockwell studied at the Chase School of Art, the National Academy of Art, and the Art Students League. He later served as an active member of the faculty of the Famous Artists School in Westport, Connecticut.

His work first appeared in *Boy's Life, St. Nicholas, American Boy, Country Gentleman,* and other magazines, as well as in books for children. Much of his talent was devoted to painting for the Boy Scouts of America's renowned calendar series, and he illustrated many of the Scouts' handbooks.

Rockwell gained great popularity as a cover illustrator for *The Saturday Evening Post* and other magazines, developing a style of finely drawn, clear realism with a wealth of anecdotal detail. He also did art work for many major advertisers. Of the many advertisements Rockwell accepted commissions to do, one of his largest and finest was a series of over seventy pencil sketches depicting the American family and the American way of life. This series of sketches was incorporated into advertisements for a major insurance company.

Rockwell's series on the "Four Freedoms" of the Atlantic Charter was widely circulated during the second World War and even today is numbered among the all-time classics. He gained additional recognition with his moon-shot paintings, now in the Smithsonian Institution. He is represented in the Metropolitan Museum of Art, and was named "Artist of the Year, 1969" by his colleagues of the Artists Guild of New York.

Following his early years in New York, Rockwell moved to Arlington, Vermont. In 1943 a fire in his studio in Arlington destroyed many of his original paintings, and over the years many other Rockwell paintings have simply disappeared. Among those no longer accounted for are many of the original paintings prepared for *Saturday Evening Post* covers. Many of the original covers themselves have also disappeared, and those that remain have become rare collector's items.

No one captured America like Rockwell. "I paint life as I would like it to be," he once said. "If there was a sadness in this creative world of mine, it was a pleasant sadness. If there were problems, they were humorous problems. I'd rather not paint the agonizing crises and tangles of life."

Norman Rockwell died on November 8, 1978, and was laid to rest on Veterans Day. The man is gone; his work will be cherished forever.

Now you have completed the second volume of this collection and enjoyed Mr. Rockwell's exciting middle years with *The Saturday Evening Post*. During this period his styles changed on several occasions as he experimented with design, technique, and subject matter. Now you can look forward to the final volume, *The Later Years*, when the real Norman Rockwell emerged as an American legend. His art was everywhere and his signature was almost unnecessary, as his style was unmistakable and his pictures unforgettable.